A Pacific Legacy

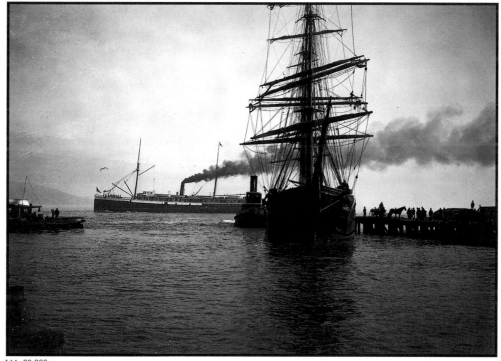

*Steamer George W. Elder and down-easter Two Brothers,
San Francisco waterfront, c.1890, by J.E. Allen.*

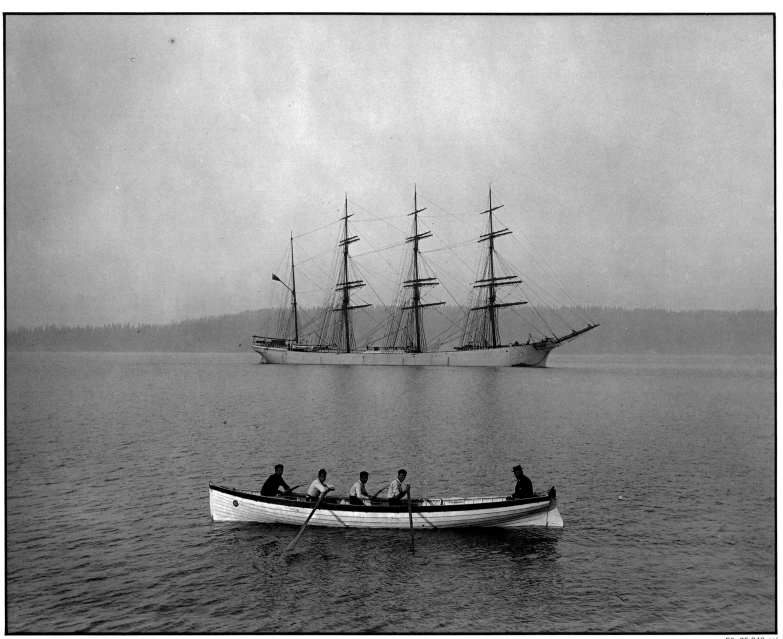

Bark Forteviot *and crew members, Commencement Bay, Washington, c. 1904, by Wilhelm Hester.*

A PACIFIC LEGACY
A Century of Maritime Photography 1850~1950

Wayne Bonnett

Foreword by Robert A. Weinstein

Photographs from the Museum Archives
of the San Francisco Maritime
National Historical Park

CHRONICLE BOOKS • SAN FRANCISCO

Dedicated to the memory of
Alvin Dewey Bonnett,
sailor and landsman.

ACKNOWLEDGEMENTS

I wish to express my gratitude to the management, administration, and staff of the San Francisco Maritime National Historical Park who assisted me and put up with me during the preparation of this book. I am especially appreciative of John Maounis, former Supervisory Curator, and Steve Haller, Curator of Historic Documents, San Francisco Maritime NHP, without whom this book would not have been possible. Thanks also to Steve Canright, Curator of Maritime History, and David Hull, Principal Librarian, and a special thanks to Bob Weinstein, whose knowledge of historical maritime photography is matched only by his zeal for all things nautical.

Printed in Hong Kong.

Library of Congress Cataloging in Publication Data
Bonnett, Wayne.
 A Pacific legacy : a century of maritime photography, 1850–1950 /
by Wayne Bonnett : foreword by Robert A. Weinstein.
 p. cm.
 Photographs from the Museum Archives of the San Francisco Maritime
National Historical Park.
 Includes bibliographical references and index.
 ISBN 0-8118-0023-7
 1. Photography—Pacific Coast (U.S.)—History. 2. Pacific Coast
(U.S.)—History—Pictorial works. 3. Seafaring life—Pacific Coast
(U.S.)—History—Pictorial works. I. Title.
TR23.8.B66 1991
778.9'37'0979—dc20
 91-19556
 CIP

Book design: L.W. Bonnett

Distributed in Canada by Raincoast Books,
112 East Third Avenue,
Vancouver, B.C., V5T 1C8

10 9 8 7 6 5 4 3 2 1

Chronicle Books
275 Fifth Street
San Francisco, California 94103

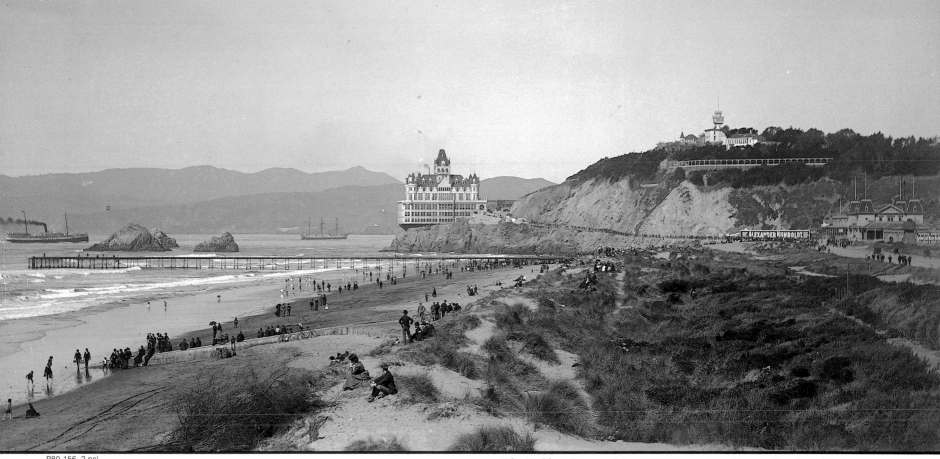

The Golden Gate and the Cliff House from Ocean Beach, c.1890.

TABLE OF CONTENTS

PREFACE		7
FOREWORD	*Robert A. Weinstein*	9
INTRODUCTION	*Wayne Bonnett*	21
CHAPTER 1	Sail and Steam	29
CHAPTER 2	Pacific Coast Ports	47
CHAPTER 3	The Lumber Empire	59
CHAPTER 4	Pacific Coast Shipbuilding	75
CHAPTER 5	Pacific Voyagers	103
CHAPTER 6	Uncle Sam's Navy	121
CHAPTER 7	Inside the Golden Gate	131
AFTERWORD	*Steven A. Haller*	153
BIBLIOGRAPHY		154
INDEX		156

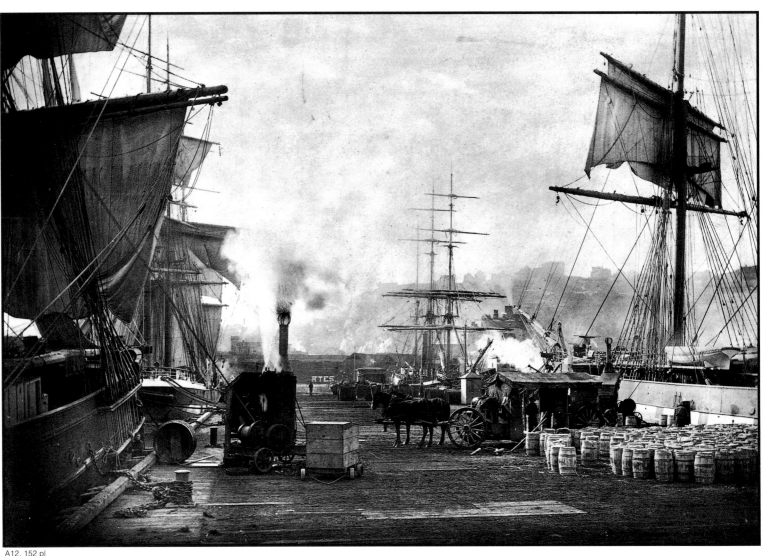

Green Street Wharf, San Francisco, 1894, by O.V. Lange.

𝓗istoric maritime photographs have captivated me since my boyhood days along the California coast. My father, who spent seventeen years at sea during his thirty-year Naval career, collected many wonderful photographs of steam and sailing vessels and faraway ports. He photographed junks and sampans along the Yangtze River in the 1920s, battleships in San Diego, and steam ships and the last remnants of sail in San Pedro and San Francisco Bay. His photographs provided me many hours of fascination and wonder. When I became a marine artist and discovered the collection housed in the San Francisco Maritime Museum, photographs of historic vessels became an important tool of my trade. Each time I visit the museum (now part of the San Francisco Maritime National Historical Park), I am astounded by the breadth and depth of the photographic collection. For one engaged in maritime historical research, the historic documents, library, and photo archives are invaluable.

Contained in the museum's historic document collection and its fabulous J. Porter Shaw Library is more maritime history of the region than one could digest in a lifetime. Many able historians have contributed countless years of research and hard work to record and preserve a maritime legacy. In compiling this book it was not my intention to attempt a definitive pictorial maritime history of the Pacific Coast. My purpose is to provide an insight into the rich photographic archives held in the public trust by the San Francisco Maritime National Historical Park.

The museum's photographic collection presents a challenge. Its existence is well-known to any serious student of American maritime history, and photographs from the collection have illustrated many works by many authors. A few of the photos in the collection have been used so often in books and periodicals worldwide that they have become familiar symbols of our nation's maritime heritage. Yet most of the more than 200,000 historic photographs have not been published and are rarely seen by anybody but researchers and historians. Obviously, no single volume could contain more than a fraction of the total. Thus, the selection process of photographs for this book became one of frustration and opportunity.

I decided on a two-part criterion. First, each photograph selected must stand in the place of hundreds, sometimes thousands, of others. It must be unique, yet representative of a specific group of other photos in the collection. Second, each photo selected must have artistic merit and qualities beyond its documentary content. Even using this method, plus a good deal of personal subjectivity, one is left with thousands of remarkable photographs encompassing a wide range of maritime subjects. A final, and painful, distillation process reduced the possibilities to the 140 photographs reproduced here.

The photographs are arranged into loose groupings or "chapters" that have a certain logic and chronology. They reflect Pacific Coast maritime historical development, but the compositional emphasis is the interplay between photographs on facing pages without regard necessarily to historical context. The brief text at the beginning of each chapter and the captions are intended to give perspective rather than to educate. Usually in books, historical photographs are selected to illustrate text, to graphically enhance a point made by the author. In this book, photographs were chosen for their intrinsic worth, their ability to stand alone. The photographs are paramount, the written word supplementary.

Whenever possible I have credited the photographers. Unfortunately, in some cases the photographer is unknown or unrecorded. I have tried to be accurate with dates, locations, and vessels and have relied primarily on information recorded with the photos and from published sources. The burden of responsibility for any errors or omissions, however, rests with me. Here then is a visual journey through Pacific Coast maritime history from the 1850s to the 1950s, a sampling of an immense photographic legacy.

WB

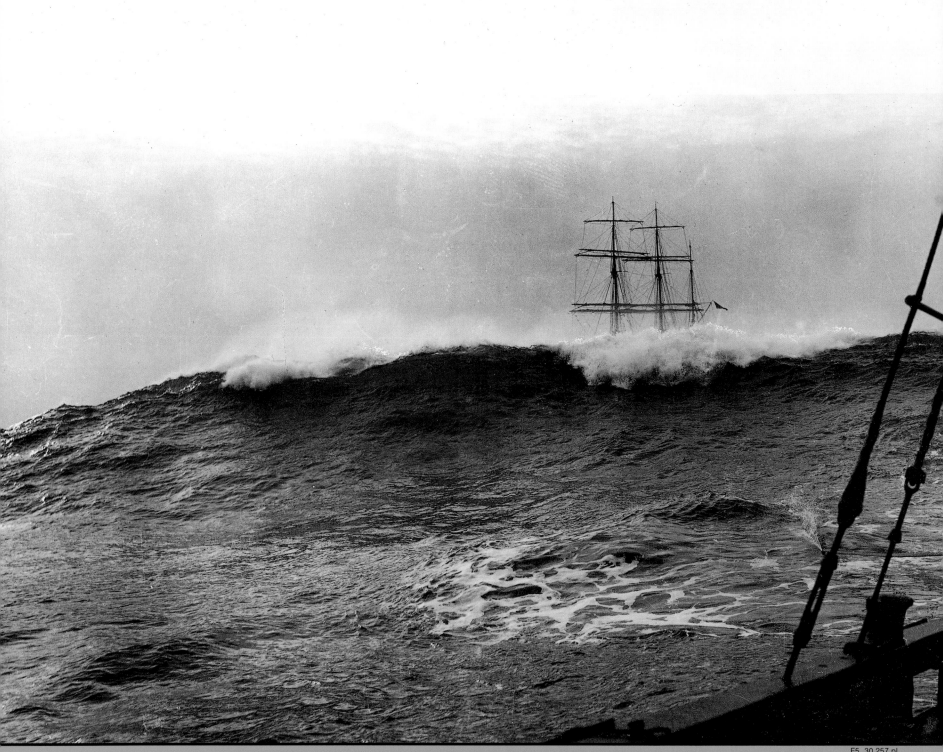

F5. 30,257 pl

The bark Colonel de Villebois Mareuil under tow at the Columbia River Bar, 1912, photo taken by Capt. Orison Beaton from tug Goliah.

Robert A. Weinstein

Few of Nature's wonders have so fascinated mankind as the great oceans, whose mercurial moods have inspired artists throughout recorded time. Literature, music, poetry, painting and its allied arts, including sculpture, have continued in un-broken homage to the great oceans. It is thus no accident that after the first public announcement in 1839 in France of the daguerreotype process, the making of photographs on sheets of silver-plated copper, those who used this fledgling artform suc-cessfully would likewise find the sea an inspiration. How natural that many early-day photographers included among their ear-liest images pictures of the sea, its ships and boats and portraits of the men, women and children serving her.

Whatever could be photographed in those earliest days was tried. Few out-of-doors scenes that could be captured on the new copper plates went unrecorded. Compared to the difficulties in creating a painting, the new "sun pictures" were produced in quantity, quickly and relatively easily. The cheap availability of the daguerreotypes only heightened demand for the fascinating images. Customers for the new daguerreotypes were abundant, anxious to experience the strangely familiar world the pictures revealed. Their hunger to see this world newly defined by the camera quickly became a near mania in many different coun-tries. More importantly, photography increasingly altered man's natural vision, teaching men, women and children to see the world as the camera reproduced it, forcing them to look a second time and see things around them they had often overlooked in casual glances at the passing scene.

For most nineteenth-century inhabitants of North Amer-ica's Pacific Coast the still-untracked wilderness bordering much of the 1,500 mile coastline between Puget Sound and San Diego literally forced dependence on the sea for communication. These same ocean waters and the bordering bays and rivers also provided avenues of commerce for the rich harvest of natural resources this new empire supplied to the world.

The business of shipping goods and passengers by sea pros-pered in the West, nourishing the lives and fortunes of many who depended upon it for their livelihood. Sharing in this bounty were a number of Pacific Coast photographers who chose the sea and its ships as their subjects.

Early photographers on the Pacific Coast made thousands of photographs documenting its varied maritime activity. Catch-ing the dramatic impact of the sea and ships, the photographs' force and eloquence is still deeply affecting, helping to recall the vigor and excitement of the coast's maritime trades. The photo-graphs would be valuable if they were no more than accurate visual records of those turbulent early years, but many of them—each limited in what it offers by the few seconds recorded—are surprisingly often images of great beauty deserving to be cher-ished as artistic documents.

These mute images can be likened to a Rosetta Stone of coastal maritime history waiting to be deciphered. Locked with-in these photographs is important information often obscure in written records, details illuminating little-known corners of the maritime scene that help to explain much that can still only be

guessed at from written histories. It is hardly surprising that the photographers who could make such images would find enthusiastic customers for them.

Since 1840, early photographers in the United States had been producing and selling these newly invented daguerreotypes. Among other subjects they photographed the maritime trades on the waterfronts of the nation's Atlantic Coast cities. To the 1849 gold rush in California came the more daring and the more enterprising of these Easterners, as well as some Europeans, to record on silver-plated daguerreotypes and on chemically-sensitized drawing paper details of this startling event. Everything that might verify what was happening in gold rush California was fair game, including grim-looking portraits of its participants: bearded men, hardy young women and cherubic children. The demand for believable information about the gold rush was insatiable.

From the first it was inevitable that some of these gold rush photographers, particularly those based in San Francisco, would focus their primitive cameras on the coast's ever-changing maritime activity. There was much to attract the eye of maritime photographers on the Pacific Coast. Sailing ships from foreign ports bound in for San Francisco Bay, the Columbia River and Puget Sound arrived in steady procession, while their timber and wheat-laden sisters departed at equally frequent intervals, bound "down under" to Australia or around Cape Horn to Europe. Huge trans-Pacific passenger steamers entered and departed West Coast ports in solemn majesty, and tiny coastal steamers carried freight and passengers along the coast on a regular basis.

Nowhere was the pageant of greater interest or diversity than the parade of vessels entering and leaving San Francisco Bay. Powerful barkentines, handsome Pacific Coast-built vessels, departed to load cargoes of lumber for Australia, while others arrived with Hawaiian sugar for California refineries. Bouncing around the Bay were two-masted "firewood" schooners loaded to their marks and often deeper with redwood from northern California forests, and three, four, and five-masted schooners staggering along under deckloads of Puget Sound's best Douglas fir. Sturdy feluccas, the exquisite boats of Italian fishermen, darted about like butterflies at play, as dark Chinese junks, ungainly but powerful craft, fished for shrimp. Not the least interesting vessels were the overloaded and overworked scow schooners. White-winged and boxy-looking, these "square-toed packets" were as slow as cold molasses in winter. They often carried baled hay, towering deckloads of it from small farms near the Sacramento Valley sloughs.

The varieties of activities at hand in Pacific Coast ports could be bewildering for the uninitiated. Deep-bellied steamers (windjammer sailors sneeringly called them "stinkpots") lumbered into West Coast ports heavy with British Columbian coal for Southern Pacific Railroad locomotives. Tugboats hooting on their steam whistles dashed about the waterfront docks like nervous grasshoppers, hauling vessels in and out of slips, running mooring lines and attending to the endless responsibilities of any busy harbor.

"Valuable glimpses of early-day shipping, tantalizing bits of evidence, may be found among the surviving daguerreotypes of San Francisco Bay."

Ships were not the only appropriate subjects for the maritime photographers, however. The noisy docks and wharves of Pacific Coast ports provided colorful, ever-changing spectacles. Of equal interest were the great smoking sawmills that dotted the lumber spits of Puget Sound: Port Blakely, Port Gamble, Port Ludlow, Port Townsend and Port Angeles. New harbor construction everywhere called for photographic documentation. No activity, from work in progress at wooden-shipbuilding yards to the launching and sea trials of newly-built vessels, seemed too prosaic to be recorded. Even the stowing and discharging of cargo by agile longshoremen seemed touched with visual magic when framed on a camera's ground glass. The noisy gulls wheeling in flight behind San Francisco Bay ferries were transformed by talented photographers into models of nautical beauty. It is no small wonder that the waterfronts of the Pacific Coast remained pictorially exciting year after year.

In the United States, marine photography developed first in the middle nineteenth-century, finding support from those

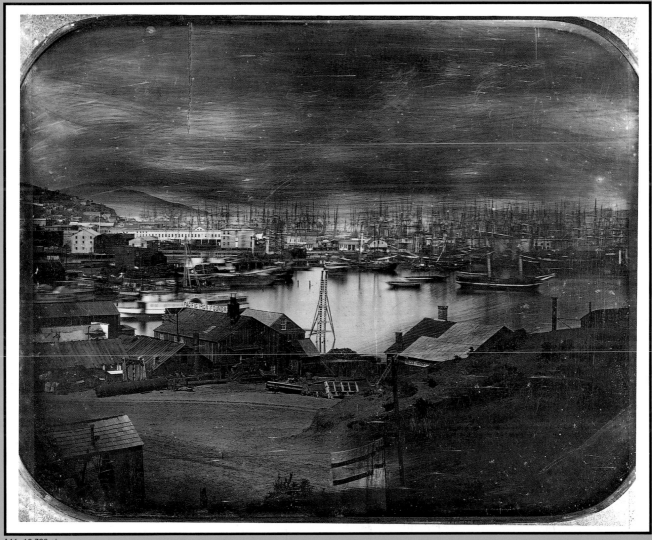

A11. 16,726 pl

Gold rush ships abandoned in Yerba Buena Cove, San Francisco, 1851.

maritime and merchant communities whose good fortune was linked to the sea. From Boston to New Orleans, early-day photographers recorded harbors, docks, warehouses, and newly-built ships. The personalities dominating these early enterprises, the merchant princes and the famed shipmasters, sat eagerly for their photographic portraits.

Such early efforts proved to be a useful training ground for Eastern photographers drawn westward by the California gold rush, men and women destined to become the cadre of the Pacific Coast photographic community. Arriving with—or in frequent cases, as—gold hunters in 1849 and 1850, these pioneer photographers quickly discovered how valuable was their earlier experience in making daguerreotypes of the Eastern maritime scene. Apart from the differences in their new surroundings, the San Francisco waterfront scene, filled with ships, warehouses, wharves, merchant princes and shipmasters, was a familiar photographic subject. That it all looked a bit shabby compared to the settled Atlantic Coast mattered little to anyone. Acquiring gold was the thing in El Dorado.

Struggling with fierce competition only a few years after their arrival, many of these first coast photographers would leave San Francisco's frenzy, spreading out all along the Pacific Coast, traveling from hamlet to hamlet, photographing as they went the expanding maritime activity and whatever else they could sell in the photographic line. With the exception of San Francisco and a few smaller shipping centers, the nineteenth-century maritime photographer's world on the Pacific Coast was, from the first, bounded by numerous frequently isolated coastal communities, each devoted to logging, sawmilling, fishing, and shipbuilding or some combination of them.

They photographed the forested wildernesses, the thousand and one lonely coves and rocky headlands, and the assortment of bar-bound river mouths that substituted then for harbors and ports. Poor weather and shifting, watery light occupied these picture-makers as much as the silent eloquence of tall ships arriving and departing. Few of the day-to-day activities in these fledgling communities were overlooked, each proving to be a compelling photographic subject. The special struggle for su-

premacy on the Pacific Coast between sail and steam, a battle to the death, overshadowed all others, and its picture-making possibilities provided endlessly exciting photographic opportunities. The Pacific Coast maritime scene proved photogenic beyond compare. Every type of sensitivity and insight was required of its photographers, so varied were the problems.

Of paramount interest are the three broad groups into which West Coast maritime photographers easily collect. Chronologically, the first are the professional daguerreotypists and wet-plate collodion process photographers who worked in the larger cities mainly from 1849 to 1883. Next are those photographers working with dry plates in the smaller coastal towns, although they include many holdovers still using the earlier wet-plates. This second group worked during the years 1875–1900. The third group consists of amateurs and hobbyists—they called themselves "Kodakists"—who made their pictures from the turn of the nineteenth century through the later introduction of automatic, hand-held cameras and color film. The types of maritime activity each group photographed, as well as their differing styles and techniques, are important in understanding the pictures they produced.

"The ability to stop movement in their photographs of sailors at work and ships under way was a turning point for maritime photography."

Because most daguerrians and wet-plate photographers specialized in portraits made in indoor, often quite formal, galleries, only a handful made landscape views. For many, landscapes on the Pacific Coast in those early days meant only the available coastal scene and necessarily its maritime activities. It is hardly surprising that some of the pioneer photographers specialized in maritime views. Their remarkable photographs concentrated on such shore-based functions as ship construction and repair, cargo handling, coaling and supplying, dock construction and

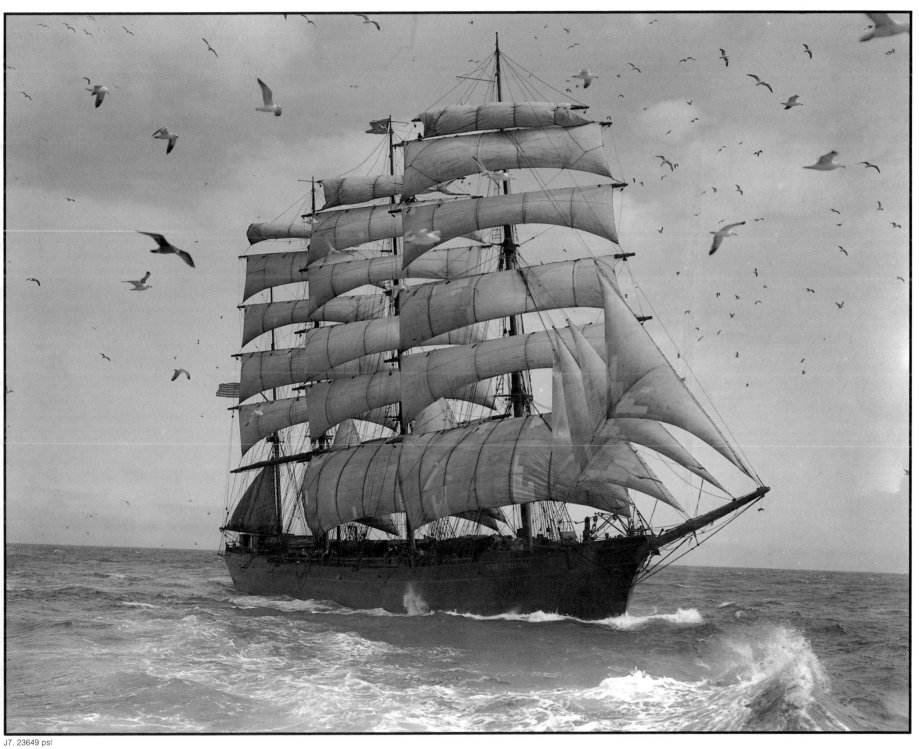

The bark Star of Shetland, *ex* Edward Sewall, *of the Alaska Packers' fleet.*
Photographed by Gabriel Moulin, c.1922.

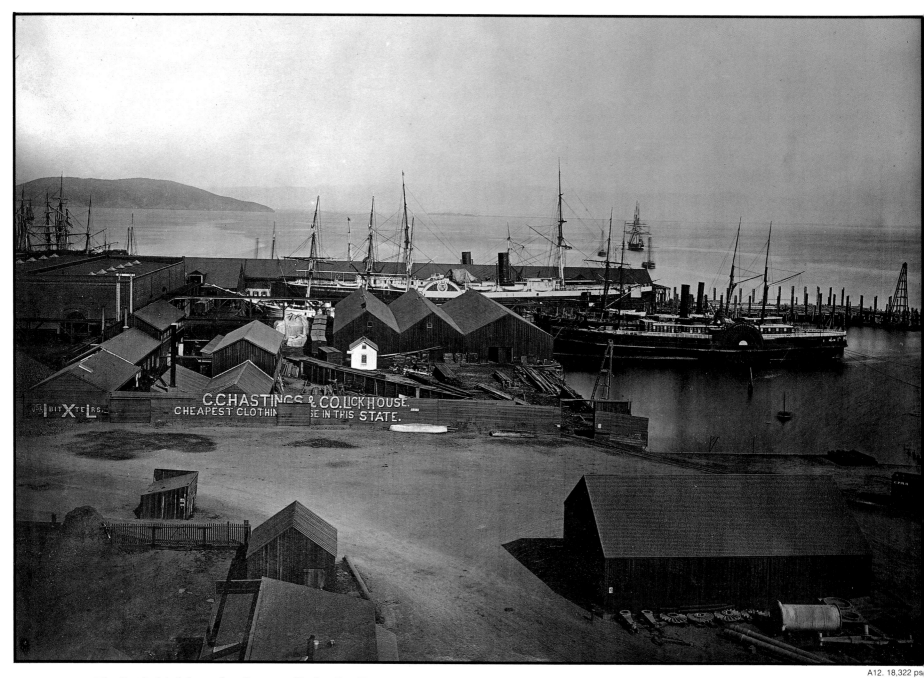

The Pacific Mail Steamship Company Docks, San Francisco, 1871.
Paddle-wheel steamers Colorado, *center, and* Senator *on the right.*
Carleton Watkins, photographer.

related activities. Unable to successfully photograph motion of any kind due to the time it took to expose their slow photographic plates, they were virtually prisoners of the land. They tried everything they could to stop movement, to show more than the milky blurs made by moving objects when photographed on wet-collodion negatives. Pictures made aboard a vessel under way or at sea were utterly impossible. Since cameras then required stout tripods and emulsions were slow (lacking a rapid response to light), they forced photographers to employ long exposures of seconds, and even minutes, far too long to capture photographs of people and objects in motion. These problems were greatest for the Pacific Coast's pioneer image-makers, the daguerreotypists.

"One striking example is a magnificent portfolio of twenty by twenty-four inch albumen prints produced by Carleton Watkins in the 1870s for the Pacific Mail Steamship Company."

Glass-plate negatives used in the wet-collodion process were effective only while their freshly-prepared light-sensitive emulsions remained damp. In preparing them on the spot, as was so often necessary, an operator frequently crouched on the ground under a black cloth, balancing a twenty by twenty-four inch sheet of highly polished glass on the finger tips of one hand while with the other hand he poured a sticky mixture of ether and syrupy collodion, tilting it to direct the slow-moving chemicals evenly over the plate's smooth surface. It was a tricky feat at best, and on a hot day in the bottom of a California ravine with fleas and flies for company, it was an ordeal. These heavy glass negatives required great care in handling, and the obvious difficulties in using them should not be overlooked but rather understood and appreciated.

With dry plate photography came faster emulsions and improved cameras and lenses that could "freeze" moving subjects. The ability to stop movement in their photographs of sailors at work and ships under way was a turning point for maritime

photographers. Only then could their pictures reveal the true sense and feeling of work, the beauty of ships at sea, and the explosive power of sails shaking and snapping in strong winds.

Valuable glimpses of the early-day shipping, tantalizing bits of evidence, may be found among their surviving daguerreotypes of San Francisco Bay, especially several multi-plate panoramas and many additional single plates depicting the bay choked with moored vessels abandoned by their gold-hungry crews. Vessels such as the famed ships *Niantic, Apollo,* and *General Harrison* are identifiable, even though they had been transformed by commercial necessity into covered warehouses, hotels and jails and look very little like rigged sailing ships.

Detailed evidence is available in these plates of the appearance of paddle-wheel steamers, different rigs of sailing vessels, the primitive wharves, the muddy foreshore, the outlines of the emerging city. More vividly the first daguerreotypes project the sense of the bawdy, bustling bedlam of mudholes and shanties that marks the transformation of the Spanish port of Yerba Buena into the Yankee outpost of San Francisco.

Surely there were more images. Where are the expected plates of legendary clipper ships that came to San Francisco: the *Witch of the Wave, Red Jacket, Challenge, Young America* and the immortal *Flying Cloud* or her speedy challenger *Andrew Jackson?* Where are the views taken on the decks of these celebrated vessels and those others important in the commercial life of gold rush San Francisco? Such subjects would not have been overlooked then by daguerreotypists attempting to record whatever excited the popular fancy.

What of the storied shipmasters of the day, such celebrities as Josiah Cressy, Nat Palmer, Bully Waterman or Philip Dumaresq; where are their daguerreotype portraits? They would add increased credibility to the surviving images we have presently of the Pacific Coast's early-day maritime scene and its heroic and fascinating personalities. Through whatever circumstances, they have been lost to us.

Certain photographers of the 1860s and 1870s, best remembered today for pictures unrelated to the maritime scene added to their luster by photographing the activities and personnel of several great shipping companies and commercial institutions.

Esteemed California photographers Carleton E. Watkins, Eadweard Muybridge, Isiah W. Taber, and Thomas Houseworth, who often traveled by deepsea steamer or riverboat to the locales of their well-known landscape scenes, included important waterfront views among their work. One striking example of such coverage is a magnificent portfolio of twenty by twenty-four inch albumen prints produced by Watkins in the 1870s for the Pacific Mail Steamship Company, showing its newly-constructed San Francisco wharf, warehouses, and coaling yards. Muybridge, Taber, and Houseworth produced similar images, including many stereographic photographs of waterfront activities. We are particularly indebted to these and other big-city photographers for the understanding we now enjoy of the appearance and workings of the major Pacific Coast seaports of a century ago. Nevertheless, while the waterfront activity of these pioneers was important and visually rewarding, it provided only a limited view of the entire maritime scene.

Other full-time professionals specialized almost exclusively in maritime work. These included such well-known photographers as T.H. Wilton, R.J. Waters, E.B. Swadley, Walter Scott, and W.E. Worden, all of San Francisco; Wilhelm Hester and Harry Kirwin of Puget Sound; Billy Phelps and a Mr. Scott of San Pedro; and Herbert Fitch and Lee Passmore of San Diego.

A major occupation of these photographers was the much esteemed art of ship portraiture. Feelings of pride and affection for one's ship were emotions shared by owner, master, and crewman alike, and a professionally photographed and mounted view of a command was highly prized. Usually made from a convenient dock, wharf, bridge, or other location firm enough to support the photographer's heavy view camera and tripod, the pictures were most often carefully-composed broadside views of vessels at anchor or tied up at a dock. Sometimes the photographer hired a boat to obtain a desired vantage point.

Wilhelm Hester, a Puget Sound photographer particularly sensitive to maritime subjects, created a series of images around the turn of the century unique among the work of photographers specializing in ship portraiture. His surviving negatives, now in the collection of the San Francisco Maritime National Histori-

cal Park, include some two hundred amazingly detailed deck scenes made aboard sailing ships in Northwest ports. Apparently made with the aid of a wide angle lens, they are photographs of great artistic merit and impact.

A popular custom among the seamen of Hester's day was to purchase a photograph of oneself and companions aboard one's own vessel, either gathered aft by the wheel or forward on the fo'c'slehead. Hester was pleased to oblige, and scores of group photographs showing sailors aboard ships at the flour and lumber docks at Tacoma or Port Blakely are among his surviving work. Ship's officers, often posing with their own seagoing families or shoreside acquaintances, were also popular subjects for Hester's shipboard camera. The sailors and their officers, in fact, proved to be his best customers. Hester regularly mailed large numbers of these group portraits to families and friends of the seafarers he photographed, men who had arrived at Puget Sound from Europe during round-trip voyages that would take months.

Hester also made a number of richly detailed photographs showing ships' masters and officers in their cabins. These studies, especially remarkable in view of the difficult lighting conditions under which the photographer labored, are of inestimable value today, providing an intimate glimpse into a domain once treated as near-sacred and inaccessible to all but a favored few. Hester's views of these ship's saloons stand alone; no similar views have yet been discovered.

Another aspect of West Coast maritime activity was documented by the commercial photographers who catered to the general photographic needs of such small coastal towns as Arcata on Humboldt Bay, Bandon on the Oregon coast, and Redondo Beach in Southern California. They inevitably made pictures of the daily maritime activities bound up with the town's fortunes. Our surviving images of a number of the coast's smaller ports and harbors were made almost exclusively by such itinerant image-makers who often stayed only briefly in individual communities.

For many of these photographers, isolated as they were in small areas, the local markets for such pictures were limited, and determining what photographs would sell was a risky and uncer-

tain business. Some events were of such historical importance as to be obvious choices; the arrival of Teddy Roosevelt's Great White Fleet at San Pedro in 1908 was such an occasion. The launching of the Union monitor *Camanche* at San Francisco to protect Pacific Coast shipping from the Confederate raider *Shenandoah* during the Civil War was another. But more frequently their best guide was to photograph what they or the townspeople found significant in their own lives or communities.

Sea disasters, all too frequent on the Pacific Coast, were events of considerable interest, and rarely did local photographers overlook the importance of making a pictorial record of such tragedies. Certain photographers such as Frank Woodfield at Astoria and Jack Slattery near Bandon specialized almost exclusively in such scenes.

Among these small-town photographers were certain men and women of particular sensitivity, some with backgrounds in art, who succeeded in opening themselves more fully than the average marine photographer to the wild beauty of the Pacific's sea frontier. The photographs made by these camera artists surround us with beauty and drama not found in conventional views, catching the emotional intensity and transient mood that often more exactly define a particular scene or event. The photographic images these artists made of nineteenth and early twentieth-century seafaring are not only believable documents of the ships and ports of the time, but poetic statements of great sensitivity as well.

Charles Robert Pratsch of Aberdeen at Grays Harbor and August W. Ericson of Arcata on Humboldt Bay are two sterling examples of small-town coastal photographers. Fresh research is constantly unearthing new names. A few whose work is only now becoming better known include J.F. Thwaites at Sitka in Alaska; Asahel Curtis (brother to the noted photographer of Native Americans Edward S. Curtis); W. Jenner, Paul Richardson, Edward Lincoln, Webster and Stevens, and C.H. French all operating on Puget Sound; Colin MacKenzie and Jesse O. Stearns at Grays Harbor; Frank Woodfield at Astoria; a Mr. Davidson in the Portland area; Emma Freeman on Humboldt Bay; A.O. Carpenter, Martin M. Haseltine and a Mr. Wood on the Mendocino coast; O.V. Lange and F. Moebus on San Francisco Bay; Charles Wood and William Godfrey in San Pedro and Rudolph Schiller, J.A. Sherriff, the Parker brothers and a M. Judd in the San Diego area.

A third category of maritime photographers consists exclusively of amateurs and hobbyists. Few are known by name; far too many such "snapshooters," deserving recognition, remain unidentified. They include ship's passengers, officers, and crew members who took cameras to sea with them and used them with great success. Many important waterfront photographs are also the work of amateurs who found the activity, color and excitement of the waterfront community irresistible.

"Many important waterfront photographs are the work of amateurs who found the activity, color, and excitement of the waterfront community irresistible."

These amateurs were greatly helped by the steady improvement in photographic equipment which, by the turn of the century, had resulted in small, manageable cameras that could at last be held easily in one's hand, employing fast lenses and more sensitive film emulsion. Glass plates were replaced by easily handled roll film. Picture-taking at sea on a rolling deck in heavy weather, or even in a mild breeze, previously impossible with glass plates in a view camera on a tripod, became an increasingly popular and rewarding pastime. Amateurs who took their cameras to sea often found images of great visual power for their trouble. As a result we are now able to examine thousands of photographs of Pacific Coast maritime history taken by scores of unknown seamen, ship's officers, tugboat masters, bar pilots, docking masters, harbor aficionados and thousands of ship's passengers—camera buffs every one. If not for their efforts much of this period in Pacific Coast maritime history would have vanished unrecorded.

Some few of these amateurs, each deserving recognition, are known to us at least by their names. Working around and on Puget Sound were James McCurdy of Port Townsend and two talented tugboat captains, Orison Beaton and Hiram Hudson Morrison, who made unforgettable images of ships at sea at the request of their employer, George Plummer.

Each of these two seamen-photographers deserves to be better understood and appreciated. Their jobs as tugboat masters on Puget Sound were demanding, their burdens of responsibility heavy. No one expected tugboat skippers busy with their work to take photographs from the wet decks of their tiny vessels. Little has survived in documents or oral remembrance to help us share their responses to their employer's atypical request. The only surviving records, their personal monuments, are the stunning collections of photographs Beaton and Morrison made of the vessels they encountered at sea.

Untrained in visualizing a photograph as professional photographers can, little more than willing amateurs in handling the cameras given to them by their employer, they photographed sailing vessels at sea, under sail, under varying conditions of wind and weather, and the results are not only impressive, but unrivalled *anywhere* for their excellence. Remember, these seadogs were not aboard their tugs as photographers, obligated only to take pictures; they were tugboat skippers freighted with the serious responsibility of shepherding vessels in and out of boisterous Puget Sound. In addition to handling their towing responsibilities properly, they were required to think, as well, of taking pictures. This meant finding the time to see their pictures in the camera's ground glass or view finder, snatching precious minutes from their sea duty to point their cameras, compose the image and click the shutter at the decisive moment. Always the heave and roll of a vessel under way required consideration, for if a photograph were to be sharp, as theirs were so often, the shutter could be snapped only at either end of a vessel's motion, that moment when movement seems to be suspended. Given the ofttimes emergency conditions in which they had to make their images, their photos are the more remarkable.

Archibald Treat, John W. Procter, and William Letts Oliver, each an accomplished amateur, produced notable work on San Francisco Bay as did Bert Leach at Redondo Beach and San Pedro. Captain Joe Brennan, dean of pilots at San Diego, richly deserves esteem for his photographs.

Continuing interest in photography increasingly pressures researchers in many fields to consider photographs in a different light, more as credible documents than as mere illustrations or textual embellishments. Photographs are increasingly being used and accepted as primary source materials, the precise detail they contain often unobtainable elsewhere. Few documents have proven to be as credible as a first-rate photograph. Often they are the *only* dependable authority. For historians and scholars, and for maritime enthusiasts in general, the type of maritime photographs reproduced in this book are uniquely valuable.

The images reproduced on these pages will never again be seen in real life. The marine photographers of the Pacific Coast, whether honored by name or unknown, professional or amateur, are our hosts. They would only hope that we will share their enthusiasm and their excitement.

"The images reproduced on these pages will never again be seen in real life."

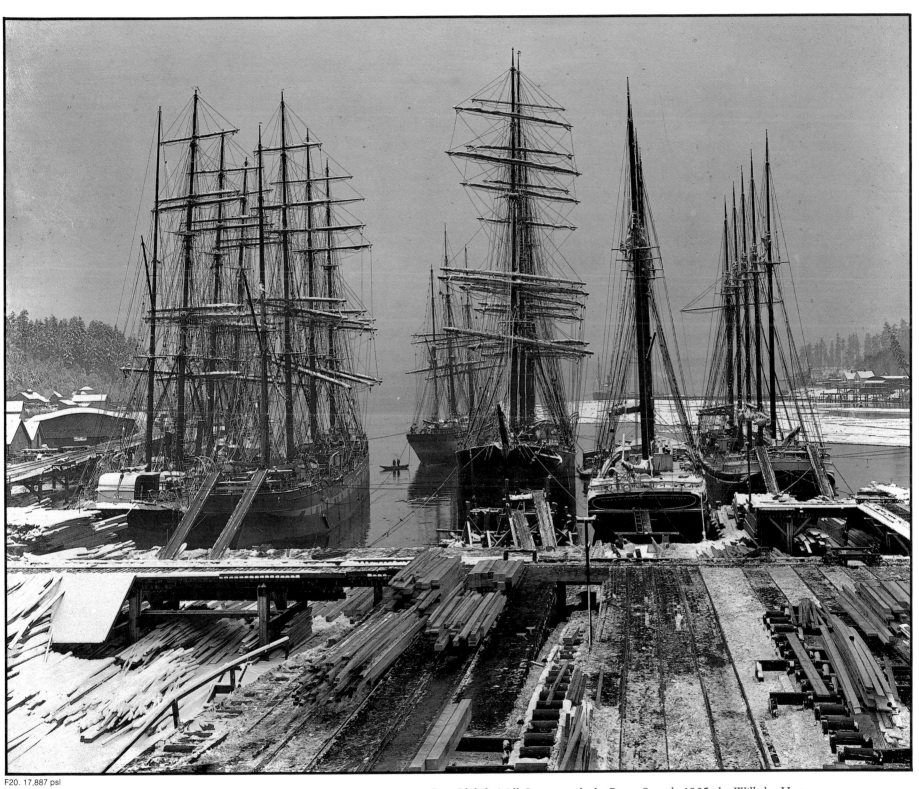

Port Blakely Mill Company dock, Puget Sound, 1905, by Wilhelm Hester.
The vessels from left to right are the four-masted barks Englehorn *and* Bracadale,
the barks Albania *and* Wanderer *and the schooners* Lyman D. Foster *and* Crescent.

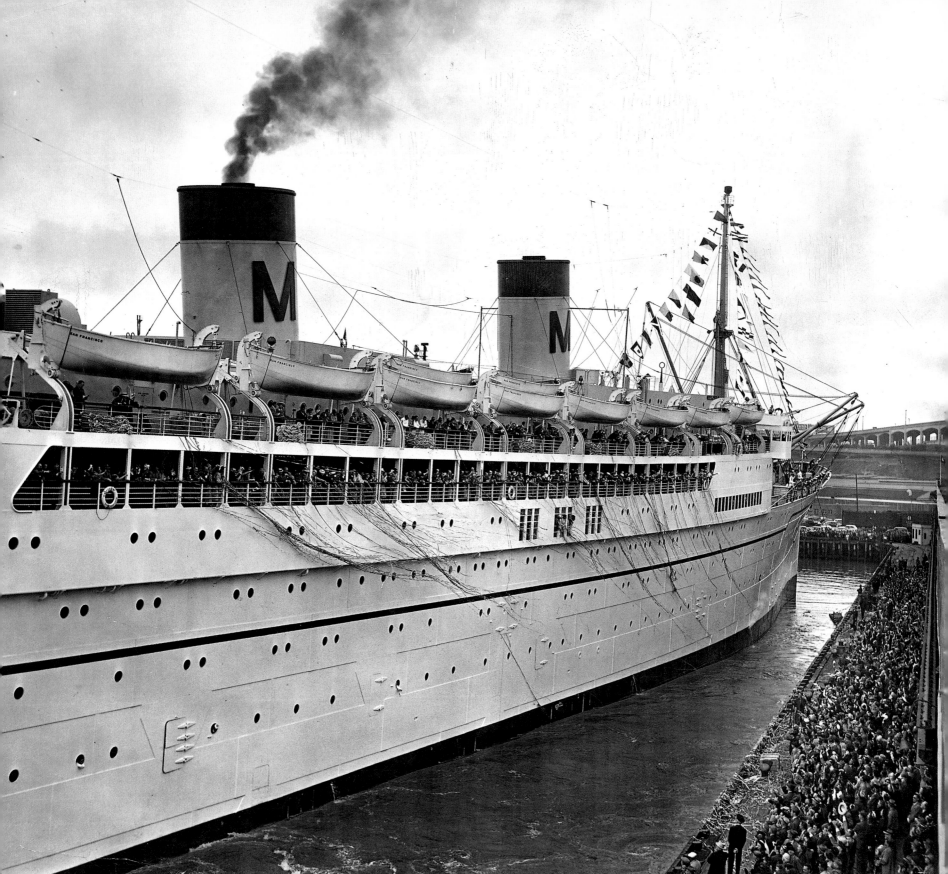

The Matson liner Lurline *departs San Francisco for Honolulu on her maiden post-war voyage, April 15, 1948.*

The world is entering the Pacific age, during which nations of the Pacific hemisphere, including the United States of America, will exert an influence over international trade and politics unprecedented in world history. The end of World War II is a convenient date which future historians might well identify as the beginning of an era in which the trading nations of the Pacific, rather than the Atlantic, will decide the course of world history. By the 1990s, the force of change, a tilt to the Pacific, has become undeniable.

The dramatic growth of the Japanese economy since the end of World War II could well be a prologue to prosperity for the entire hemisphere, a hint of things to come for nations relatively new to the Western concept of foreign trade; Taiwan, Korea, Singapore, and the potential colossus of China. Some economic pundits have proclaimed that the Pacific Century is already at hand. Despite the emergence of Japan, the United States, they say, is the key player in this great age. That may be so. In any case, the fortunes of the United States of America are inexorably linked to the Pacific Basin.

Maritime commerce, historically crucial to the economic well-being or decline of nations, will be the principal means by which future international trade will be conducted. For America, Pacific Coast seaports will continue to be vital import-export gateways to the world.

The photographic legacy of those American seaports and Pacific Coast seafaring from the California gold rush to the end of World War II is the subject of this book. Excellent books have been written that document the ebb and flow of Pacific history, and no attempt here has been made to duplicate those numerous works. For a brief part of the long epoch of Pacific maritime history, the camera has recorded it. Fragments of the visual record that speak of seafaring with profound eloquence constitute the major part of this book.

That nations of the Pacific might rise to world economic dominance is not a new thought. Early European seafarers from Cabrillo, Vizcaino, and Drake to relative latecomers like Vancouver and Cook have all expressed awe at what they beheld. Their interest, however, was not raw land rich with promise, but abundant treasures readily at hand, wealth that could be extracted by trade, or by force, from already well established civilizations in the Americas and Asia. The Pacific Coast of North America was potentially rich in furs, timber and ivory, but the wild shore was inhospitable, and the interior reaches were beyond the grasp of colonial powers of the time.

Later adventurers who came to stay on the Pacific Coast were up to the challenges of the new land. Theirs was a vision of unlimited prosperity that would surely come from hard work and divine guidance. Argonauts and entrepreneurs in the nineteenth century boasted of a day when cities beyond dreams and empires of infinite scope and variety would rise in California (or Oregon, or Washington, or British Columbia).

The lure of the Pacific Coast and the prophecy of its greatness has been a persistent theme in American history, and the prophecy has become self-fulfilling. The birth and rise of Pacific seaport cities in less than a century is due in large measure to the efforts of men and women with vision and determination to make dreams into realities.

In spite of this nation's recent and perhaps temporary economic difficuties, she is today the most powerful and influential nation of the Pacific hemisphere. But this was not always so.

During the first sixty years of independence, the United States' only seacoast was the Atlantic shore. The nation's origins and destiny were closely linked to the Old World countries of the Atlantic community. As a nation, the United States has had a Pacific Coast for only about 140 years, not long as world history goes. During a time approximately equal to two average American life-spans, the entire story of American Pacific Coast seafaring has unfolded.

Prior to the 1840s, the limited sea-borne commerce off the Pacific coast was dominated by English-owned fur trading enterprises, the Hudson's Bay Company, and their biggest competitor, the North West Company. On the California coast, a small trade existed between Spanish, later Mexican, hide and tallow merchants and American seafarers, who were twelve thousand miles or more from their home ports. The Pacific shore, as described by Richard Henry Dana in *Two Years Before The Mast*, was used primarily as a way-station by ships bound elsewhere.

Boston merchants had established a prosperous triangle trade involving the Pacific Northwest. Their ships sailed from Boston to the Pacific via Cape Horn to trade Yankee tools to the Indians for seal and otter furs. The next leg of the triangle was across the Pacific to China, where the furs were sold at a profit. Silk, tea, cottons, chinaware and other goods were then purchased for the homeward leg. This cargo was transported around the Cape of Good Hope to Boston, then sold at a profit to a ready market throughout the Atlantic seaboard states.

Whale hunters from New England, who had depleted their Atlantic hunting range, tracked the elusive prey in ever more distant seas. As early as 1795, Nantucket whalers were well established in the Pacific Ocean. The long journey home from the Arctic or South Pacific necessitated brief stop-overs along the way for fresh water and supplies. Although Hawaii, or the Sandwich Islands, became a whaling center that surpassed in importance any on the Pacific mainland, safe harbors along the California coast became familiar ports of call for whalers. Russian trappers made tentative probes down the Pacific Coast from Alaska and established a foothold just north of San Francisco Bay, but for the most part, the rich untapped resources of the Pacific Coast were not part of the maritime commerce of any nation. Any year prior to 1840 in which more than a half-dozen merchant vessels other than whalers appeared in a Pacific port was a remarkable one.

Tales of the Pacific Coast brought back to the United States by seamen, overland explorers and trappers helped incite an already restless spirit in many Americans and set the stage for the first major westward migration. By 1841, there were only about 400 non-Mexican, non-Indian inhabitants of California, even fewer in Oregon. In the two succeeding years, over 4,000 Americans made the trek west over the Oregon Trail, drawn by the lure of land in Oregon and California, many pushed by disappointment and misery from their depression-ridden farms in the Mississippi Valley.

Maritime activity along the Pacific Coast increased after 1840, as Boston traders looked westward with growing interest. Weak Spanish rule had given way to Mexican rule in California in 1822, and Mexico seemed to condone, if not invite, foreign intervention, at least in the minds of the interveners. Elsewhere in world trade, the prowess of American merchant shipping was becoming evident. Yankee ships made bold intrusions into heretofore European controlled markets. Europe itself was becoming a market for American exports. In 1846, Britain repealed her protectionist corn laws, thereby allowing America to export grain to England just at a time when America's newly tilled heartland west of the Appalachians became productive. Substantial grain exports from the Pacific Coast, however, were still more than twenty years in the future.

Demand for more ships was increasing, and shipbuilders from Maine to New York responded. American shipyards, already experienced in building vessels such as small brigantines and schooners, turned out full-rigged ships. They built packet ships in the 1840s for the Atlantic trade that provided American shipping companies with American-owned hulls. Many of these ended up abandoned in the shallows of Yerba Buena Cove during the California gold rush. The loss of these ships, an estimated 400 vessels in the single year of 1850, spurred even greater shipbuilding activity in the east. American shipyards in New York and Maine produced a new class of speedy ships that became known throughout the maritime world as "clippers." The term had already been applied to speedy vessels prior to 1850, but it became forever entwined with the romantic myths

and harsh realities of the gold rush era. Political events prior to the gold rush, however, had prompted increased interest in shipbuilding in the United States.

An event of monumental importance to America's future occurred in 1846 when the United States of America officially became a two-ocean nation. The Oregon Territory, claimed jointly by Great Britain and the United States since 1814, became undisputed American soil on June 15, 1846 by virtue of a treaty that established latitude 49 degrees north as the international boundary between Canada and the United States. From a cluster of former colonies huddled along the Atlantic seaboard, the young American republic had already more than doubled in size in 1803 with the Louisiana Purchase. The new territory had also provided direct access to the Gulf of Mexico through New Orleans. The American Gulf Coast was expanded in 1845 when Texas was annexed. Now with the addition of Oregon, the nation stretched across the great plains and the Rocky Mountains, beyond the Cascades and the Coast Ranges, to the Pacific.

Added to the one thousand miles of Atlantic and Gulf coastline of America were over four-hundred miles of Pacific shore. Moreover, the rugged shoreline was the western boundary of 286,500 square miles of forests, mountain ranges, and fertile flatlands. Although news of the treaty was welcomed by most Americans in the east, there were no great celebrations to commemorate the event, no cannons fired, no parades. It was taken in stride by most Americans as a logical step toward "Manifest Destiny," a thrilling phrase that expressed the mood of an energetic and ambitious nation. Besides, an increasing number of Americans already on the land considered both Oregon and California *de facto* American possessions, lacking only official recognition by the nations concerned. That recognition was to come after the Mexican War of 1846–48.

America's war with Mexico was the culmination of prolonged efforts to wrest Texas and California from first Spain and then Mexico. Congress had attempted without success to purchase California as early as the 1820s. Later attempts to buy it or create an independent California by negotiation failed as well. Americans living on the Pacific Coast finally ran out of patience and precipitated events to force America's hand. A band of American soldiers and aggressive malcontents seized the town of Sonoma in northern California and declared a half-baked republic in 1846. The turmoil attracted the attention of the English, who had long sought a means to bring California into the British Empire. Another ingredient was added to the bubbling brew when the British made overtures to the Mexican government suggesting that California might become part of the British Commonwealth. War was inevitable. When it did come, the main battles were fought in Old Mexico, not in California. After quick seizure of Monterey by Americans and a relatively minor battle near Los Angeles, California was in American hands.

Thus on February 2, 1848, the Pacific Coast of the United States was officially lengthened by some eight-hundred miles with another stroke of a pen. The treaty of Guadalupe-Hidalgo followed Mexico's defeat by the United States and fulfilled the American dream of manifest destiny, at least for the time being. Under terms of the treaty, the territory that later comprised the states of California, New Mexico, Arizona, Utah, and Nevada, and parts of Colorado and Wyoming, was ceded by Mexico to the United States. The Pacific Coast of the United States now extended from Puget Sound in the north to San Diego in the south, and the nation truly stretched "from sea to shining sea."

Whatever these events might portend for the eastern states and for the Indian tribes that occupied much of the new territory, they marked a geo-political change of enormous consequence for the entire world. As a two-ocean nation, the United States suddenly gained strategic potential to become a world power. For better or worse, the Pacific basin, its archipelagos and the ancient worlds of China and Japan would never be the same.

But full impact of America astride the continent was still in the future. The paramount focus in 1848 was on gold. As if by divine guidance, at least in many American minds, California had been delivered into American hands just as her golden treasures were being laid bare. Actually, John Marshall's discovery of gold preceded the treaty by nine days. Excitement over the new find grew slowly at first. Six months passed before news of the discovery reached the East Coast. Then the aptly-named Golden Gate and the great seafaring sanctuary of San Francisco Bay took on new importance.

Discovery of gold in California set the course of Pacific Coast maritime history for the next century. Gold brought people in

numbers unimagined by the early settlers of California. Unlike the East Coast where seafaring traditions had built up slowly over two centuries, the West Coast was an instant maritime center, launched suddenly in a maelstrom of gold fever. Beginning in 1849, hundreds of vessels from maritime nations of the world converged on San Francisco bringing a polyglot assortment of sailors and soldiers, speculators and adventurers. Some found their fortunes, most did not. Few came with the intention of staying permanently in California, and most did return east, either with their riches or, at least, with stories to last a lifetime. As a fortuitous by-product of the gold rush, San Francisco had an unparalleled assemblage of master mariners; deep-water men from Liverpool, Marseilles, and Hamburg; schooner men from New England, Chesapeake Bay, and the Carolinas; experienced whale hunters from Nantucket and the Pacific islands; and steamboat men from Aberdeen and from the rivers Thames and Clyde. Judging from early records, there were also shipwrights, sawyers, sailmakers, riggers, and chandlers from almost every seaport on the globe. Many who came to labor in the goldfields lent their skills instead to an expanding maritime industry.

Among those who did stay after the initial gold rush had subsided were men and women of vision with a deep faith in the new land. They discovered the true nature of the Pacific Coast's untapped treasures: an empire for the making in manufacturing and intercostal commerce, an empire for the taking in lumber and grain. And silver, passed over in the mad rush for gold, promised seemingly unlimited wealth. Rich silver ore from the Comstock Lode and other strikes in Nevada brought yet another flood of prosperity to the Pacific Coast.

Gold and silver from California and the west bankrolled American commercial expansion. American diplomacy opened formerly inaccessible Chinese ports to Yankee traders, and American boldness introduced the Western world to Japan. A need for quicker transit between American coasts prompted diplomatic machinations in Central America aimed at securing passage across the Isthmus of Panama. Dreams of a canal were born. By 1851 the world's first transcontinental railroad, just forty-seven miles long, crossed that narrow isthmus linking a port on the Atlantic Ocean to one on the Pacific. And for the first time the United States cast her gaze westward across the Pacific in search of potential territory for naval bases and coaling stations necessary in the coming age of steam power.

The United States Navy's Pacific Squadron, a feeble force prior to 1848, would emerge in time as the Pacific Fleet, equal to any in the world. New deep-water steam side-wheelers operated out of Pacific Coast ports would carry mail, dispatches, and even passengers across the Pacific on a regular basis.

The navigable rivers of the Pacific slope, the mighty Columbia and the Sacramento, and the wild Yukon in Alaska, would generate fleets of riverboats designed by westerners and tempered by the rivers themselves. Need for transport across the broad reaches of San Francisco Bay and Puget Sound would result in the largest fleet of ferryboats in the world. Pacific Coast shipbuilding would evolve from East Coast traditions and materials to take advantage of abundant Douglas fir and cedar. Eastern vessel designs were modified for conditions and materials unique to the Pacific Coast.

In 1849 Great Britain repealed its Navigation Laws, longstanding trade barriers that prohibited trade to Great Britain in anything but British ships, or in ships of the country in which the goods originated. The resulting lack of competition had caused the British merchant marine to stagnate. American ship owners competed vigorously for any trade and demanded ships capable of reaching any point on the globe. The quick advantage they took of the changed conditions in Great Britain plus Yankee determination gave America superiority in shipbuilding that soon led to a golden age in American seafaring. American clipper ships, which had a monopoly on the California run due to America's own restrictive navigation laws, were now free to tackle well-established British trade routes.

The brief but glamorous era of clipper ships resulted from a quest for speed at sea over long distances. Clipper ships were immensely suited to needs arising from the gold rush in California. They could deliver mail, passengers, manufactured goods and stores at record speeds between the coasts. However romantic and awe-inspiring the "Greyhounds of the Sea" were, they were not particularly suited to carrying large payloads of bulk cargo. So when gold fever subsided and grain became the principal commodity shipped from the Pacific Coast, the Yankee clippers became obsolescent; the need for speed-at-any-cost

passages around the Horn had diminished. Extreme clippers that required large crews to handle their many large sails were no longer being turned out in eastern shipyards.

Britain meanwhile, had turned to iron-hulled sailing ships as a means of competing with American vessels. Iron had significant advantages over wood. It was fireproof, resulting in lower insurance rates by marine insurers, principally Lloyd's of London. It had greater strength, allowing for longer keels and bigger hulls that were less prone to leaking. Iron structural members, less massive than oak, permitted greater cargo capacity in iron ships of comparable size to wooden ships. English iron mills developed a process of rolling huge sheets for hull plates that reduced construction costs. America, which at the time had no mills capable of turning out affordable iron sheets and sizable structural members, relied on her abundant timber resources for wooden shipbuilding. In time she felt the competitive pinch.

By the end of the 1860s England again had the upper hand in ocean commerce. During the Civil War, many American ships were lost to Confederate raiders. Rather than see their ships sunk or captured, Yankee shipowners sold a number of their vessels to neutral European countries. After the war ended, these vessels remained under European flags. The shortage of American merchant tonnage was both cause and effect of a great decline in American maritime activity. This decline opened the door for British iron-hulled sailing vessels, whose owners had prospered during the Civil War, to dominate even Pacific Coast maritime trade. For fifty years thereafter, the British reigned supreme as worldwide bulk cargo carriers. Most of the vessels loaded in Pacific ports in those years flew foreign flags.

America's interests following the Civil War were largely internal. Southern reconstruction after the war, westward expansion, railroad building, and unprecedented domestic consumption of American products all helped turn attention away from the sea. What few American-flagged ships existed during what has been called the "dark ages" of American shipping were involved in intercostal or local coasting trade.

American sailing vessels, the square-rigged "down easters," carried the lion's share of cargo between the Pacific and Atlantic Coasts after the Civil War. These wooden ships and barks, not so glamorous but more commodious than the clippers and almost as fast, were products of "down east" shipyards in Maine, Massachusetts, and Connecticut. They were more practical and required smaller crews than extreme clippers. They were the logical successors to the clippers, and, in the view of some historians, were superior vessels in many respects.

From the California gold rush to completion of the transcontinental railroad in 1869, almost all commerce between the Pacific Coast and the east was conducted by ship. Overland routes were inefficient, dangerous and arduous. That is not to say sailing around Cape Horn was any less arduous or dangerous but it was, by nineteenth-century standards, a cost-efficient way to transport goods coast to coast on anything approaching a regular schedule. With the coming of the railroad to the Pacific, many thought sea-borne commerce would be diminished, and, indeed there was an influx of eastern goods at lower prices via the railroad. But the prosperity that rolled to the Pacific along with the railroad actually stimulated more demand for Pacific Coast products, and shipping by sea did not immediately suffer.

As early as 1855 it had been discovered that the fertile soil of the Pacific slope would yield more riches than gold and silver. That year the first small shipments of wheat were exported from California. By the 1870s, boom years for wheat growers, grain carriers from England, France and Germany were regular visitors to the Pacific Coast, principally San Francisco Bay. Lumber carriers from many nations crowded Puget Sound sawmill ports. Because development of Pacific seaports after the gold rush was principally the consequence of export rather than import, San Francisco and Puget Sound ports prospered in the 1870s and 1880s despite the decline of the American merchant marine. An influx of Scandinavian, German, French, and British seamen added to the international flavor of Pacific Coast seaports.

Even though early San Francisco is associated with clipper ships, Pacific seaports emerged in the twilight of the great age of sail and the dawn of the age of steam. A thousand-year history of ocean commerce by sailing ships was nearing its end. The final flourishes of the American age of sail were the clippers, the down easters and, finally, the big five and six-masted schooners at the close of the nineteenth century and the beginning of the twentieth. Because of the vast distances between seaports, the Pacific Ocean became the last preserve of deep-water sail.

In time, even British sail was eclipsed by distinctly unglamorous steamships from both sides of the Atlantic plodding their way with monotonous regularity from port to port. Advocates of steam power had been waiting in the wings since the 1830s to push their theories to center stage in world shipping. And inevitably, their moment came. As they had claimed, the relative efficiency and reliability of steam navigation made regular scheduling possible and established a solid future for steam power. Steamships were slow to replace commercial sail on the Pacific Coast because of the great distances between North America and Asia and Australia. Eventually, however, Pacific Coast ports became regular stops on worldwide steamer routes for both freight and passenger service.

Although not the oldest Pacific Coast port by any means (San Diego deserves that title), San Francisco quickly became the biggest, thanks to the California gold rush. In the second half of the nineteenth century, San Francisco Bay, which early explorers bragged could hold all the armadas of Europe, blossomed into a maritime center. By 1890, San Francisco was the most modern port in the nation and the third largest, by volume of traffic, in the world. Vancouver, Seattle, and Portland emerged as seaports during those decades, but each was overshadowed by the port of San Francisco. Many smaller ports along the Pacific Coast, such as the sawmill ports on the Mendocino Coast and the whaling stations in Oregon and California, were specialized and existed solely because of their proximity to a single specific commercial enterprise.

Just as gold had been the catalyst for maritime growth in the mid-nineteenth century, war was a spark that set off sweeping changes a half-century later. The little navy yard at Mare Island in San Francisco Bay had been established in 1853 to service a Pacific squadron consisting of a half-dozen vessels. Within a few years Mare Island had the capability to build ships although most of the yard's activity was maintenance of a growing fleet. Over the years Mare Island Navy Yard was expanded many times.

During the Spanish American War of 1898–1900, San Francisco became the principal port of embarkation to the Philippines. When the United States acquired the Philippines from Spain, the nation got its first overseas naval base. Naval engagements in Manila Bay, 18,000 nautical miles from Norfolk, also brought home the need for a strong Pacific fleet—and a canal through the Isthmus of Panama. The Panama Canal, opened in 1914, resulted in a new naval strategy and expansion of the naval base at San Diego. By 1918 that naval base, serving the U.S. Pacific Fleet, was a major link in navy strategy. San Francisco still had Mare Island Naval Base, and Seattle had nearby Bremerton Naval Yard, but the Pacific Fleet was too large to be maintained from any one port. Naval strategy calling for a dispersed fleet meant even further port expansion. Pearl Harbor in the Hawaiian Islands was developed as a major navy base. The presence of the United States Pacific Fleet in international waters of the Pacific Ocean forced Japan's hand and led, ironically, to expansion of the Imperial Japanese naval fleet.

The U.S. Navy's role in Pacific maritime history has grown steadily since 1900. The Navy's strength, at least in terms of numbers of vessels, reached an apex in 1945 at the end of World War II, with the majority of warships and vessels under the Navy's control stationed in the Pacific. The wartime ports of San Diego, San Francisco and Seattle were dominated by naval activity. San Francisco's Fort Mason was also the major U.S. Army Port of Embarkation for the Pacific war. Shipyards on the Pacific Coast from Puget Sound to San Diego turned out over three million tons of shipping between 1939 and 1945.

The post-war era marked the emergence of Pacific Basin nations that continues today. The Port of Los Angeles eclipsed San Francisco in shipping tonnage in the mid-1920s and is today one of the largest ports in the world. Seattle-Tacoma, too, is larger than San Francisco in shipping tonnage, and the Port of Oakland surpasses San Francisco (although it is considered by some to be a part of the "Greater Port of San Francisco"). Maritime passenger service in the Pacific has all but been replaced by air travel, yet sea-borne commerce continues as the economic mainstay of most of the Pacific Basin nations. Pacific Coast maritime history continues to be recorded by the camera.

Ships, like men, have a life span, and a relatively short one at that. A ship is a tool, seldom intended to be solely an object of beauty, and as a tool it wears out. The sea takes a heavy toll of ships, as does fire, collision, war, and man's inept navigation. Consequently, in the span of one hundred years ships of the Pacific Coast have come and gone, often leaving little trace.

Entire vessel types that played important roles in Pacific maritime history have disappeared. Other types have singular survivors, spared by human intervention, sometimes by fate, to become museum pieces. Even these are seldom part-for-part the same ships that once slid down the launching ways bearing the same names, for ships are continually modified during their active life. Wooden sailing ships in particular were altered and constantly repaired, and if they survived the perils of the sea long enough, were ignominiously converted to hulks or barges at the end of their careers. The few existing historic vessels worldwide are tributes to the indefatigable efforts of many and are truly national treasures.

For the most part, the only way to see historic vessels in their prime is through photography. Humans feel a special kinship with ships and tend to impart human characteristics to the vessels in which they risk their lives and fortunes. Many a sailor has taken a snapshot of his vessel and kept it close as he might a photo of a family member. As long as there have been cameras professional and amateur photographers have tried to capture the irresistible beauty and awesome presence of ships. For all those who have sought to preserve maritime history on film, for whatever reasons, we can be thankful.

Matson Line's SS Sonoma, San Francisco, 1926.

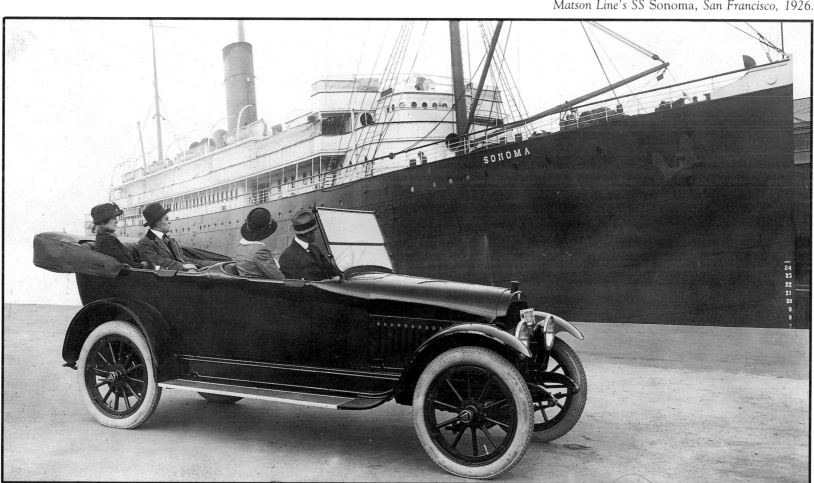

P79-220 pl

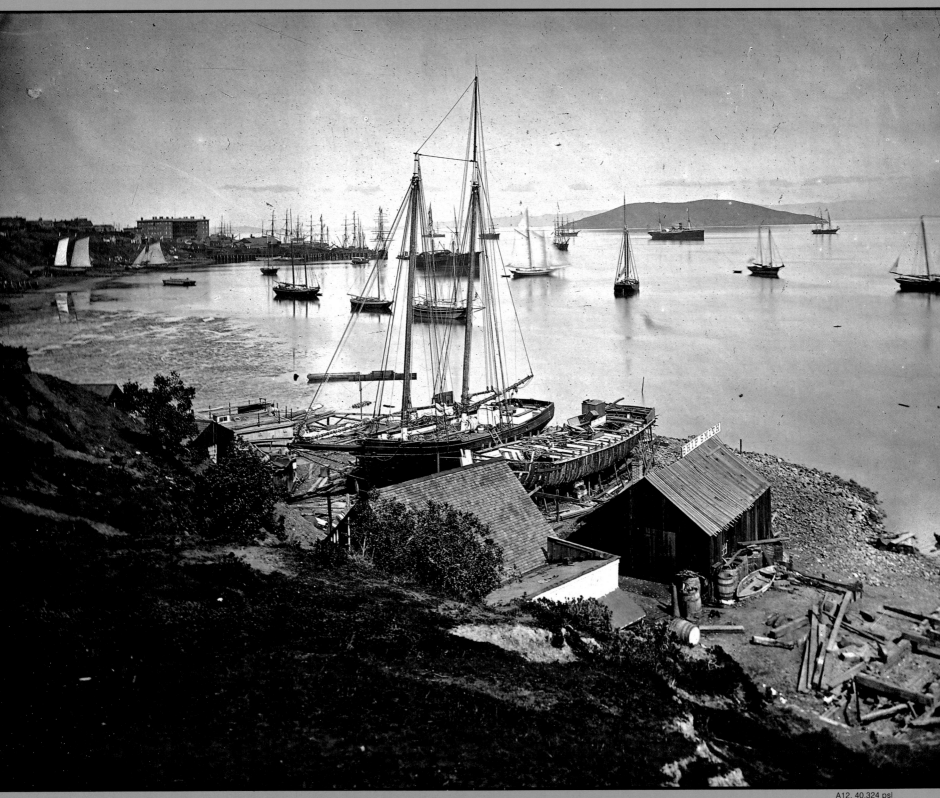

Sail and steam in peaceful coexistence, Steamboat Point, San Francisco, c.1866,
Rincon Point on the left. In the center background (between masts of schooner on ways)
is the paddle steamer Hermann, built in 1847.

Sail & Steam

Historic photographs of Pacific Coast vessels are about equally divided in number between sailing ships and steamships and that is as it should be. Photography as an element of maritime history began in the late 1840s and coincided with the emergence of steam-powered vessels and the rise of Pacific Coast maritime activity. Thus, sail and steam existed side by side almost from the beginning on the Pacific Coast. Sailing ships dominated the development of the lumber and grain industries and steamships played a key role in coastwise and intercostal passenger service.

The *California*, first vessel to deliver a contingent of gold-seekers to San Francisco in 1849, was, prophetically, a steamship. Wind-driven ships would still dominate the world's sealanes for several more decades, however, and lofty windjammers would be common in the world's ports for another half-century. It is ironic that the second half of the nineteenth century, during which the steamship was developed to commercial effectiveness, was also the period in which merchant sail achieved its highest degree of performance and efficiency.

Early American commercial steamships, like the *California*, were far from perfect. They carried more coal for their ravenous engines than cargo. Huge paddle wheels on either side of their wooden hulls churned slowly at best and, at worst, flailed helplessly in heavy seas inherent to ocean passages. Torsion created by the sea's resistance to the paddle wheels twisted the wooden hulls and shortened their useful lives. Steam-driven screw propellers were tried by shipbuilders but engine vibration transmitted by long drive shafts proved hard on wooden hulls. Great Britain produced iron hulls which, among other things, were more

resistant to vibration, and screw propellers became the drive system for steamships. In the United States, production of iron suitable for ships' hulls lagged behind that of Great Britain. As much from necessity as from choice, America continued to rely on wooden hulls driven by paddle wheels well into the 1870s, long after steamships of Great Britain and other nations were driven by propellers.

The *Great Britain*, launched at Bristol in 1843, was the progenitor of a new type of iron-hulled, screw-driven steamship. Her progeny on both sides of the Atlantic overtook their wind-driven competition. The steamship became immensely practical after the development of the compound engine in the 1870s and the triple-expansion engine of the 1880s. In time, steamships outperformed wind ships on every count save one—long distance ocean routes. Commercial sail persisted as long as it did because of the economy and efficiency of iron and steel-hulled vessels carrying bulk cargoes over vast open oceans.

The steamship may have been an object of derision for the true sailor, but it held enormous appeal to the landsman. Its relentless, panting engines represented man's conquest of nature, man's desire to force time and tide into subservience, and it made sense to the merchant whose only real concern with ships was as a safe, reliable means to a profitable end.

To the maritime photographer, steamships presented as many opportunities as windships, although nothing could match the majesty and beauty of a full-rigged ship on an open sea. One of the most fascinating photographic records is that of the transition period between sail and steam, when the two types shared the seaways and seaports in mortal competition.

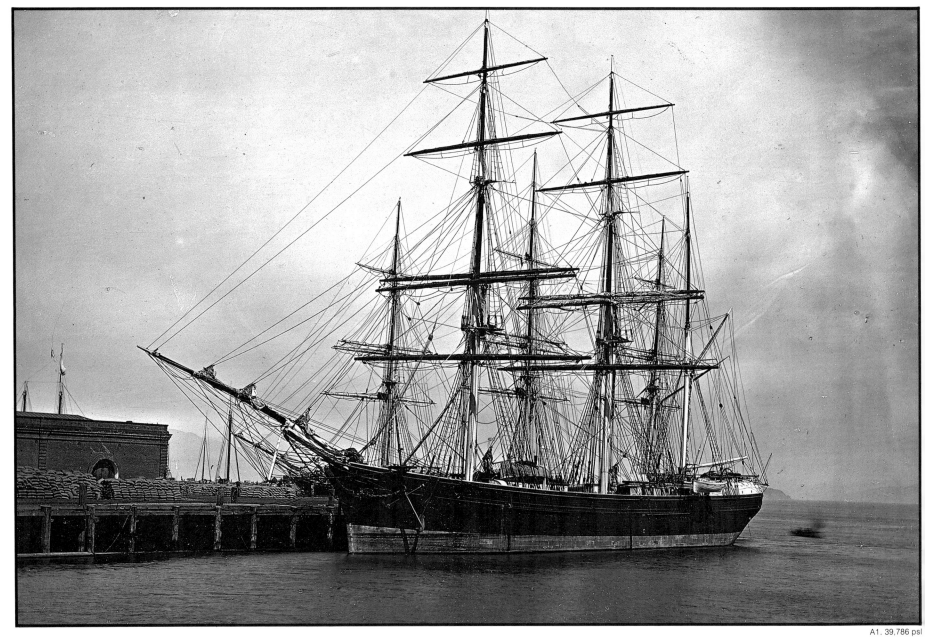

A1. 39,786 psl

Three-masted bark Strathnairn (and another unidentified vessel behind her) at the North Point Grain Warehouse, San Francisco. When this scene was taken in the late 1870s, the sailing ship was enjoying its finest hour, although steamships were commonplace on many sealanes. Speedy, efficient down-easters and composite-hulled British vessels like Strathnairn were the true monarchs of the open sea, the direct evolutionary product of 5,000 years of sail.

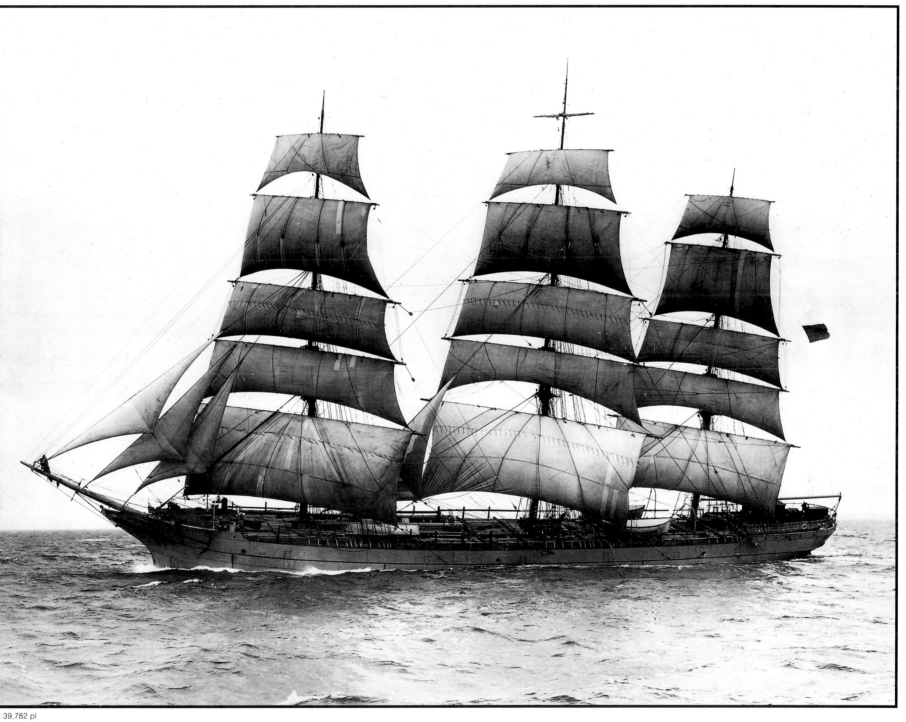

The British ship Timandra, dressed smartly for Hiram Morrison's camera sometime after 1885, shows the sailing ship at its most magnificent. Within three decades, a chance encounter between a photographer and a full-rigged sailing ship at sea will become a rare event. Morrison managed to record almost all of the locally built sailing vessels and those that visited Puget Sound in the glory days of sail.

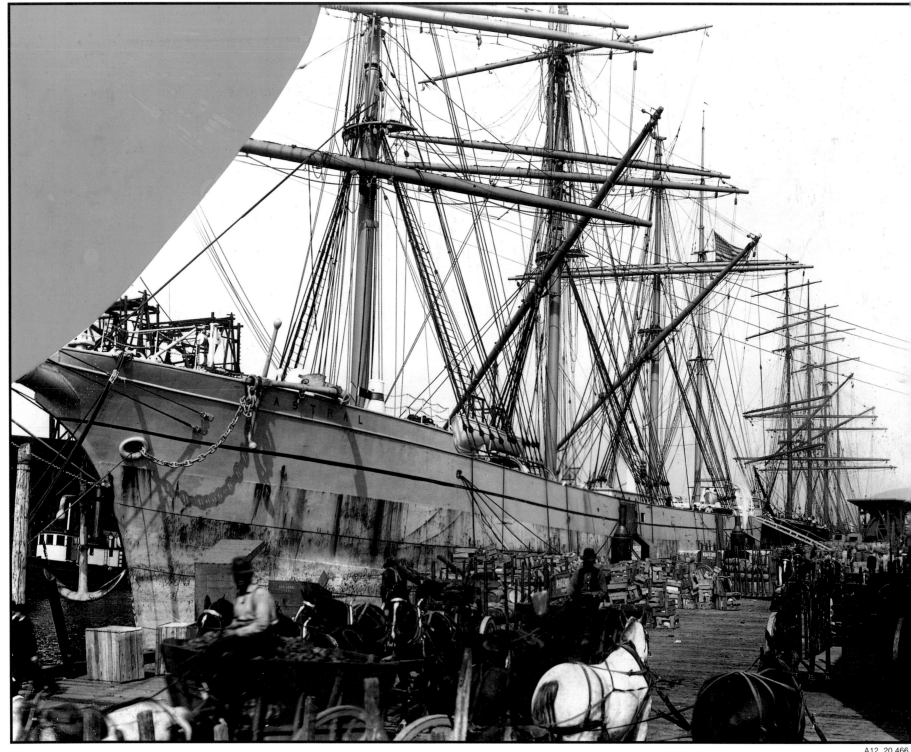

The Maine-built steel bark Astral *and the* Cissie *astern, San Francisco, c.1900. By 1900, iron and steel had replaced wood as the principal building material of ships, both sail and steam. Whereas earlier vessels relied on the flexibility of wooden hulls, masts, and spars for safety, iron and steel ships counted on the strength of rigid hulls, wire rigging, steel masts and fittings. Sailing ships had become bigger and faster, but essential characteristics and functions remained unchanged. The* Astral *later became the* Star of Zealand *of the Alaska Packers' fleet.*

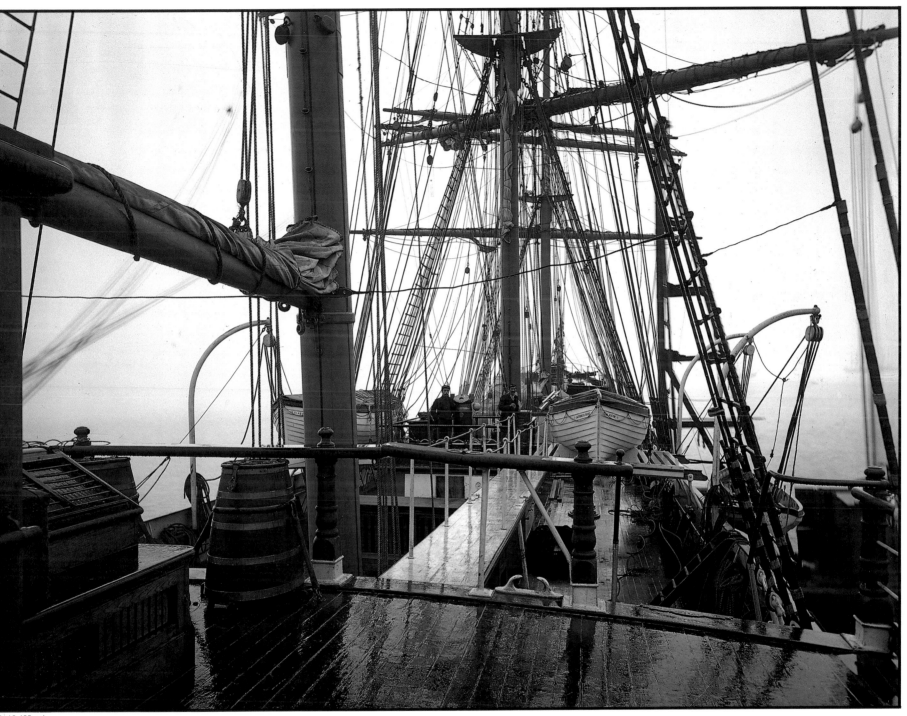

View from the poop deck forward on the Caithness-shire, Puget Sound, c.1905, photographed by Wilhelm Hester. In 1860, there were more than 25,000 sailing ships afloat worldwide and only 2,000 steamers. By the time this photograph was taken, the situation had reversed. The steel bark Caithness-shire, built in 1894, was one of the last big sail vessels built for the Shire Line of Glasgow. She was wrecked off Port Arthur, Texas in 1911.

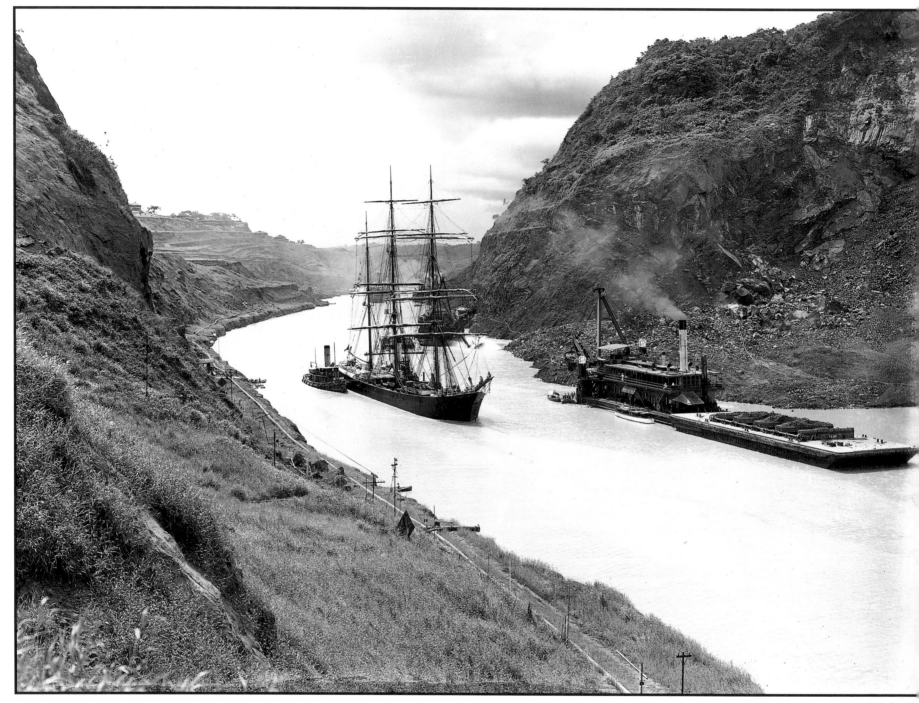

The ship Lord Templetown *passing between Gold Hill and Con-tractor's Hill, Culebra Cut, Panama Canal, 1915. Completion of the Panama Canal in 1914 shortened the distance from Atlantic Coast to Pacific Coast by roughly 8,000 miles and made steamships more profitable on long-distance runs. By the time the canal opened, however, deep-water sailing ships had passed from the longer sea routes. The canal emphasized rather than caused the end of the sailing ship era in intercoastal commerce.*

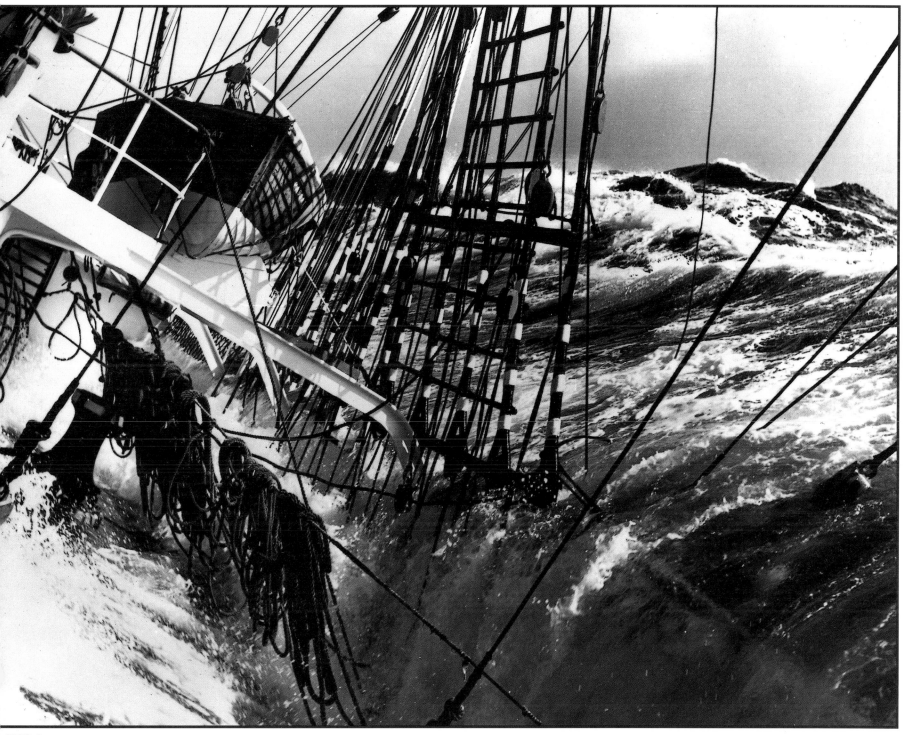

20,807 pl

The German steel bark Passat in heavy seas. This photo, taken by Captain
H. Piening, represents what the Panama Canal eliminated more than dry
mileage statistics: the sailor's age-old dread of Cape Horn, and a romantic era
of seafaring, was forever laid to rest. By the early 1920s four Pacific Coast
steamship lines regularly served the Atlantic seaboard via the canal, carrying
lumber, canned goods, and petroleum. Westbound ships carried steel and
heavy equipment for western mining and the logging industry.

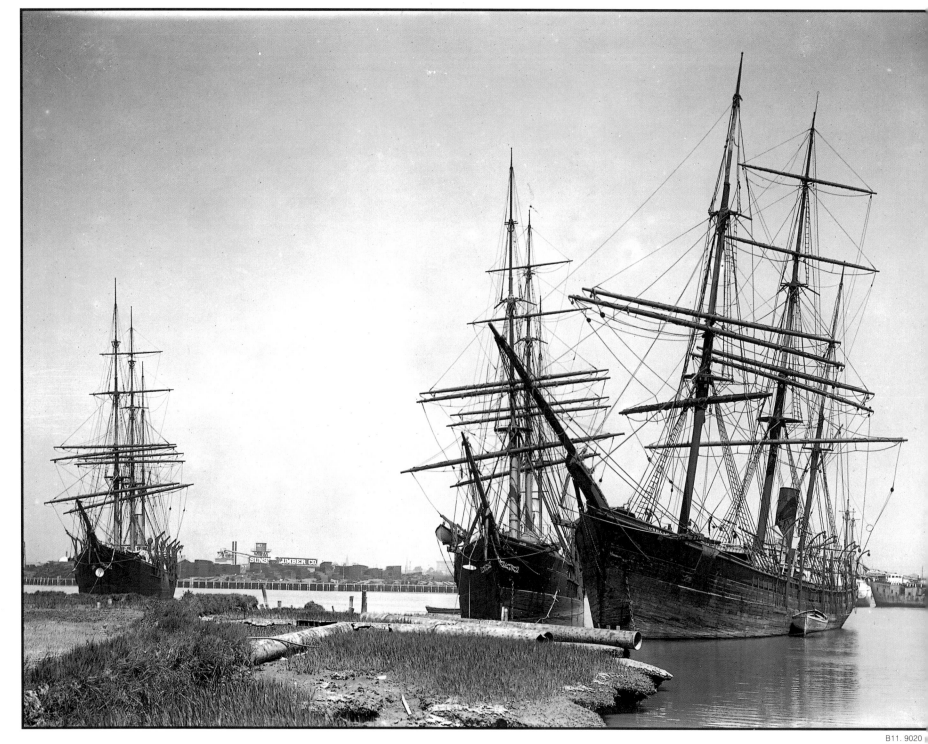

B11.9020

Whalers Bowhead, Beluga, and Thrasher, Oakland Creek, San Francisco Bay, c. 1900. Steam auxiliary sailing ships were attempts to merge the advantages of sail and steam, and the concept met with varying degrees of success. Steam power found its way aboard whalers, as evidenced by these steam auxiliary barks laid up at Oakland Creek for the winter. Steam enabled the whaling fleet to maneuver in the ice without being dependent on wind and tide. Arctic whaling, even with steam power, was not without its dangers. Wooden ships could be, and often were, crushed by the ice or lost in storms.

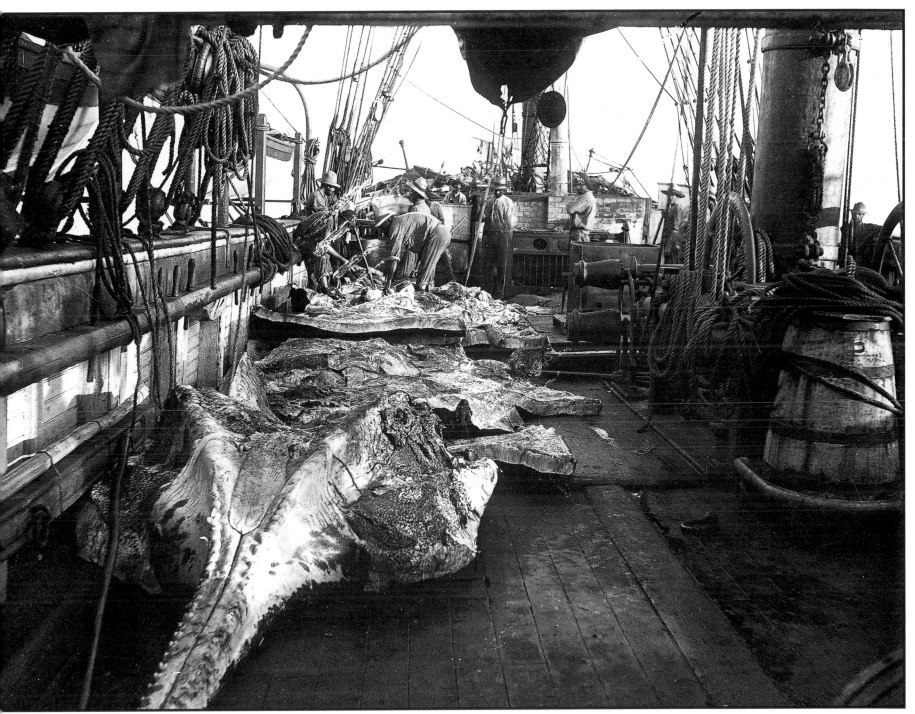

9. 35,871 pl

The lower jaw of a sperm whale aboard the Australian whaler Costa Rica Packet, 1889. American commercial whaling shifted almost entirely to the Pacific by the second half of the nineteenth century, although New Bedford on the Atlantic Coast remained the home port of many American whalers. The grisly business of whale butchering, as shown aboard this whaler out of Sydney, Australia, was still carried on in much the same way it had been aboard the early whalers from Nantucket and New Bedford.

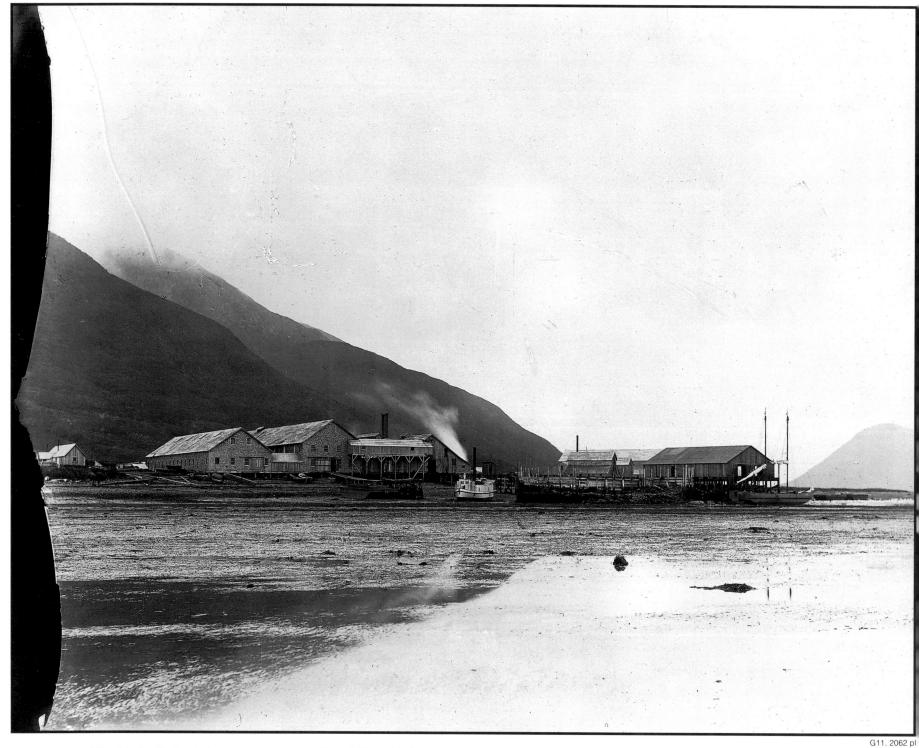

The Alaska Packers' Association cannery, Chignik Bay, Alaska, 1897.
The cold, unbearably bleak Alaskan outpost of Chignik Bay was a hub of activity
for the world's last commercial fleet under sail, the Alaska Packers' Association ships.
Chignik is on the windswept Alaskan Peninsula where it stretches
southwest to the Aleutian Islands.

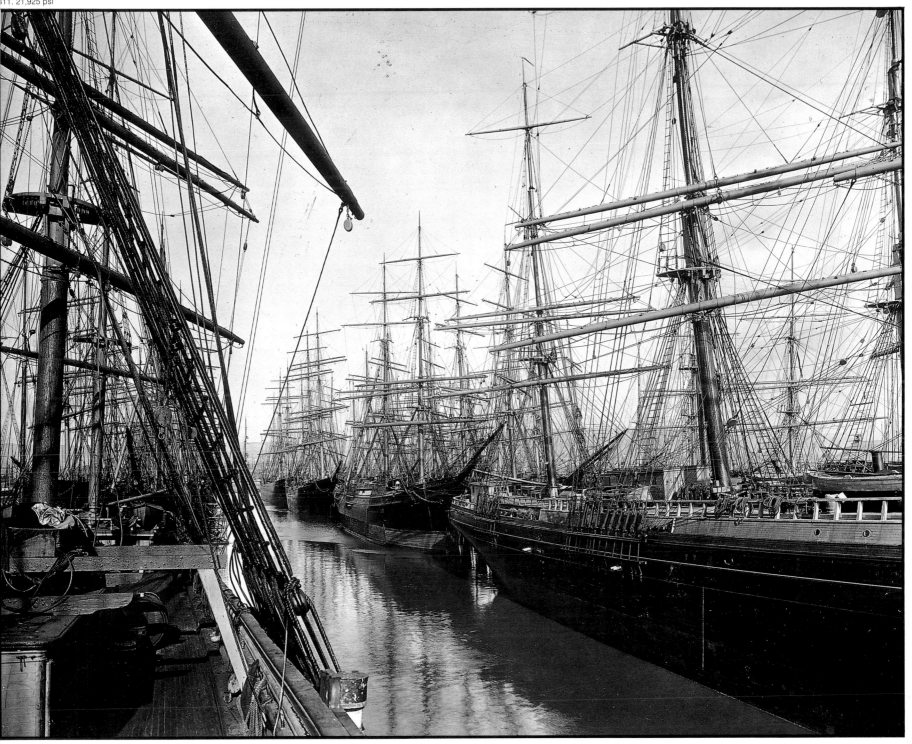

The Alaska Packers' Association fleet laid up at Alameda, San Francisco Bay, c. 1920. The ships Tacoma, built 1881, left foreground, Santa Clara, built 1876, and Llewelyn J. Morse, built in 1899, and bark Star of Finland, built in 1899, and other vessels. Long after steam vessels had dominated every major maritime endeavor, the last of the windjammers were engaged in the profitable Alaskan salmon fishery. Because of their low price and relatively low maintenance cost, sailing ships were well-suited to the salmon fishing cycle. Laid up for the winter at Alameda, the fleet required little upkeep. In the spring, the collection of American and European built ships and barks were outfitted and sailed north with cannery workers, supplies, and equipment. The salmon were caught in fish traps or gill-netted by small boats and unloaded into lighters that were towed to the cannery in ports like Chignik by steam-powered cannery tenders. As the season ended, the canned salmon was packed aboard the big sailing ships for the voyage back to San Francisco.

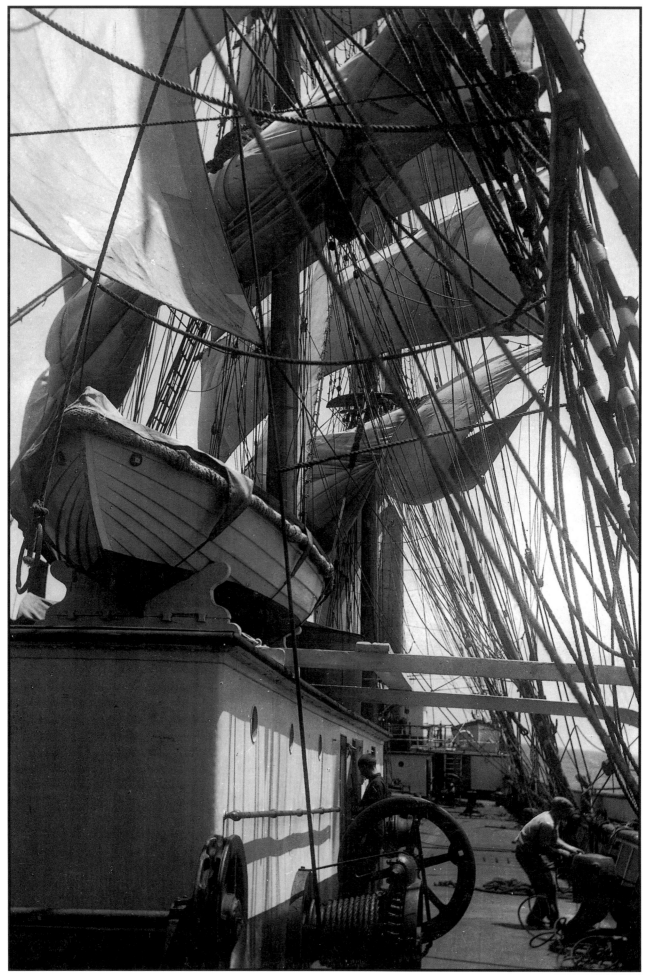

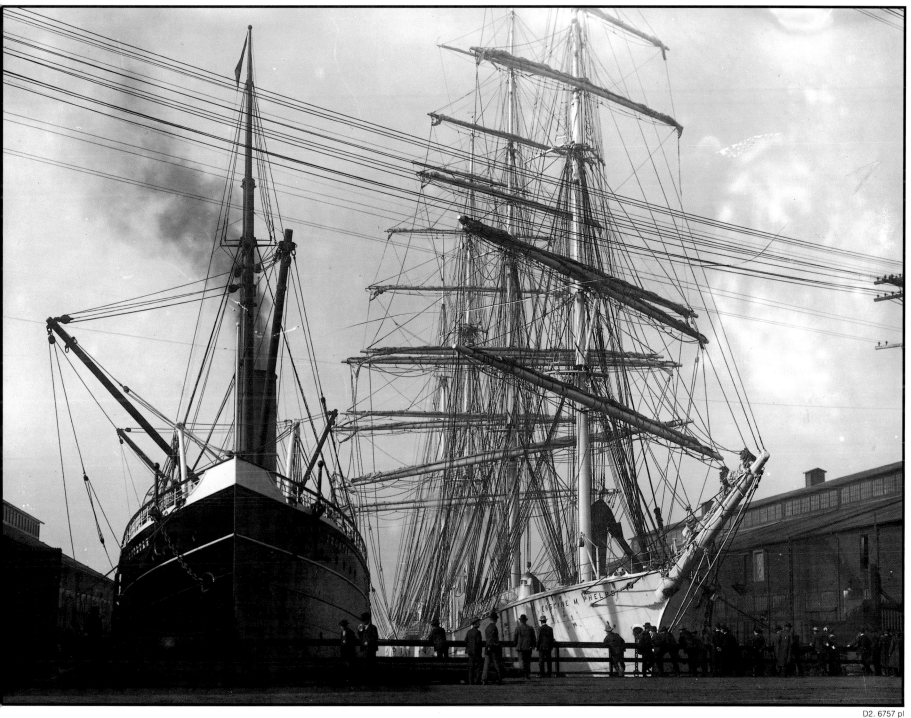

Above: One wonders if the photographer deliberately tried to record for posterity the meeting of two eras in this shot of the steamer Yucatan *and the steel bark* Erskine M. Phelps *at San Diego around 1900. Perhaps he was attempting to capture the regal grace of the big steel bark, and the squat, dark form of the steamer was just in the way.*

Facing page: A sailor's view of the four-masted bark Pommern *"going about," by Alex A. Hurst. For the men who served before the mast, steamships presented a dilemma: adapt or perish. Although many sailors made the transition from sail to steam, however reluctantly, many did not. Some, after many years of service in sailing vessels, simply left the sea rather then submit to life aboard a ship run by engineers. As the sail ships disappeared from the seas, so did the experienced and skilled men who sailed them.*

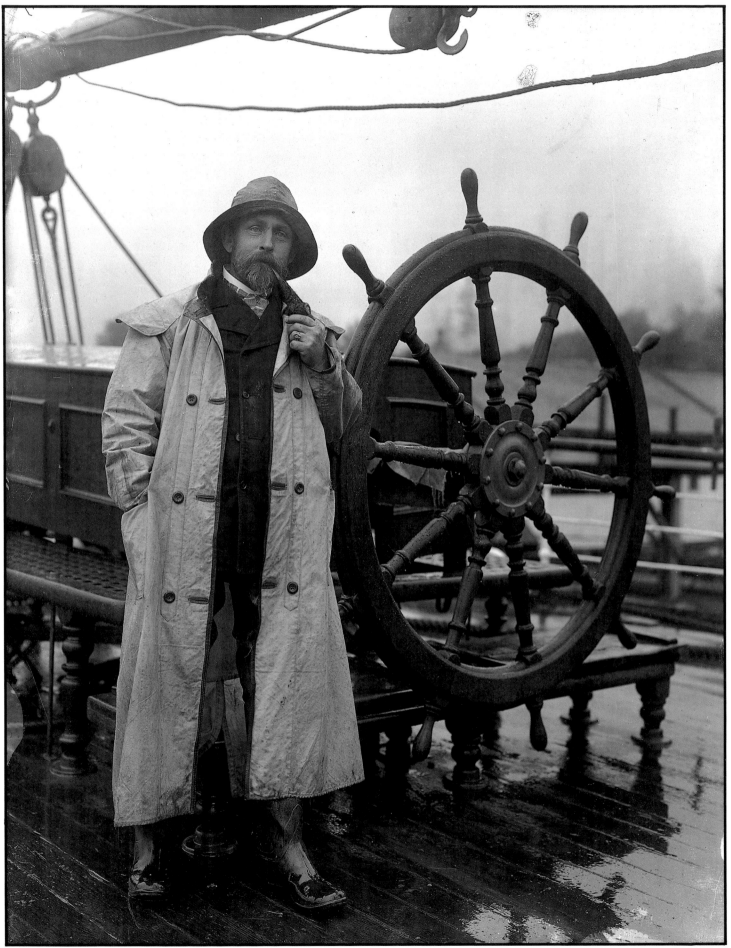

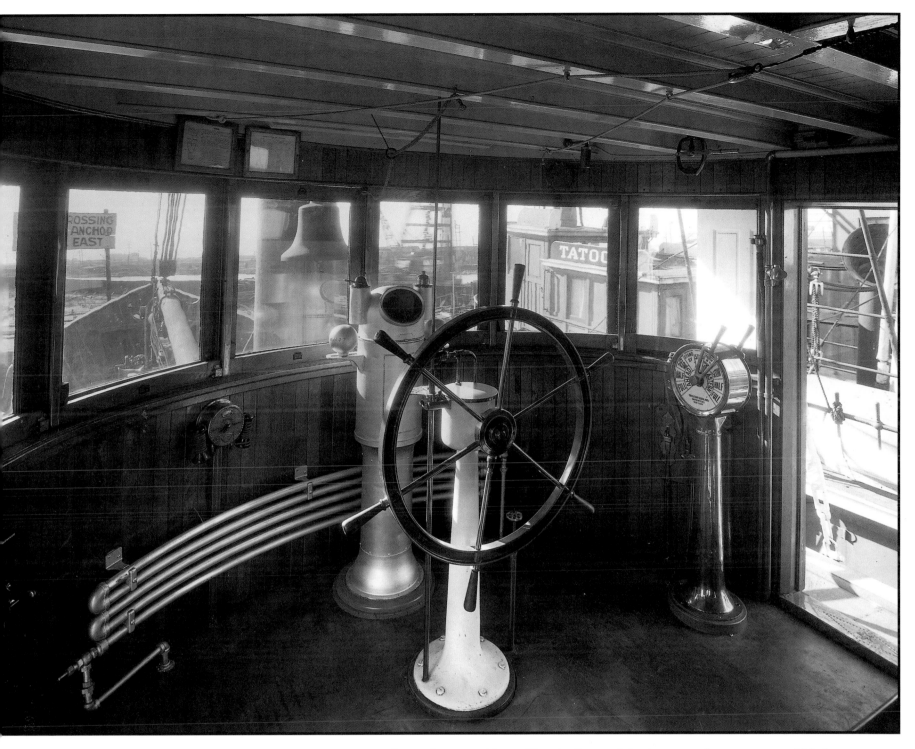

Facing page: Captain Alexander Teschner of the ship Pera stands proud and confident at the helm for this classic portrait by Wilhelm Hester. He represents many generations of sailing ship masters, men who held the open quarterdeck, exposed to the elements, ready and capable of facing the challenge of sail. His presence, his knowledge of the sea and of his vessel, and his commands called to men aloft stood between success and disaster.

Above: The wheelhouse of the Arctic expedition steam vessel Madrono photographed by Walter Scott in 1928 clearly shows the steamship's contrast to the open quarterdeck. Binnacle and wheel may be the same, or similar, but little else is. The enclosed (and hot-water heated) bridge is a tribute to engineering. No need to feel the salt air on the cheek, to sense the subtle shifts in the breeze; the harnessed power within the hull will overcome the vagaries of wind and current. The omnipresent brass engine room telegraph, gleaming and polished, stands ready to transmit the captain's commands to the engineers below.

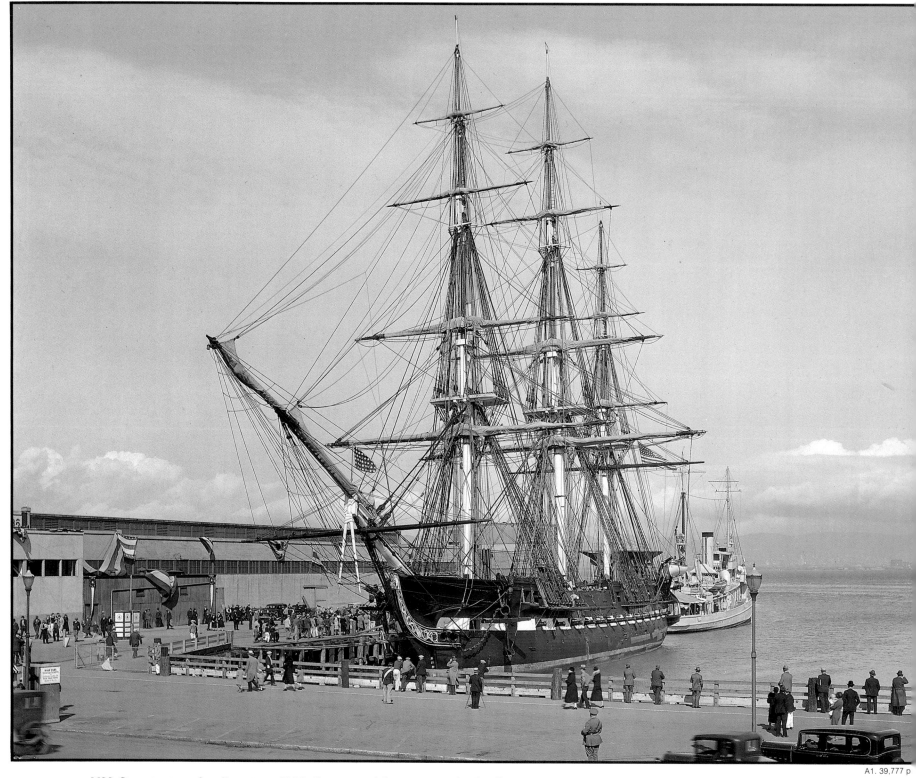

*USS Constitution, San Francisco, 1933. Survivors of the great age of sail will
always enchant and inspire. The age is past: the legacy endures. A survivor of the War
of 1812, the frigate USS Constitution, "Old Ironsides," visited San Francisco on a
goodwill tour of ninety U.S. ports from Boston to Bellingham, Washington, following
her restoration.*

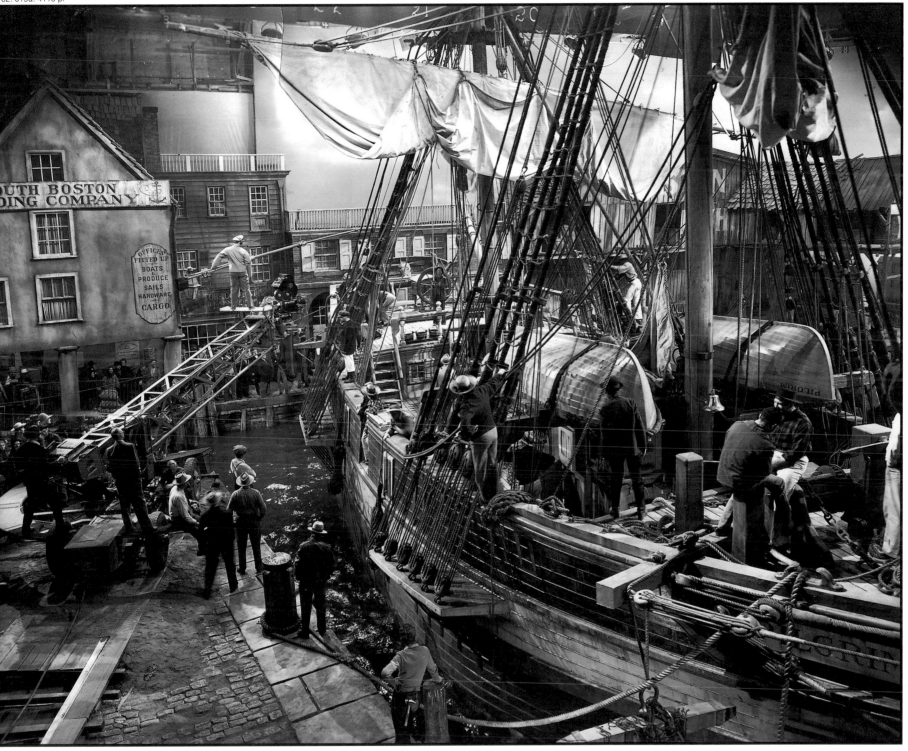

Set of the 1944 Paramount movie Two Years Before the Mast. A fascinating footnote to the age of sail exists in the movie-ships. In the 1920s and 1930s, Hollywood produced films that attempted to capture the glory days of sail. Aged but intact schooners and barks were transformed through clever carpentry into replicas of historic vessels. Retired riggers and shipfitters, survivors themselves from the great age of sail, willingly participated in making the movie-ships as authentic as possible. For the veteran vessels, it was often their last voyage. Southern California's coastline served as a backdrop, transformed by the camera's magic into the pirate dens of Hispanola or the Mediterranean, the coast of England or France, or the South Seas.

Occasionally, at times out of necessity, entire replica vessels were constructed. The old shipbuilding skills were called upon one more time. The 1944 movie, Two Years Before the Mast brought Pacific Coast maritime history full circle. It was Dana's 1837 narrative of the same name that first sparked America's interest in the unknown regions of the Pacific shore. The original brig Pilgrim carried Dana to a spot not fifty miles from the Hollywood sound stage where the replica Pilgrim awaits lights, camera, and action.

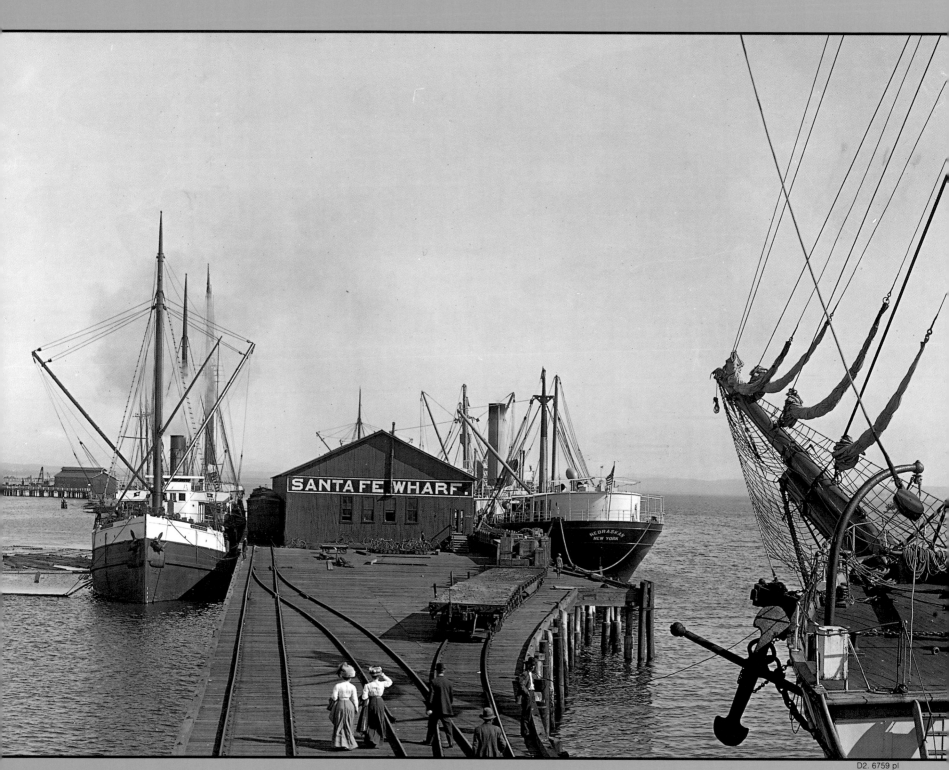

D2. 6759 pl

San Diego in 1910, by Lee Passmore: the steamer Nebraskan, right center, and the steam schooner Fair Oaks at the West Santa Fe Wharf. San Diego was the only protected natural harbor for 600 miles south of San Francisco, yet in the nineteenth century the seaport remained small because San Diego had no transcontinental rail link until 1885. The port was served by coastwise steamers from 1850 on and was a regular destination of lumber ships.

Pacific Coast Ports

*M*ost Pacific Coast maritime photographers lived and worked in the great seaports and much of their work reflects waterfront activity. Many photographs document the ports themselves and the dramatic changes taking place in the latter half of the nineteenth century. The rugged lumber ports characteristic of the Pacific Coast and the ocean front railway wharves optimistically called "ports" were recorded as well.

With the exception of San Diego, Pacific Coast seaports do not have a long history compared to those on the Atlantic Coast. Most were developed in the American period, after 1850, some in the face of spectacular adversity. While the Atlantic seaboard has many excellent natural harbors, lengthy protected river estuaries, and miles of flat beaches, the Pacific shore drops away steeply and offers few safe anchorages. From Puget Sound in the north to San Francisco Bay on the central coast to San Diego in the south, the coastline is predominantly rocky cliffs punctuated by formidable river bars, capes, and headlands that jut dangerously into the coastwise sealanes. Pacific Coast weather is cursed, from a mariner's point of view, with unpredictable dense fogs and strong on-shore winds.

Seaports along the Pacific Coast of North America have generally evolved in three stages. The first stage was the period of discovery from the fifteenth to the early nineteenth century. Then, Pacific ports (or, more accurately, harbors) saw little traffic and were primarily used by seafarers to take on fresh water, supplies, and to engage in minor local trade. The second stage

was the phenomenal growth of San Francisco as a seaport after the gold rush. When the United States began expansion westward in the mid-nineteenth century and the Far East, China in particular, was opened to "Western trade," the port of San Francisco became a true center of commerce, both trans-Pacific and intercostal. The third stage in the development of Pacific Coast seaports began with the completion of transcontinental railroads in the 1870s and 1880s linking the ports overland to central and eastern markets. The growing rail network also provided the means for inland agricultural and industrial products to reach Pacific Coast ports for export by sea. From that time on, the major Pacific Coast ports have continued to expand and have reached international scale.

San Francisco was not only the first port on the Pacific Coast to experience rapid growth, it was the only major seaport from the 1850s until about 1890. First gold, then California wheat generated outbound cargoes. San Francisco businessmen controlled the early lumber business on the Pacific Coast, and San Francisco was the destination for much of the early mill production from California and Puget Sound. Between 1883 and 1893, transcontinental rail networks stimulated growth of the Northwest lumber and grain industries, and the ports of Seattle, Tacoma, and Portland rapidly expanded. In the 1920s, Los Angeles and San Diego evolved into seaports of major stature because of the growth of the petroleum industry and expansion of the U.S. Navy on the Pacific Coast.

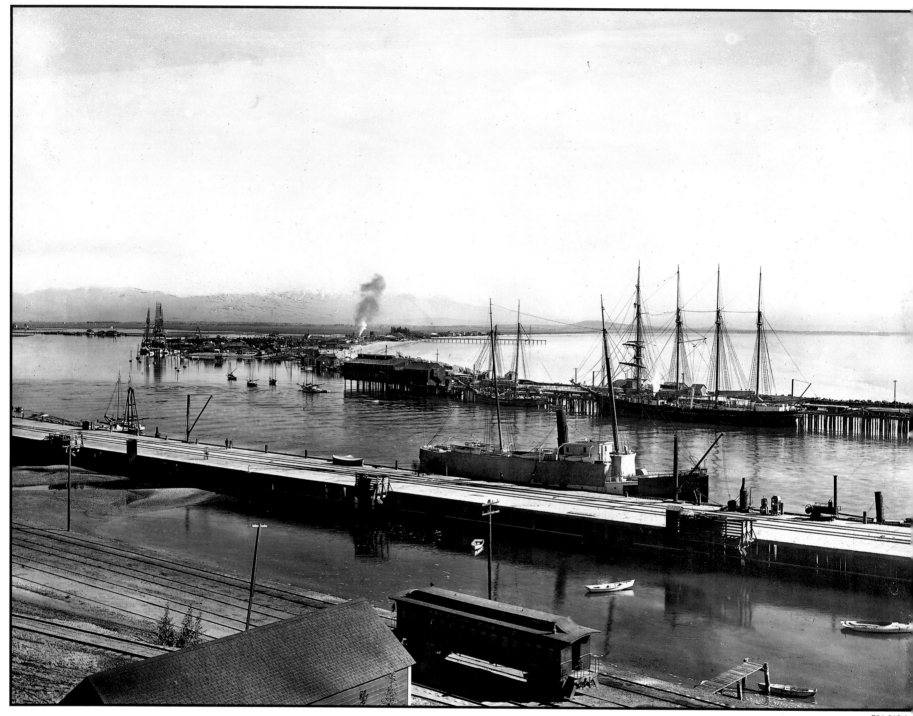

Terminal Island, viewed from San Pedro around 1899 when major development of the harbor began. The steamer Hermosa is in the foreground and the four-masted barkentine is the Willie Hume. Direct access to the sea could make or break a developing city, and nowhere was the competition for a seaport more fierce than in Los Angeles. The dispute over which "harbor," San Pedro, Santa Monica, or Redondo, should become the main port of Los Angeles lasted for over a decade, a bitter struggle between the Southern Pacific Railroad and the people, mainly business interests, of the rapidly growing city. Courtesy Ernest Marquez

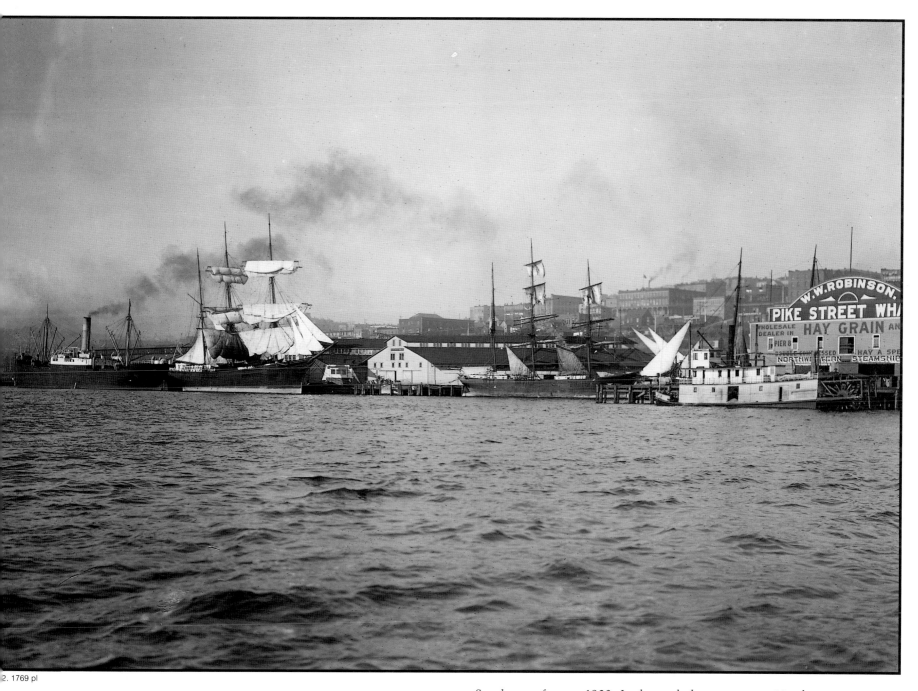

2. 1769 pl

Seattle waterfront, c.1900. In the north there was competition between ports within Puget Sound. Seattle grew slowly from a sawmill village on Elliott Bay in the 1850s to a small town of 3,500 residents by 1880. The mill ports across the Sound such as Port Blakely, Port Gamble, and Port Ludlow dominated maritime activity within Puget Sound, but as their prosperity faded, Seattle became the principal city. Less than forty years later Seattle had grown to 300,000 population and was a major Pacific Coast seaport although the city itself is 125 miles from the open ocean.

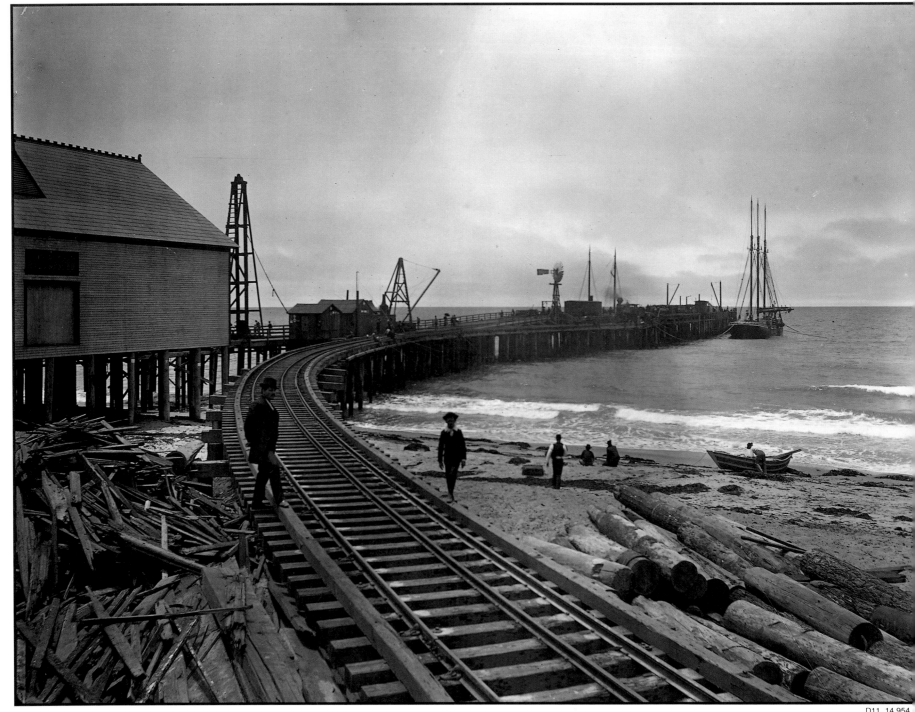

The wharf at Redondo Beach near Los Angeles juts boldly through the surf to deep water in this 1906 photo. Built by the Redondo Railroad Company in the 1880s to compete with Southern Pacific's freight stranglehold on Los Angeles, the port suffered from the lack of a protective breakwater. As this photo shows, Redondo was served by both narrow gauge and standard gauge trains. Unprotected landings like those at Redondo, Wilmington, Port Harford near San Luis Obispo, and Sterns Wharf at Santa Barbara were not ports in the true sense, but they were necessities along California's thousand-mile coastline. Redondo's bid to become a major port ended in 1892 when it was determined that an adequate breakwater would be impossible.

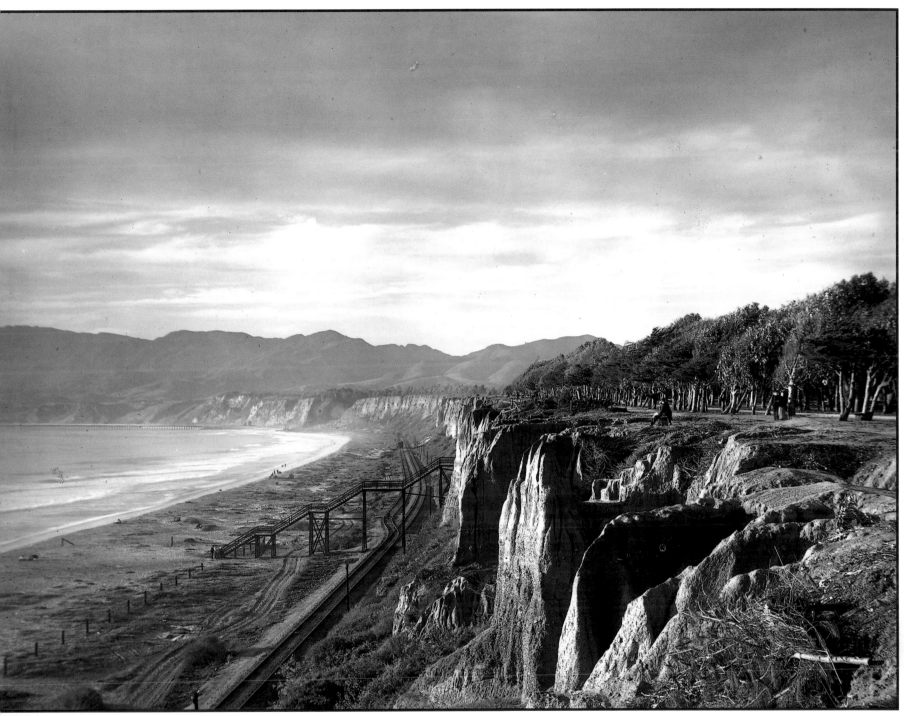

1-012.2 pl

Port Los Angeles was the ambitious name given to this railroad wharf (in the distance) near the mouth of Santa Monica Canyon. Railroad magnate C.P. Huntington of the Southern Pacific built the long wharf in 1892 in an attempt to control maritime access to Los Angeles. Port Los Angeles served lumber and coal vessels until 1897, when, after a long and bitter political struggle between competing interests, it was decided by Congress that San Pedro should become the official harbor for the city of Los Angeles. By 1910 the pier was used mainly for fishing, and in 1913 it was demolished. Courtesy Ernest Marquez

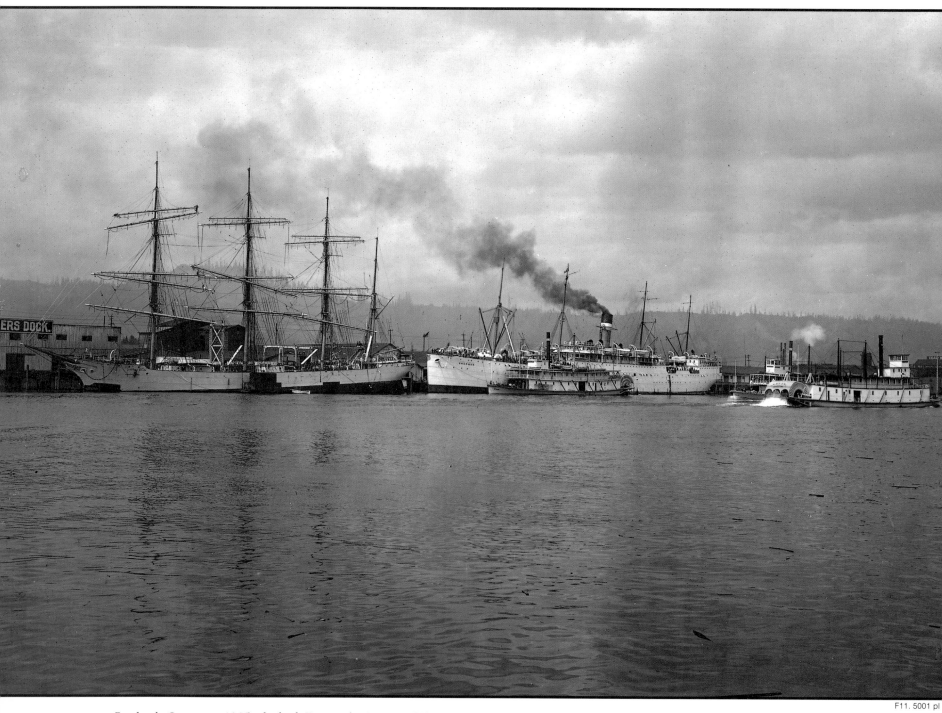

ERS DOCK.

Portland, Oregon, c. 1905, the bark Emanuele Accane, *US Army Transport* Sherman, *riverboats* Lurline, Mascot, *and* N.R. Lang. *The lower Columbia River spawned several ports and towns that struggled to become commercial centers. Portland, on the Willamette River near its junction with the Columbia, had to compete in the 1850s with Oregon City, Milwaukie, and Astoria at the mouth of the Columbia. One drawback to Portland's growth as a seaport was that the city's waterfront is 113 miles from the open ocean. Despite that, Portland became the dominant port of the region.*

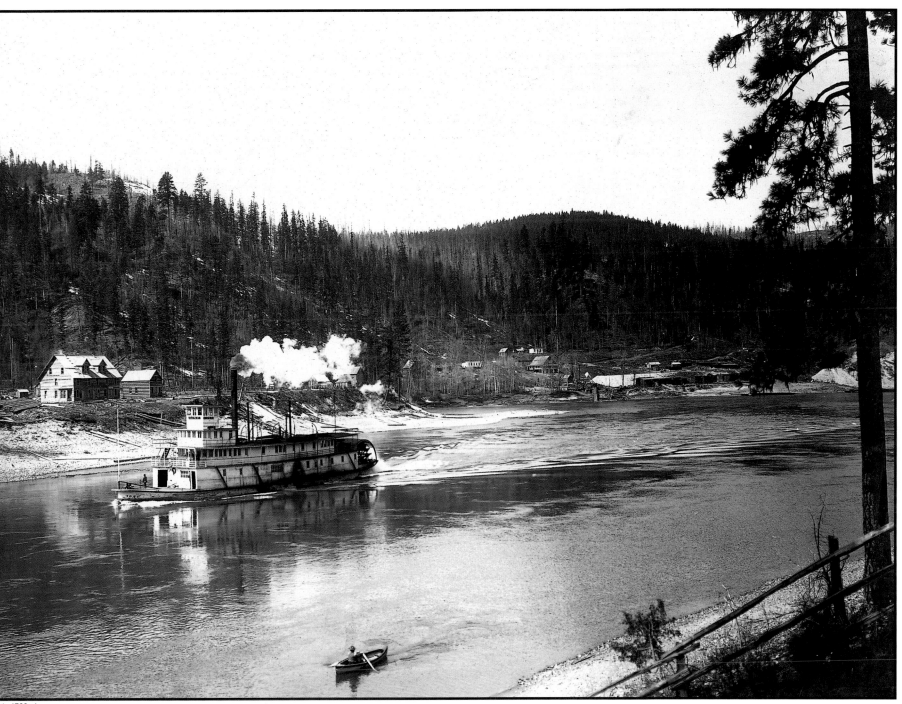

The riverboat Ione *rolls along the upper Columbia past the town of Pend d'Orelle, between Ione and Newport, Washington, in this photo by Frank Palmer of Spokane. Western rivers were avenues of commerce and vital to Pacific Coast maritime trade from the time of the earliest settlements to the present. Navigable rivers were as important to Pacific Coast seaports in the early days as railroads were in later years.*

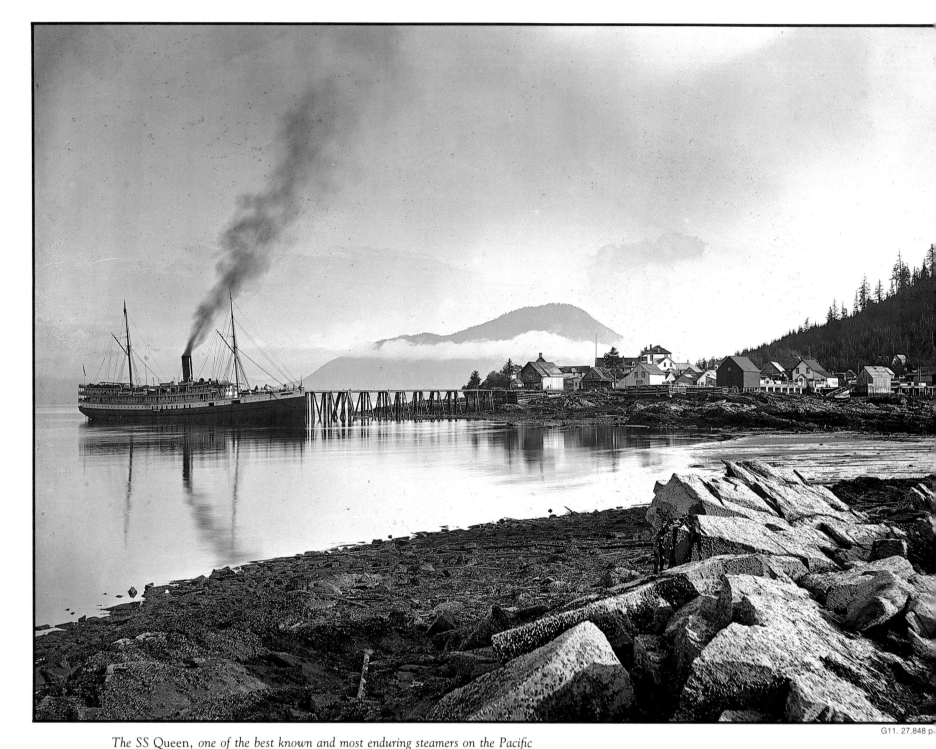

The SS Queen, *one of the best known and most enduring steamers on the Pacific Coast, in Wrangell, Alaska, c.1892. Alaskan ports came of age when gold was discovered in the Klondike in 1897. Vessels of every type and condition made their way to Alaska carrying prospectors and supplies. Nome and St. Michaels near the mouth of the Yukon River were the destination of some, while the rude coastal towns of Skagway and Dyea in the south, the closest ports to Seattle and San Francisco, were the destination for most. In the period after the gold rush, over ninety ports spread along Alaska's 2,000-mile coastline were served by over one hundred steamship companies. The steamship lines dwindled and many small ports faded in the twentieth century. The Alaska Steamship Company ended regular passenger service to Alaska in 1954.*

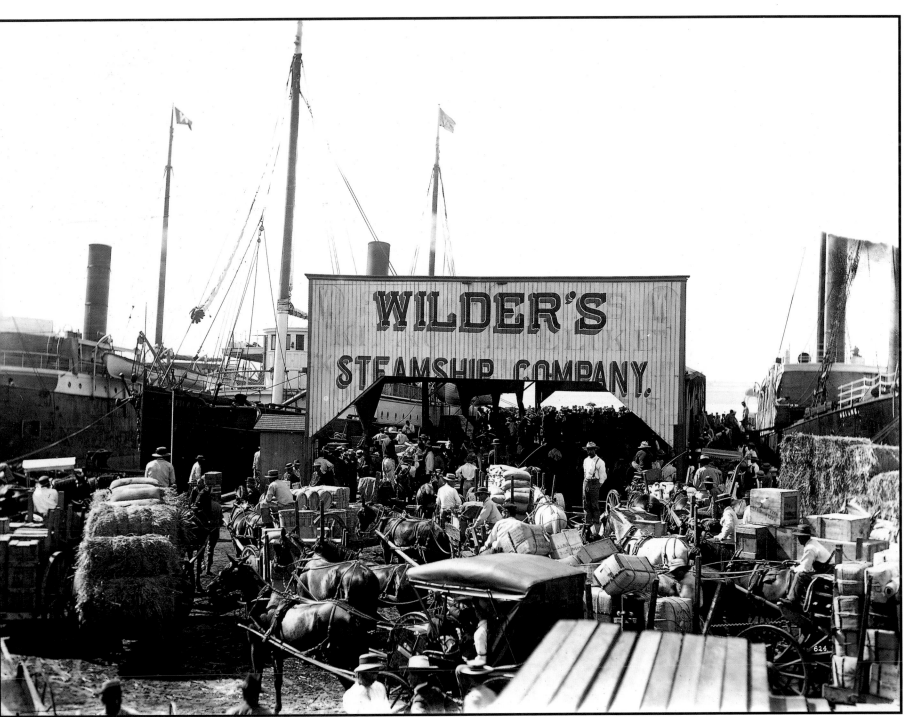

Steamer Day in 1900 at Wilder's Steamship Company dock, Honolulu, with the steamers Claudine, left, and Helene, right. The inter-island steamer Kinau, center, made weekly runs to Hilo, Lahaina and other ports. Although Hawaii is 2,000 miles from the Pacific Coast, it is nonetheless an integral part of Pacific Coast maritime history. Early whaling ports at Lahaina and Hilo and the commercial port of Honolulu made the Sandwich Islands (as the Hawaiian Islands were called) a frequent destination and point of origin for Pacific Coast shipping. As early as 1840 the Sandwich Islands were the principal destination of ships departing from the Oregon coast, and prior to the California gold rush, lumber and other commodities were imported from Hawaii to California and Oregon. Hawaii later became an important source of sugar for America.

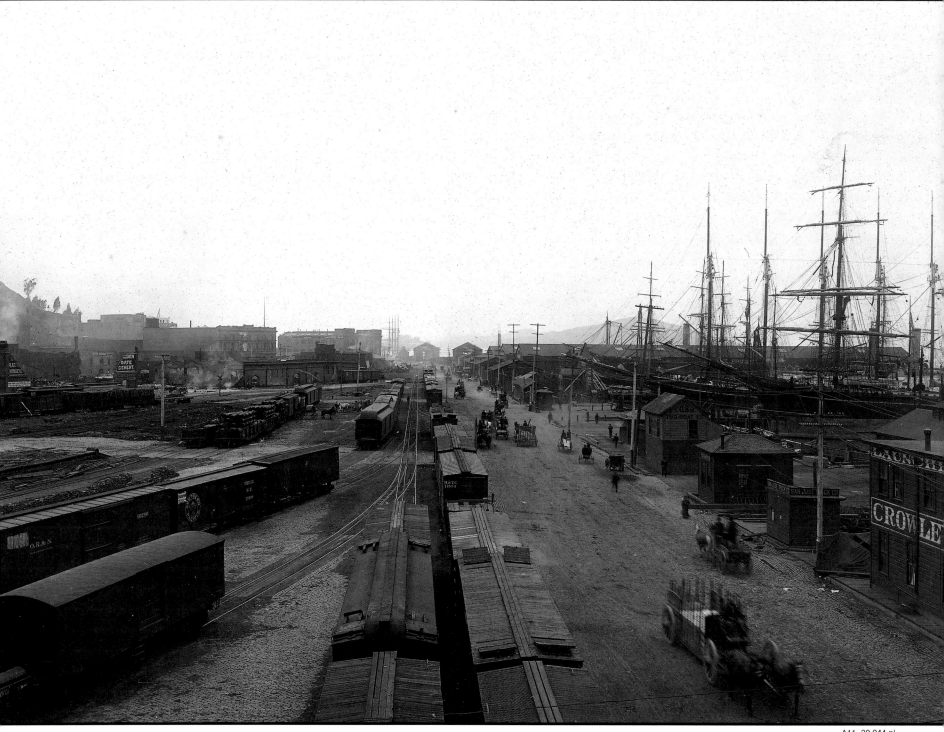

Port of San Francisco, 1906. The lion's share of Pacific Coast maritime trade until the 1920s passed through the Golden Gate and the ports of San Francisco and Oakland. San Francisco's East Street, now known as the Embarcadero, was photographed by Turrill and Miller for the California Promotion Committee. The purpose of this shot of a busy waterfront was to demonstrate that San Francisco was alive, if not well, following the 1906 earthquake and fire. The photo was taken less than a month after that disaster and demonstrates to all doubters that the maritime facilities of the port survived intact.

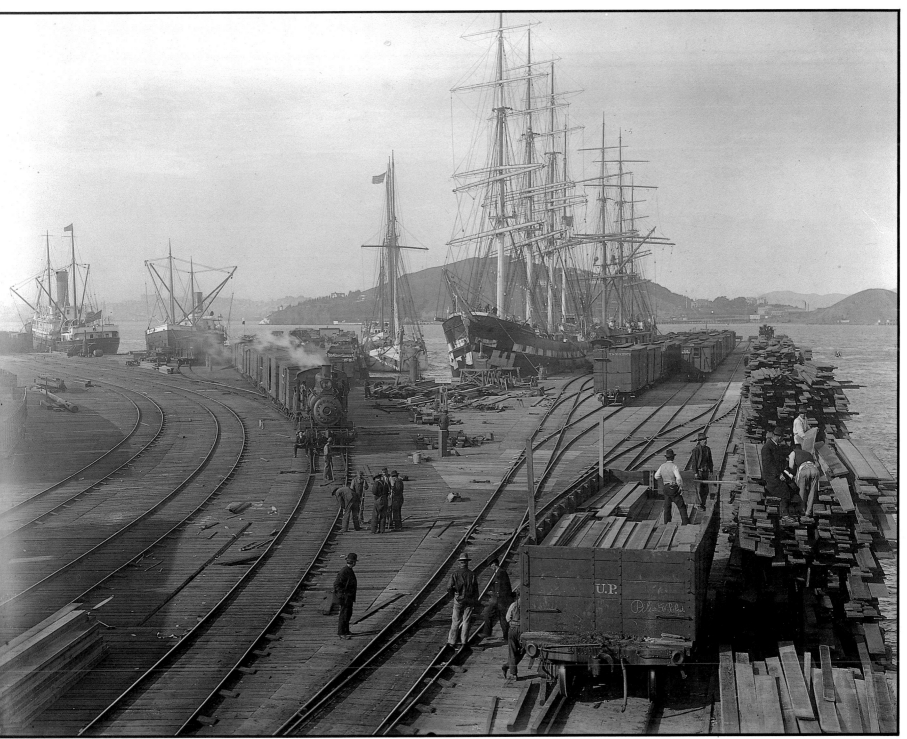

2. 4011 psl

Oakland Long Wharf taken about 1905 by Arthur Eppler, with San Francisco's waterfront in the distance, behind Yerba Buena Island and the steam schooner Melville Dollar, left. Directly across the bay from San Francisco are the ports of Oakland and Alameda. Oakland played second fiddle to San Francisco in shipping tonnage until the 1950s, when the Port of Oakland surpassed its more famous neighbor. Just as Puget Sound consisted of several ports—Seattle, Port Townsend, Port Gamble, Tacoma, and Port Ludlow—San Francisco Bay encompassed Oakland, Alameda, Port Costa, and the Sacramento and San Joaquin River ports.

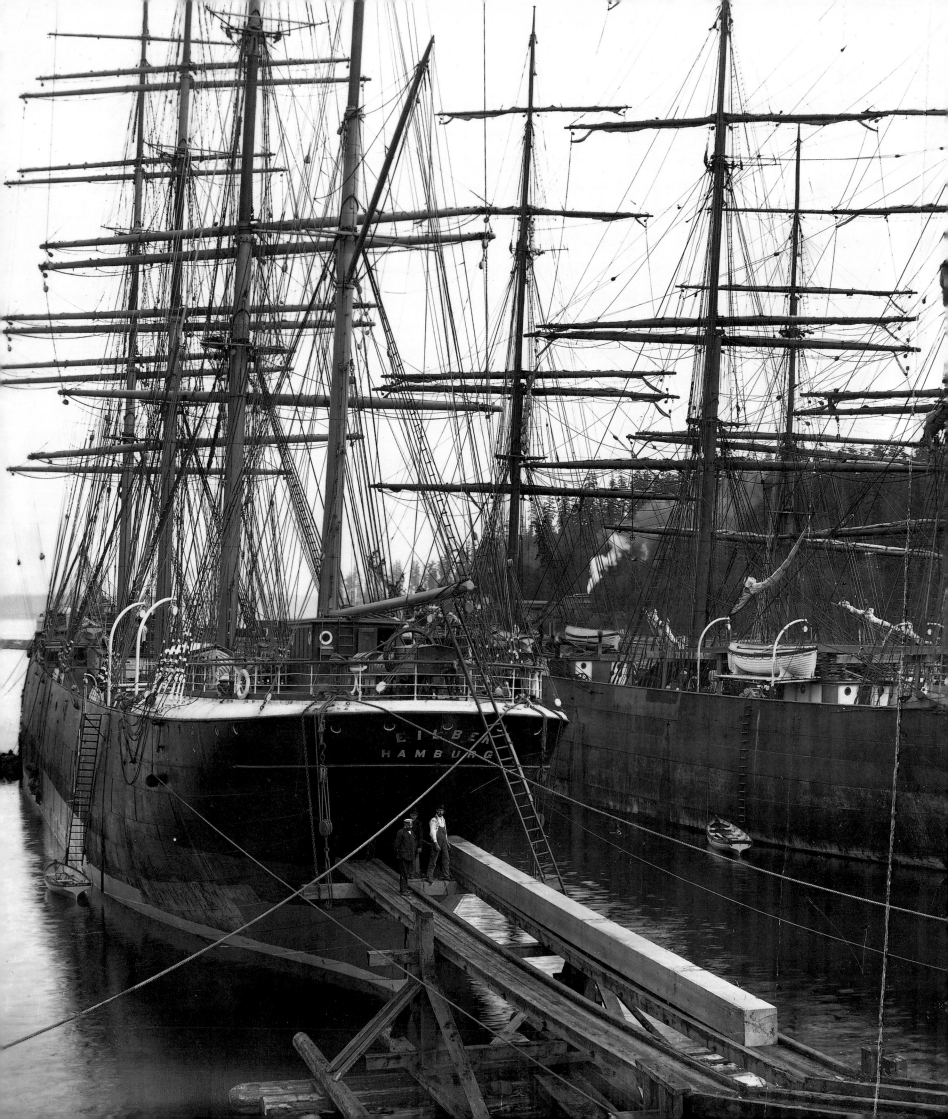

The Lumber Empire

The lumber trade was one of the largest and most photogenic maritime activities of the last century on the Pacific Coast. Exploitation of the vast conifer forests of the Northwest in the nineteenth century and well into the twentieth required ocean carriers to transport lumber to markets worldwide. Vessels designed for the trade, principally Pacific lumber schooners and the unique steam lumber schooners, proliferated, and photographers were on hand to record their construction, their careers at sea, their crews, and their ultimate fates.

Imagine a dense conifer forest that, seen from a mountain peak, stretched as far as one could see in any direction. Imagine sailing along a rugged coast mile after mile, day after day, where the huge trees came almost to the shore and extended inland to the distant mountains. These were the first glimpses Europeans had of the great forests of the Pacific Northwest—scale and abundance beyond imagination, potential wealth beyond calculation. To early explorers after beaver and otter pelts, however, the western forests were more of an obstacle to overcome than a treasure to claim. The forests were home also to numerous Indian cultures which, in time, also became obstacles to European and American expansion. Until the early nineteenth century, the Pacific slope forests remained untouched.

As people came west overland, the true scale of the forests became known. The wilderness of British Columbia, Puget Sound, Oregon and Northern California contained over 140,000 square miles of virgin forest, containing millions of trees: fir, hemlock and spruce, redwood and pine, many of a size never before seen. The unbroken forest blanketed the Northwest from the Pacific shore inland for over one hundred miles, north and south for over twelve hundred miles. Inland, another unbroken forest ranged over 170,000 square miles from the Rocky Mountain slopes westward to the Great Basin.

Whatever needs the early settlers had for lumber were satisfied locally with primitive sawmills or by importing lumber from Hawaii. Then the California gold rush provided a demand that overwhelmed the few small mills in the area. The early boom town of San Francisco burned every few years and that, plus constant expansion, created a voracious appetite for redwood, Douglas fir, and pine. Railroads and mines from Canada to Mexico needed stout timbers and wood for fuel. Western redcedar made excellent shingles, and Port Orford cedar was popular for many uses from boat planking and fancy cabinet work to aromatic closet linings. All of the kinds of trees that grew in abundance had a ready market. Other cities followed San Francisco with steadily increasing demands, and soon the world learned of the cheap endless supply of North Coast lumber. An industry was born that, over the next century, generated more wealth than did the California gold rush.

Loading long timbers through the stern ports of the German four-masted steel bark Eilbek *as she lies snugged against a loading chute at Port Blakely, Washington. The timber in the photo, bound for England to become, perhaps, the keelson for a wooden vessel, measures 22 inches square by 79 feet long.*

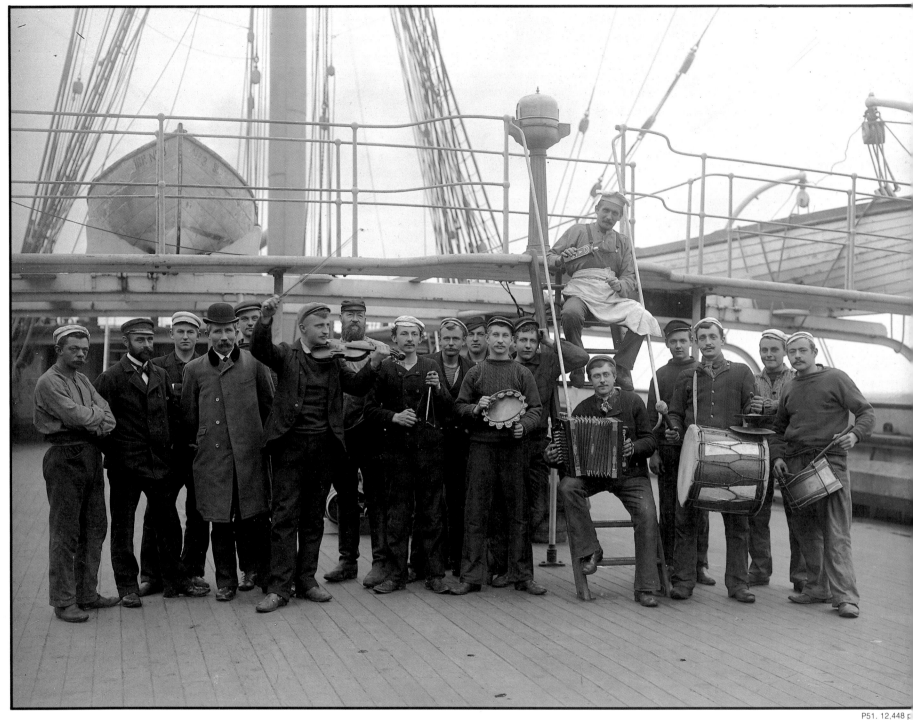

*Captain Georg Cringlen (in bowler) and crew aboard the German square-rigger
Flottbek, Puget Sound, c. 1900. The sawmill ports of Puget Sound drew ships from
every seafaring nation during the peak decades of the lumber trade, from 1880 to 1910.
Photographer Wilhelm Hester was on hand at Port Blakely and Tacoma to record vessels
and crews that visited the ports. He not only succeeded admirably in that; his keen eye
for composition and lighting resulted in some of the finest maritime photographs ever made.*

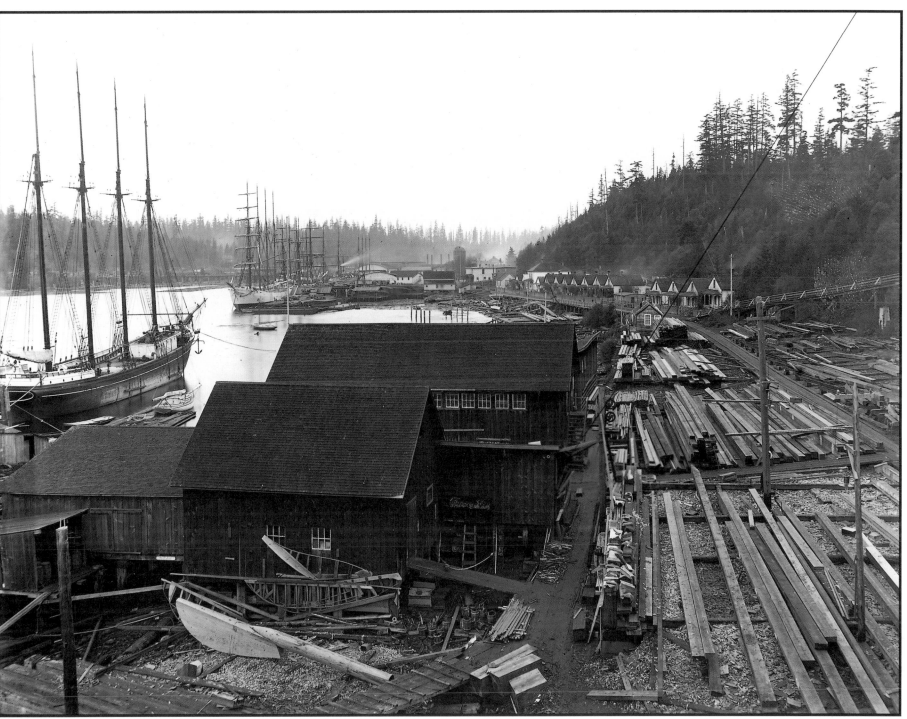

Hall Brothers shipyard, Port Blakely, Washington, with the sawmill in the background and company houses at right. Not all lumber cut in the Pacific Northwest was exported. Wooden shipbuilding became a major industry on Puget Sound. This 1902 photograph from the deck of the schooner Mabel Gale on the launching ways is one of a series of shipyard scenes made by Edward Lincoln, former shipwright foreman for Hall Brothers.

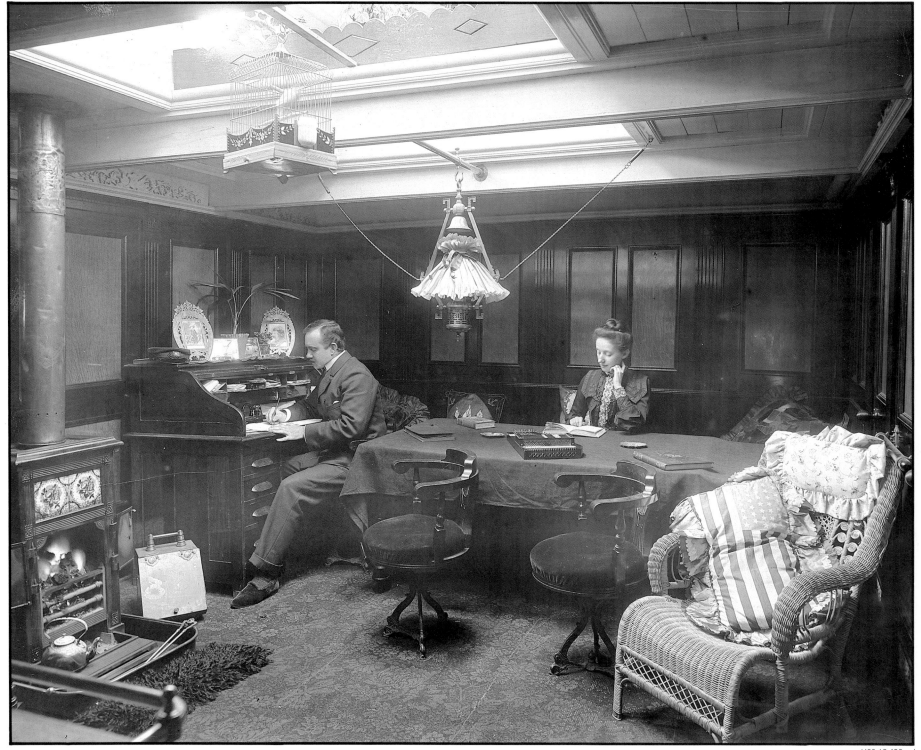

Two of Wilhelm Hester's remarkable interior shots of vessels lying in lumber ports: saloon of the British steel full-rigged ship Eva Montgomery, *Puget Sound, c.1904. Captain and Mrs. Harrison are seated in Edwardian comfort in their home-at-sea. The captain catches up on his correspondence, while his wife, having set aside her autoharp and scrapbook, reads from a novel. Overhead, the canary flits out of focus in his cage.*

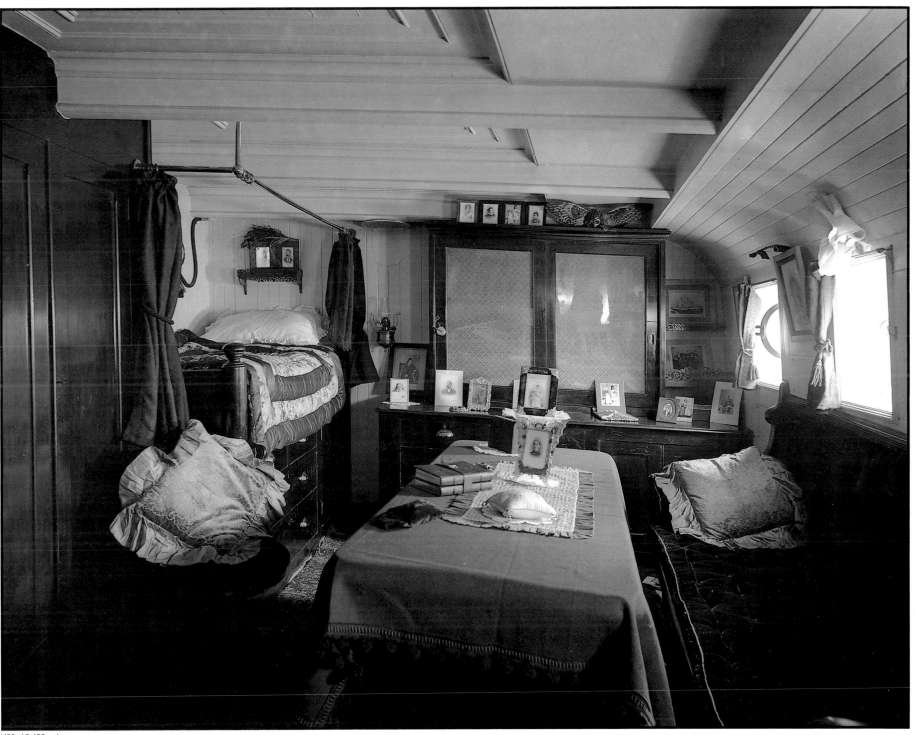

U60. 12,493 psl

Captain's cabin of the British four-masted bark Lynton, c.1905. Portraits of Captain and Mrs. Edward Gates James are mounted above the bed, and other family photographs and reminders of home abound in this floating Edwardian bedroom. The Lynton was built on the Mersey in 1894 and was beautifully fitted and finished throughout. She was reputed to be fast and a good sailer. In 1917 she was sunk by a U-boat off Ireland.

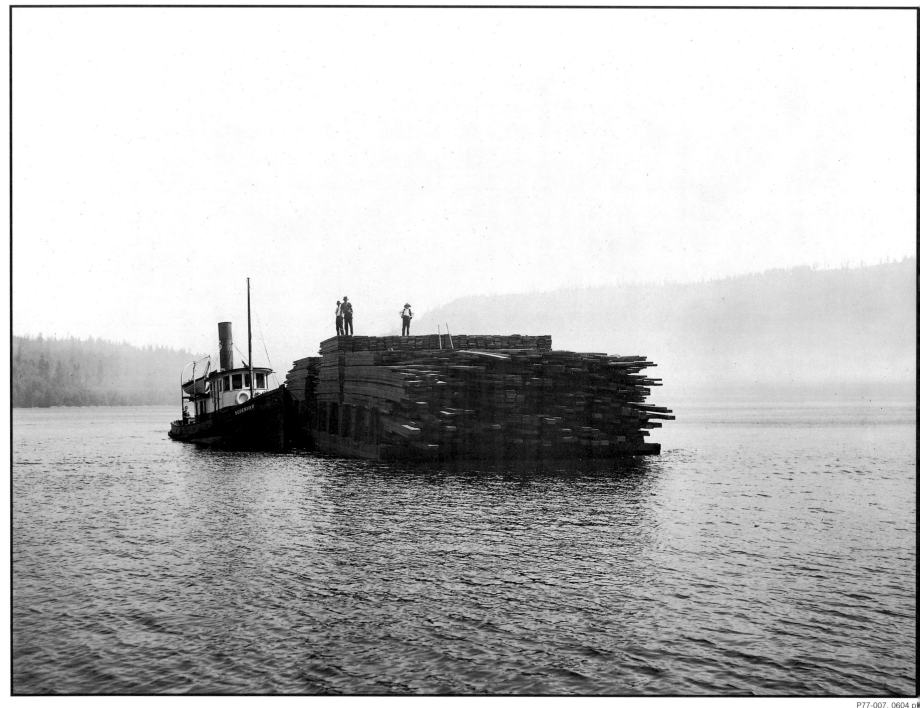

The tug Superior maneuvers a barge loaded with lumber from the Dollarton mills near Vancouver in this Dominion Photo of 1918. Every navigable waterway on the North Pacific Coast was used to keep the flow of logs and lumber moving: lumber was king, and every town and port was involved in the production of it. Sawmills were dependent on getting lumber to market, and therefore the manufacture and shipment of lumber by sea was considered part of the same business.

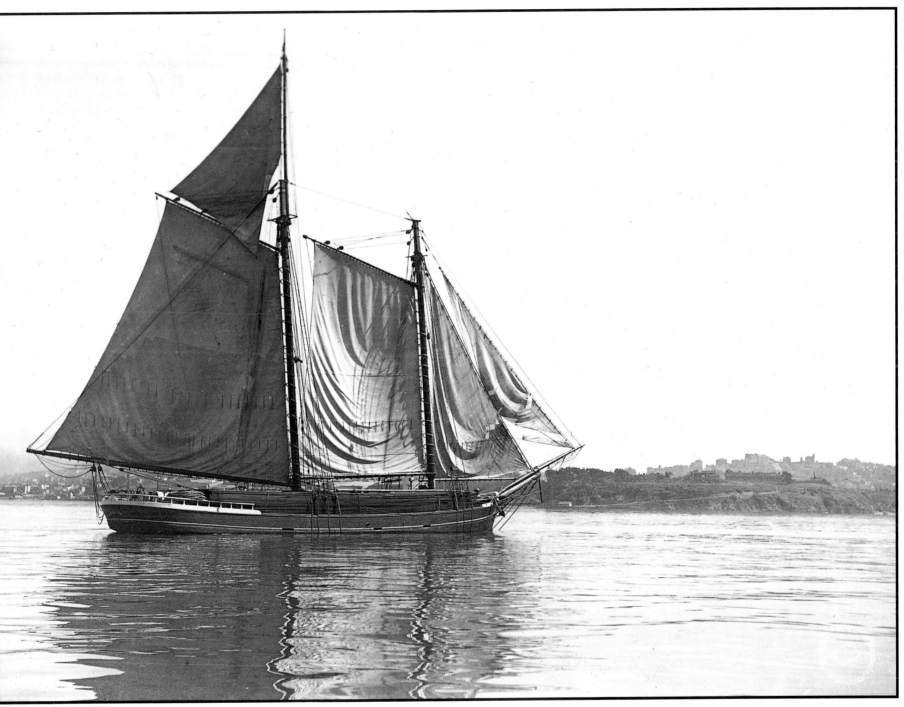

Schooner Bobolink, built in 1868 at Oakland. The most prevalent type of lumber carrier on the Pacific Coast in the 1860s and 1870s was the small "one topmast schooner" like Bobolink. They were locally produced and owned and served large and small ports from Washington to the Mendocino Coast. Three and four-masted schooners and the big five-masted barkentines and schooners, largely a Pacific Coast development in the 1880s, displaced the small schooners on long hauls. Steam schooners eventually cut into the sawmill port trade.

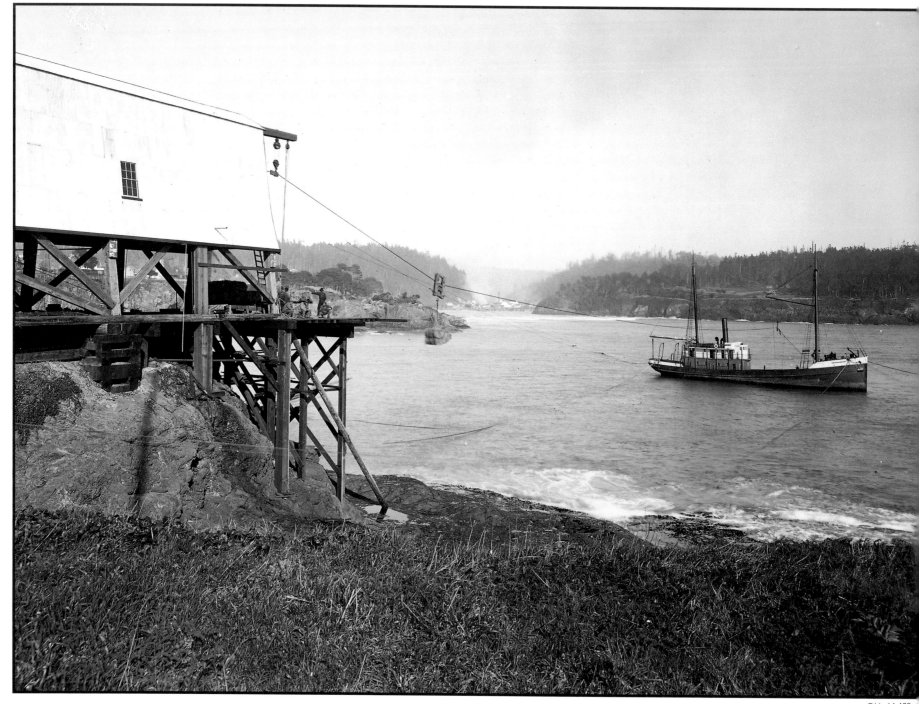

The steam schooner Phoenix at Big River, Mendocino County, California, probably in 1903. In addition to lumber from Puget Sound and the Columbia River regions, logs and lumber from small ports along the California and Oregon coasts supplied much of the demand in San Francisco and Los Angeles. Inventive lumbermen and seafarers came up with ways to overcome a difficult and dangerous coastline. Lumber chutes were threaded precariously over rock cliffs; overhead cables and pulley wheels supported slings to carry lumber and logs to vessels anchored below. The ports were well-known to master and mate alike, for each port required special knowledge and special procedures for entering and exiting safely.

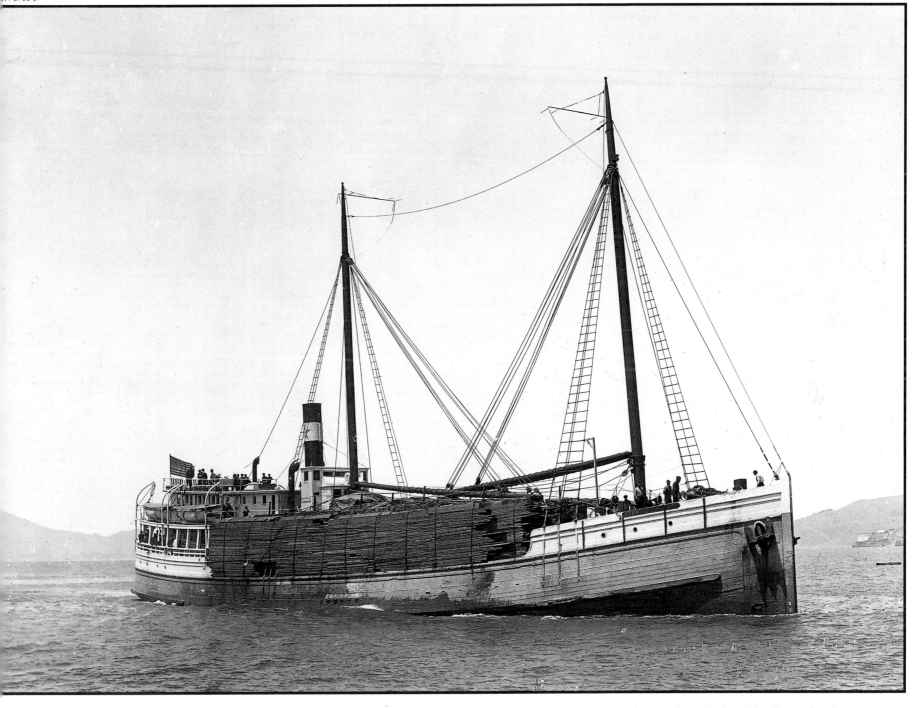

Steam schooner Willamette, San Francisco Bay, by Walter Scott. As early as the 1880s, lumbermen and ship builders fitted steam engines in wooden lumber schooners to make the vessels more maneuverable in small ports. The evolutionary result was the highly successful Pacific Coast steam schooner, typified by the Willamette, capable of carrying over a million board feet of rough-cut lumber and eminently suited to working the tiny sawmill ports along the coast. Steam schooners traditionally had their engines and deck houses aft to leave the deck clear for their huge deckloads of lumber. Some later steam schooners were "double enders" with a more traditional ship layout, deck houses amidships and booms at either end. Densely packed with lumber and with an additional deckload rising above the gunwales, a steam schooner was almost a solid wooden, unsinkable object.

Steam schooners, usually company owned, served the needs of their home ports as well as provided water-borne passenger transportation and general cargo shipping along the coast. Lumber was the main southbound load and northbound the little steamers carried canned goods, cement, steel, and general merchandise. In addition, a typical steam schooner had spartan passenger accommodations for twenty to fifty people.

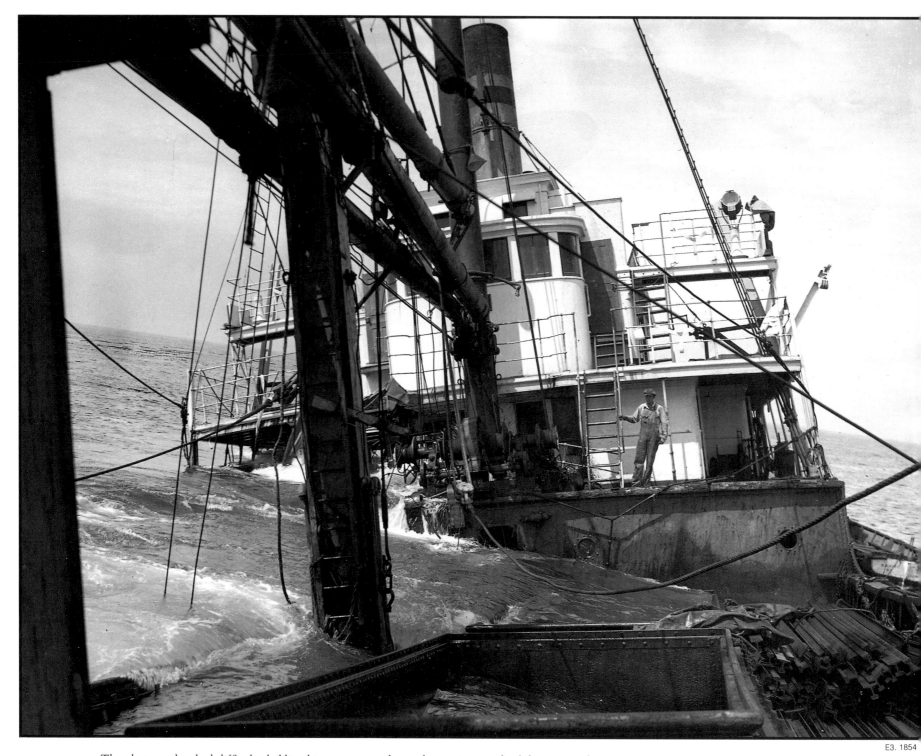

The photographer had difficulty holding his camera steady on the surging wreck of the steam schooner Riverside in this 1913 photo. The vessel struck Blunts Reef off Cape Mendocino on the California Coast. The Riverside was larger than most steam schooners with a capacity of 1,750,000 board feet of lumber, made possible by a steel hull. Her size and strength, however, didn't protect her from a fate suffered by so many of her contemporaries. Of over two hundred steam schooners built between 1890 and 1915, more than one hundred fell victim to storms, fires, river bars, shoals and collisions. Despite their seagoing qualities, steam schooners were subject to navigational limitations of the day and the traditional hazards of the sea.

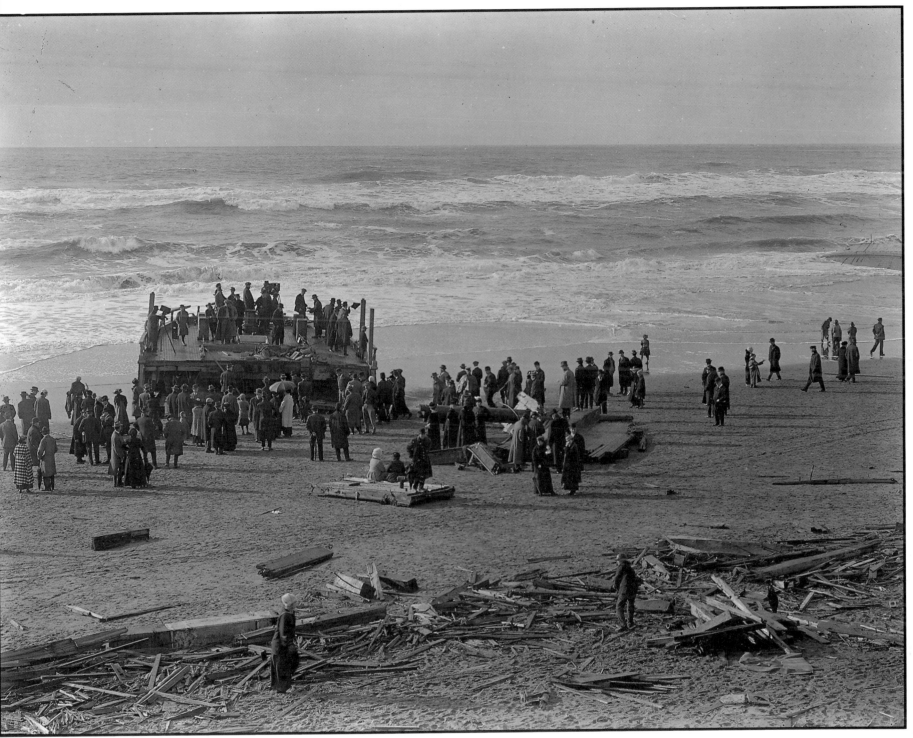

The remains of the steam schooner Aberdeen at Ocean Beach south of the Cliff House, 1916, by Walter Scott. Aberdeen was one of twenty or more steam schooners converted to other uses after larger steamers and the railroads made the little steam schooners obsolete. They became salvage ships, fish-reduction ships, and cattle carriers. A few, like the unfortunate Aberdeen, became garbage carriers, dumping urban waste at sea. It was in this ignominious capacity, hauling garbage for the city of Oakland three times a week, that Aberdeen struck the San Francisco bar and broke up. Today, the sole survivor of the steam schooner fleet, Wapama, a national historic landmark, is preserved by the San Francisco Maritime National Historical Park.

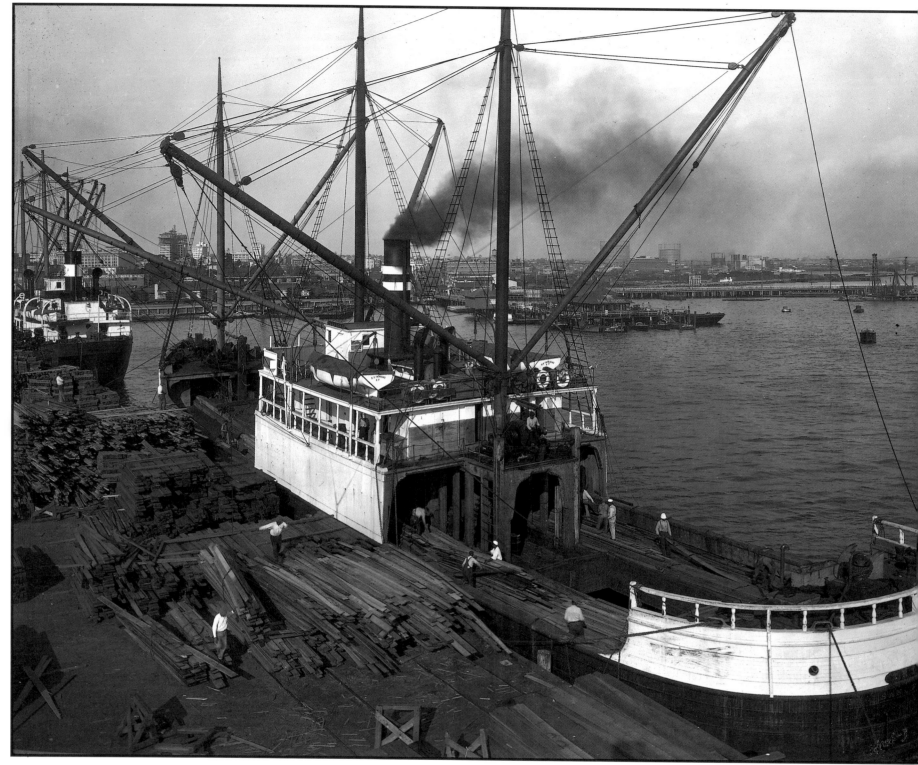

Steam schooner Trinidad "rough piling" her load at Santa Fe Wharf, San Diego, around 1920. Most of the time steam schooners successfully delivered their cargo. After 29 years of faithful service, the 974-ton Trinidad, built by Hammond Lumber Company at Fairhaven, California, met her end on Willapa Bay, Oregon, in 1937. Caught in a fierce gale, she was driven on the bar and smashed to pieces. All but one of her crew were rescued by the life-saving crew from Grays Harbor.

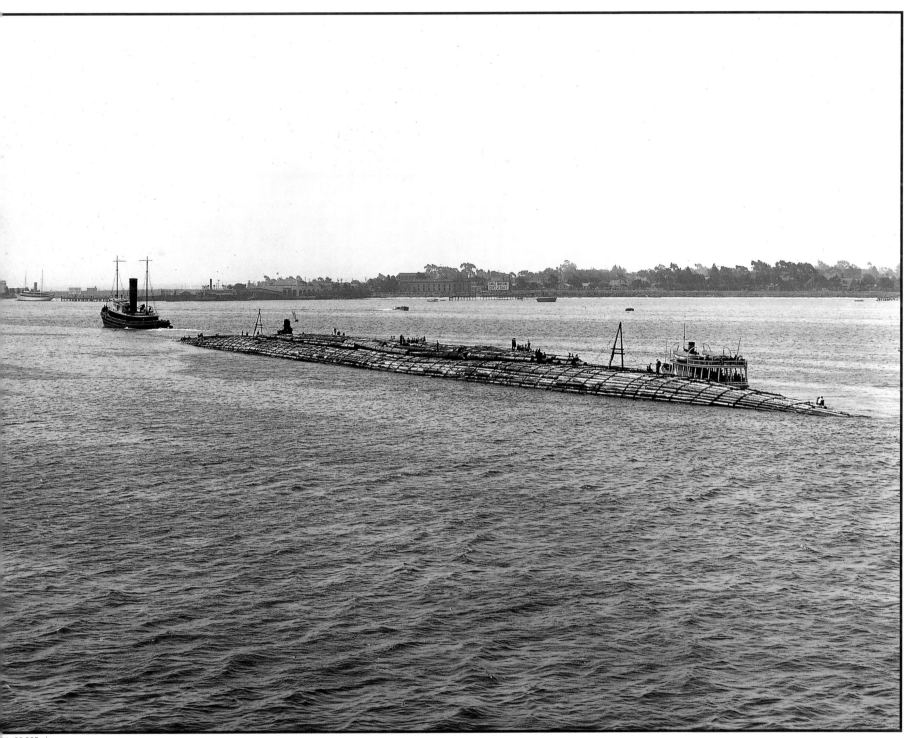

A Benson log raft, c.1920. As the tug Sea Scout pauses near the Benson Lumber Company wharf in San Diego Bay, visitors from the excursion boat Estrella explore the raft. Coronado Island is in the background as the ferry Morena prepares for the short run across the channel to San Diego.

The most economical method of moving logs to Southern California sawmills was to float them down the coast. From 1910 until the late 1930s, more than a hundred log rafts similar to the one shown here were assembled on the Columbia River near Clatskanie, Oregon, then pushed downriver to Astoria. At the Columbia bar the huge cigar-shaped rafts were attached to a line and towed to their destinations. Benson rafts, named for the man who developed the assembly cradle and system of chains that held the raft together, were the largest man-made floating objects of their time.

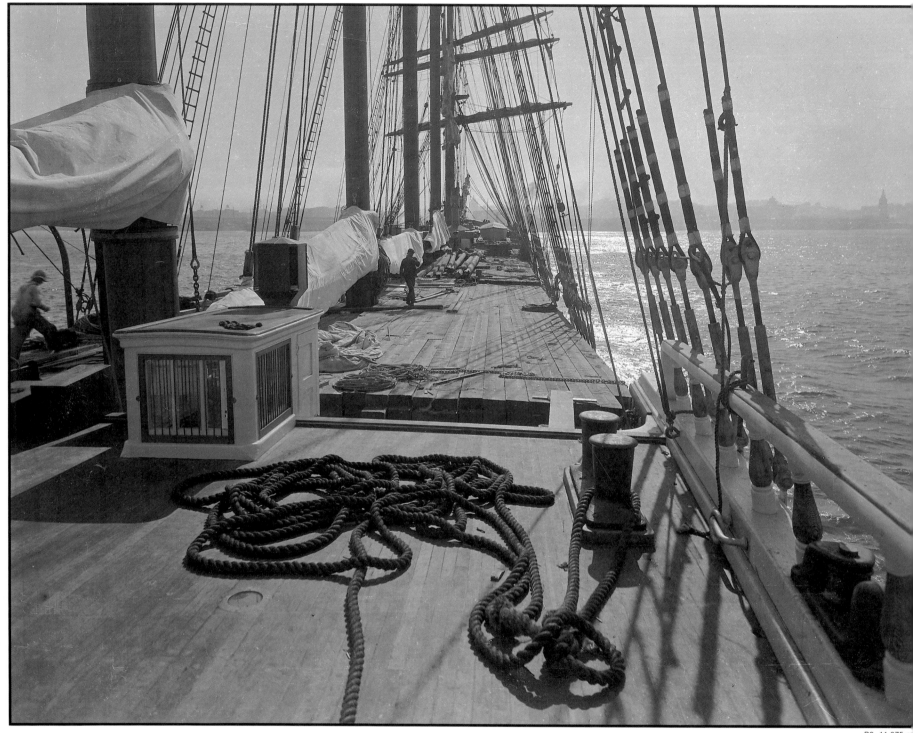

Deck of the new five-masted barkentine Monitor *by Walter Scott, San Francisco Bay, 1920. Although San Francisco was a primary destination for Pacific Northwest lumber particularly prior to 1890, lumber was shipped in huge quantities to every major seaport on the globe. San Francisco-owned sailing vessels often carried Pacific Coast lumber to countries that were not maritime powers such as China, Australia, and Hawaii. On the return trip, they carried cargoes arranged by their owners such as coal, sugar, and general merchandise. If no return cargo awaited them, the captain was expected to find one.*

11. 4037 psl

San Francisco in 1898 was a city built of North Coast timber. Most of it was carried through the Golden Gate on lumber schooners, both sail and steam. After 1890, prime grades of lumber were shipped to the East Coast, Europe, and Asia, where they commanded premium prices. It was not profitable to ship lesser grades overseas, so local cities received a cheap abundance of construction grade lumber. All cities on the Pacific Coast consisted primarily of wooden structures, and the steady supply of Douglas fir and California redwood made rapid expansion possible.

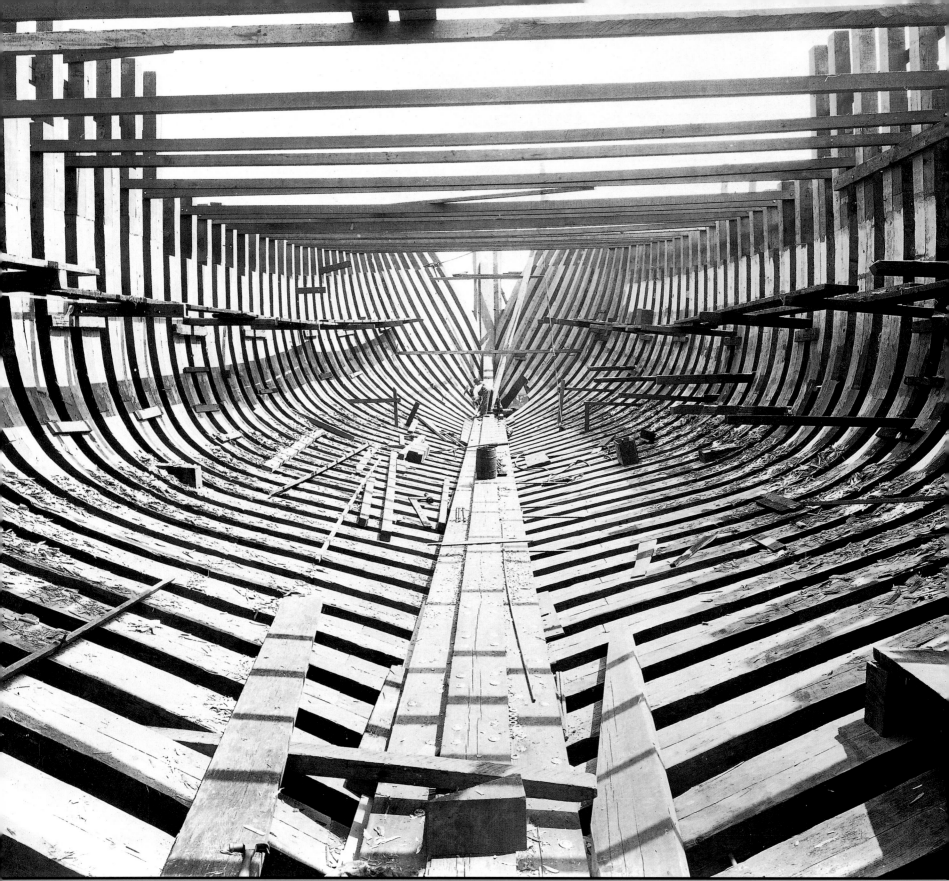

B4. 11,129 pl

Schooner Doris Crane in frame, W.F. Stone & Son's yard, Oakland, California, 1920. Walter Scott made a series of photographs of the schooner under construction and captured the essence of wooden shipbuilding. The timbers were hand-selected, hand-cut and shaped, and hand-fitted. Each vessel reflected the knowledge and skill of its builder.

Pacific Coast Shipbuilding

*P*acific Coast wooden shipbuilding began as early as the first permanent settlements and was essentially a small-scale, do-it-yourself activity. Before the California gold rush, small coastal schooners and other types were built as needed on convenient launch sites with nearby stands of usable timber. During and after the California gold rush, highly skilled and experienced craftsmen, including shipbuilders, came west, and the size and number of locally-launched vessels slowly increased. In spite of local activity, however, most large vessels on the Pacific Coast prior to 1865 were built in eastern yards and sailed around Cape Horn. By that time, local builders knew enough about (and trusted) North Coast fir to construct large ocean-going vessels. By the 1880s wooden shipbuilding was a major Pacific Coast industry.

At first, vessels built on the Pacific Coast appeared identical to Atlantic Coast vessels. Of necessity, different types of timber were used; oak in sufficient quantity and quality was unavailable, for example, and western species were substituted. Pacific Coast geography and weather differed, too, and modifications were made to hulls and sail rigs. In time, Pacific Coast vessels took on characteristics that set them apart from their Atlantic Coast counterparts. Many specialized types of small watercraft unique to the Pacific Coast appeared. The lumber carrier, built for both coastal and trans-Pacific voyages, became a highly-evolved specialty of Pacific Coast yards. These were principally sturdy lumber schooners and barkentines built by mill companies in their own yards and by private shipbuilders in Puget Sound, San Francisco Bay, and smaller ports along the coast. Between 1850 and 1900, hundreds of two, three, four, and five-masted lumber schooners and steam lumber schooners were constructed. As the

lumber business rose and fell according to economic expansion and recession, wooden shipbuilding went through similar boom and bust cycles.

The last nationwide boom in wooden shipbuilding occurred during World War I when the government called for a fleet of merchant ships, wooden and steel, large enough to replace losses to German submarines and supply the American Army in France. Of thirty shipyards on the Pacific Coast that turned out wooden steamers during this period, only seven were old yards from the lumber schooner era; the rest were new. In addition to the scores of new large sailing vessels, Pacific Coast yards built 202 wooden steam-powered freighters.

Wooden shipbuilding on the Pacific Coast experienced a brief resurgence during World War II when there was a need for sea-going wooden barges for use as coal carriers on the Atlantic Coast. Old shipyards close to timber supplies on the Pacific Coast were activated. As in the 1917 emergency, most of the construction took place along the Northwest Coast and on the Columbia River, at Anacortes, Seattle, Port Angeles, and Longview, Washington. But even with the close proximity of timber, other priorities than shipyards had first call for it. By the time enough lumber was available for the barges, the crisis had passed and barges were no longer needed in large numbers. The yards also turned out wooden torpedo boats, picket boats, rescue craft, minesweepers, tugs and small knock-down wooden barges. In Southern California, wooden barges and tugs were built at Long Beach and San Pedro. When the war ended, wooden shipbuilding again faded out and the few yards remaining went back to building small pleasure craft and work boats. Large-scale wooden shipbuilding on the Pacific Coast was at an end.

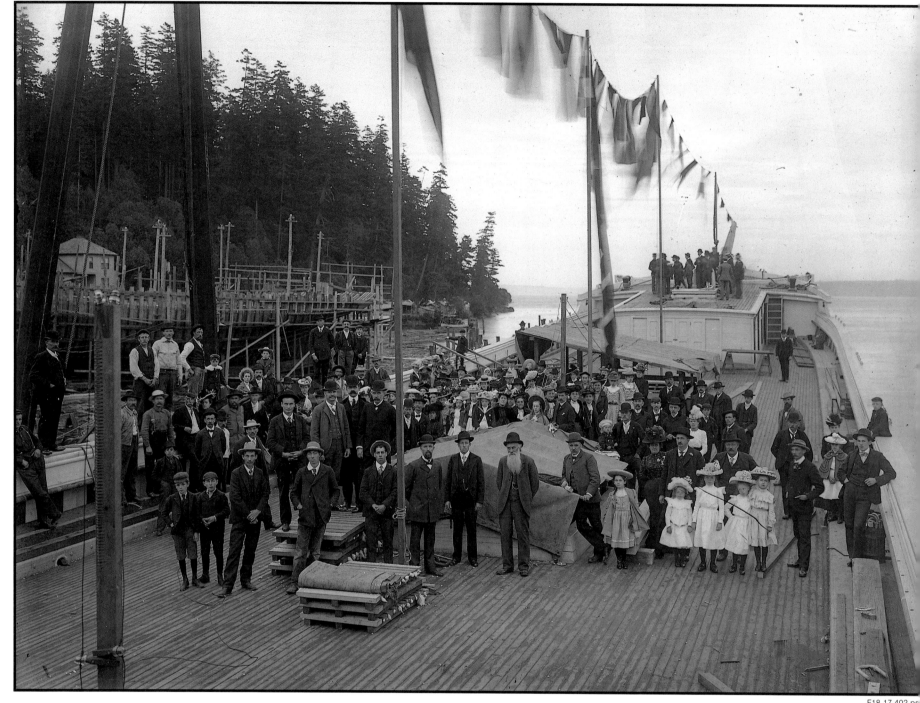

F18.17.402 ps

Shipbuilder Henry Knox Hall, center with white beard, presides over the 1902
launch of his five-masted namesake, the schooner H.K. Hall in this photo by Wilhelm
Hester. The Hall brothers were pioneer shipbuilders on Puget Sound who by 1903 had
launched 108 vessels. The Alaska gold rush produced a boom in Elliott Bay shipbuilding,
and shipyards in Seattle produced a variety of wooden steamers, schooners, and tugs. In
the first half of 1898, local yards launched seventy-four ships, mostly for the Alaska
run. The Moran Brothers Company of Seattle, which had prospered during the gold
rush, got a government contract in 1902 to build the battleship Nebraska, the first big
steel ship launched on Puget Sound.

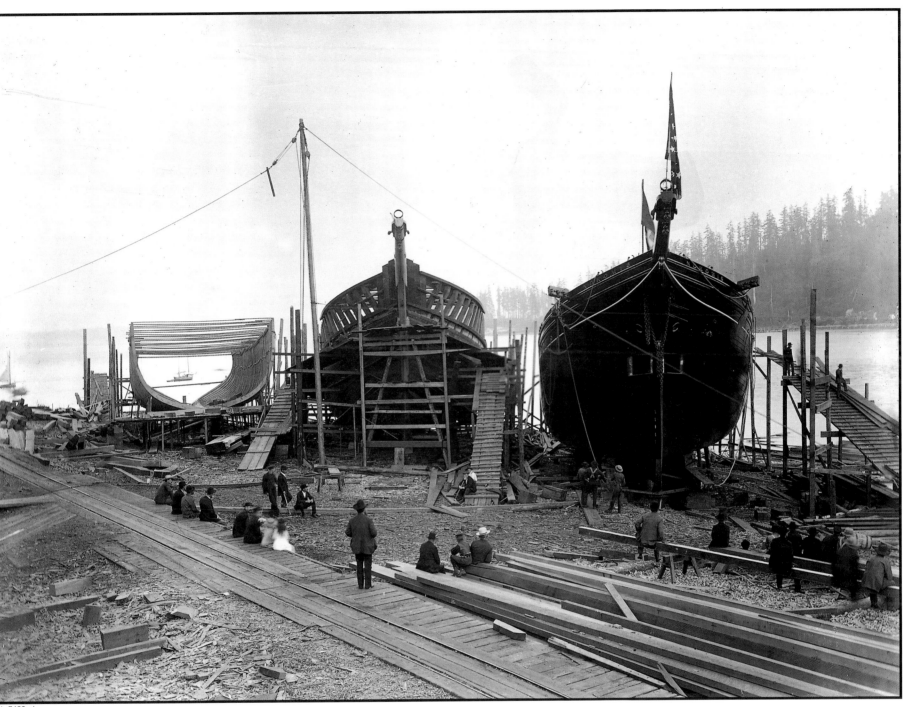

A crowd gathers as preparations get under way for the launch of Hall Brothers' schooner Nokomis. The two other unidentified vessels under construction on the ways illustrate the builders' efforts at economy by having more than one vessel at a time under construction. In addition to sailing vessels for the lumber trade and ocean steamers for the Alaska run, Puget Sound shipyards also produced the "Mosquito Fleet," scores of small side-wheel and stern-wheel steamers for use on lakes, rivers, and Puget Sound.

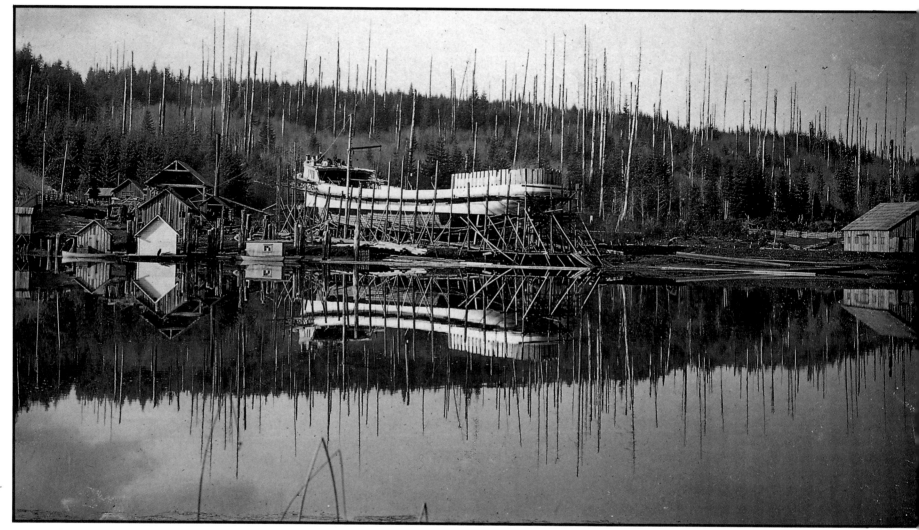

The steam schooner Santa Ana on the ways in 1900 at Hans Reed's
yard on Coos Bay, Oregon, shows the way wooden ships were built on the
Pacific Coast before the advent of large commercial shipyards. Even well
into the twentieth century, wooden ships were built on site at small ports
on rivers and along the coast. Steam schooners often were towed to San
Francisco to have engines installed at Union Iron Works.

78

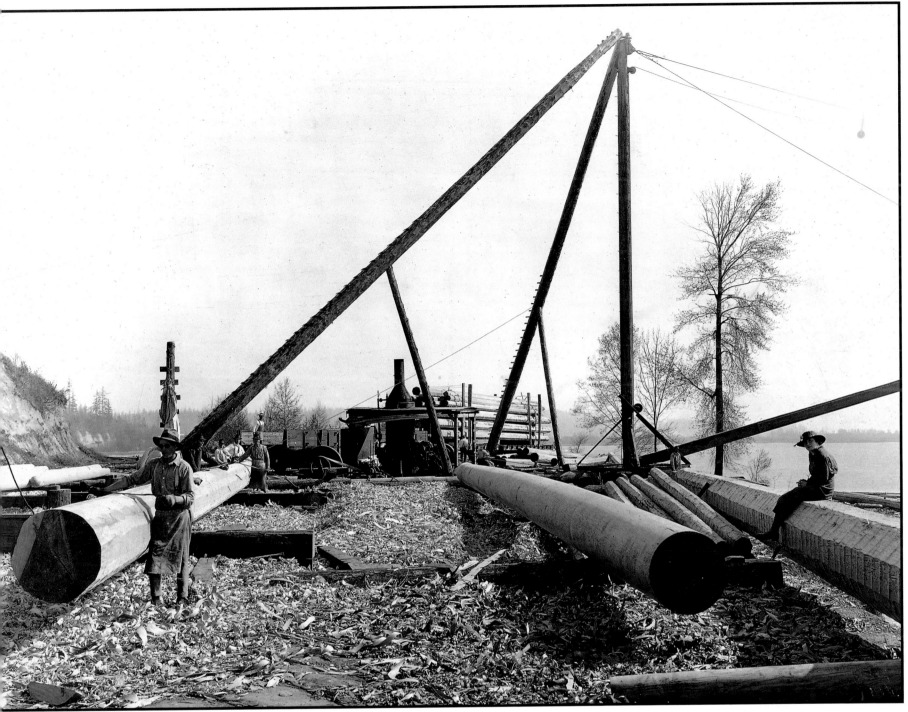

11. 14,680 pl

Spar making at W.I. Logan and Company, Kennydale, Washington, 1917. Mast and spar making was an ancient craft that changed little in the centuries of wooden ship building. By the time of this photograph, sailing ship masts were either all steel or composite wood structures, but wood spars were still needed. Between 1916 and 1918 Pacific Coast shipyards produced over 150 big three, four, five, and six-masted schooners, and sixteen barkentines, and the skills of experienced spar-makers were in demand.

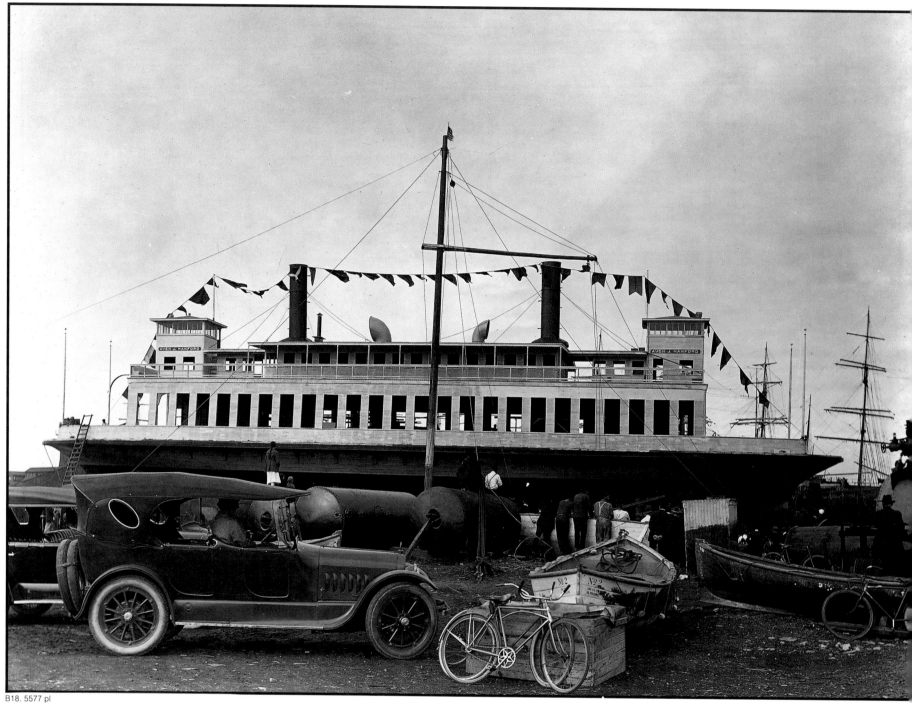

A small crowd gathers as the wood-hulled auto ferry Aven J. Hanford is made ready for launch in October, 1920 at James Robertson's shipyard in Alameda, California. She was one of the last wooden-hulled ferryboats made on the Pacific Coast. Named for the president of the Rodeo-Vallejo Ferry Company, the vessel was leased by the new Golden Gate Ferry Company for the Sausalito-San Francisco run immediately after launch. Just five years later, as the Golden City, she was lost in a collision.

Facing page: W.F. Stone & Son's boatyard, Oakland, California, launched the graceful schooner Northern Light in 1927. The Pacific Coast was, and is, home to many small boatyards which turned out a wide range of small wooden pleasure craft, work boats, fishing boats and tenders, lighters, and barges.

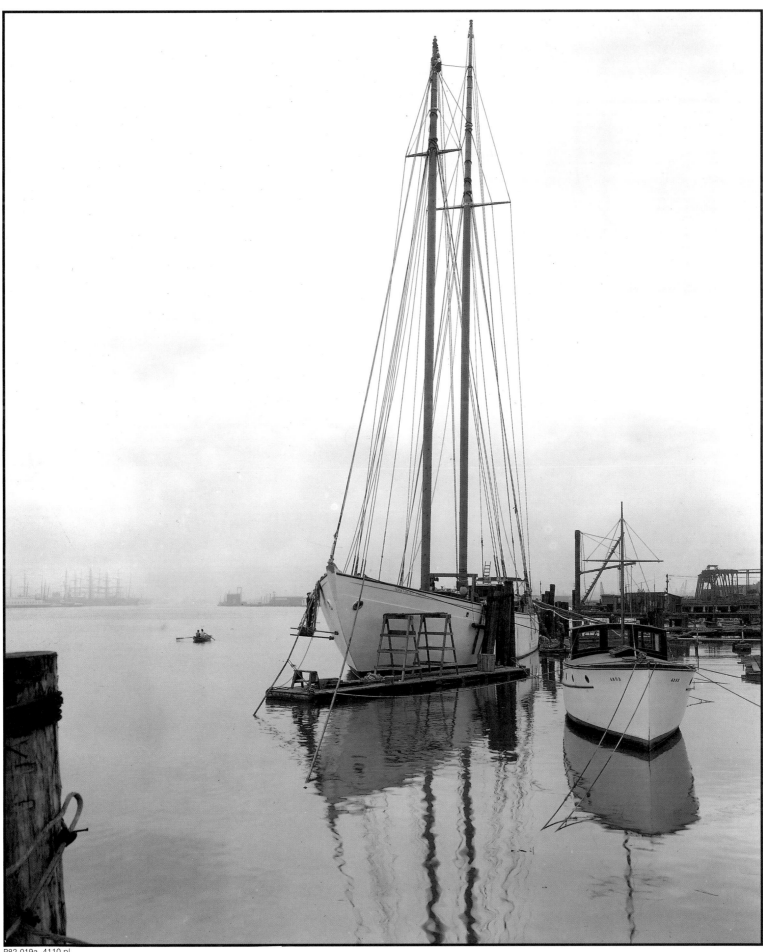

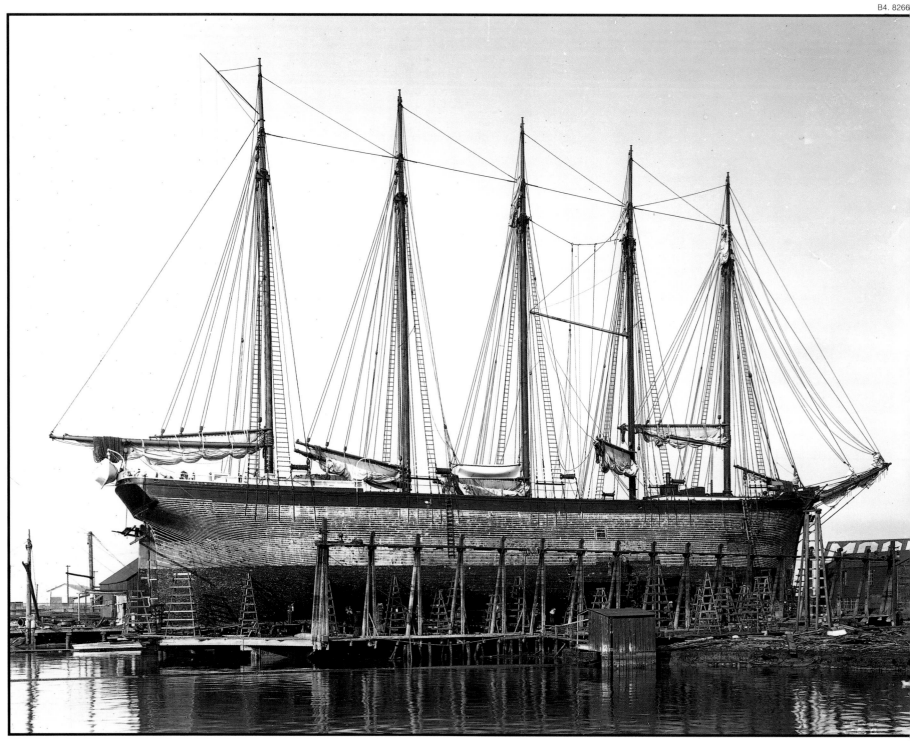

Wooden ships often found their way to Pacific Coast shipyards that specialized in steel vessels. Moore & Scott Iron Works in Oakland could easily handle repairs and maintenance on any vessel. Here, Gabriel Moulin found the Snow & Burgess on the ways as she received caulking and a new copper bottom in December 1914. Built at Thomaston, Maine, as a full-rigged ship in 1878, Snow & Burgess was sold in San Francisco in 1890 and became a bark. Then, in 1904, she was again re-rigged as a five-masted schooner (as seen here) for the coastwise lumber business and the trans-Pacific trade. She was burned for scrap metal in Puget Sound in 1922.

Facing page: An unidentified photographer couldn't resist the harmonious, utilitarian lines of the steam schooner Samoa as she rode light at low tide. Repairs on wooden vessels were constant, a never-ending battle against wet rot, dry rot, ship worms, salt water, and wounds inflicted by moorings and other vessels. Shipbuilders knew that a wooden vessel was a living thing, subject to inherent weaknesses, rot and vermin among them. It was said that a wooden ship began sinking the instant it slid into salt water. Maintaining its useful life was a constant battle against the forces of nature.

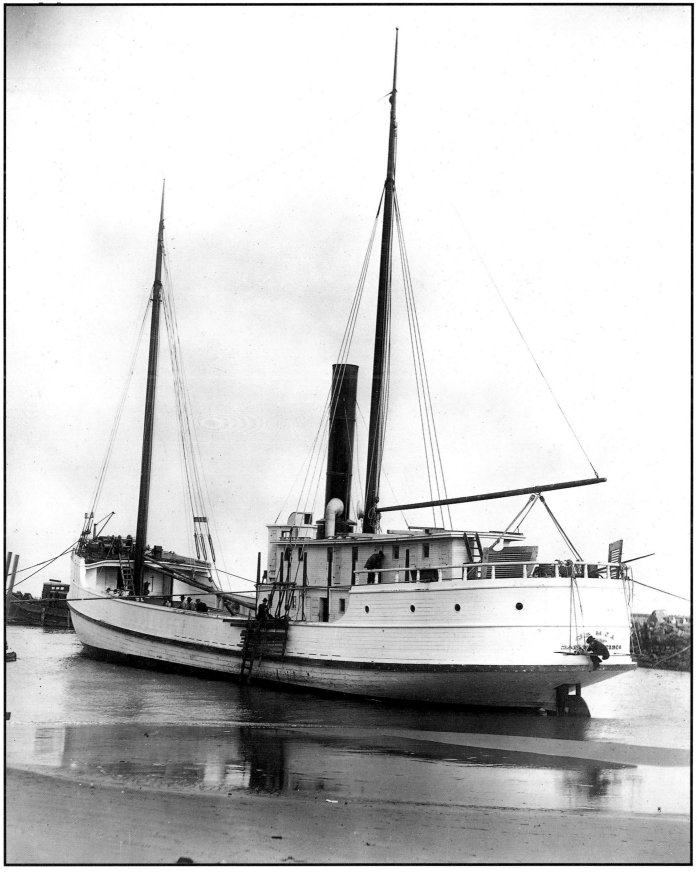

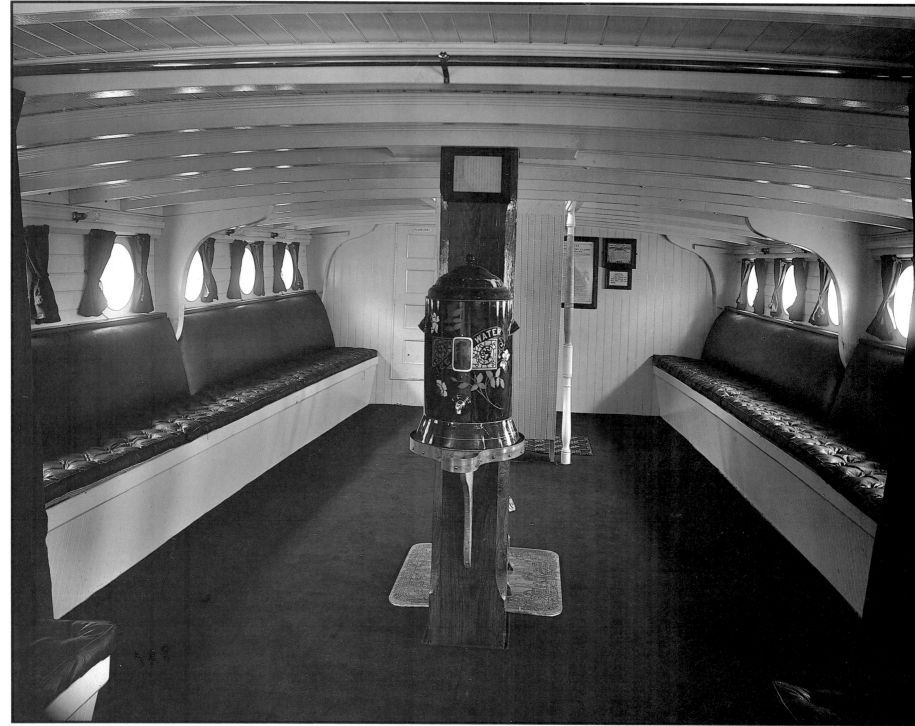

Wooden boat and ship interiors involved the skills of hundreds of specialized shipyard workers. The interior of the Empress was typical of many small bay and river passenger launches, functional and simple, yet well crafted. The wooden launch Empress was owned by Lauritzen Transportation Company of Antioch and operated on the lower Sacramento River.

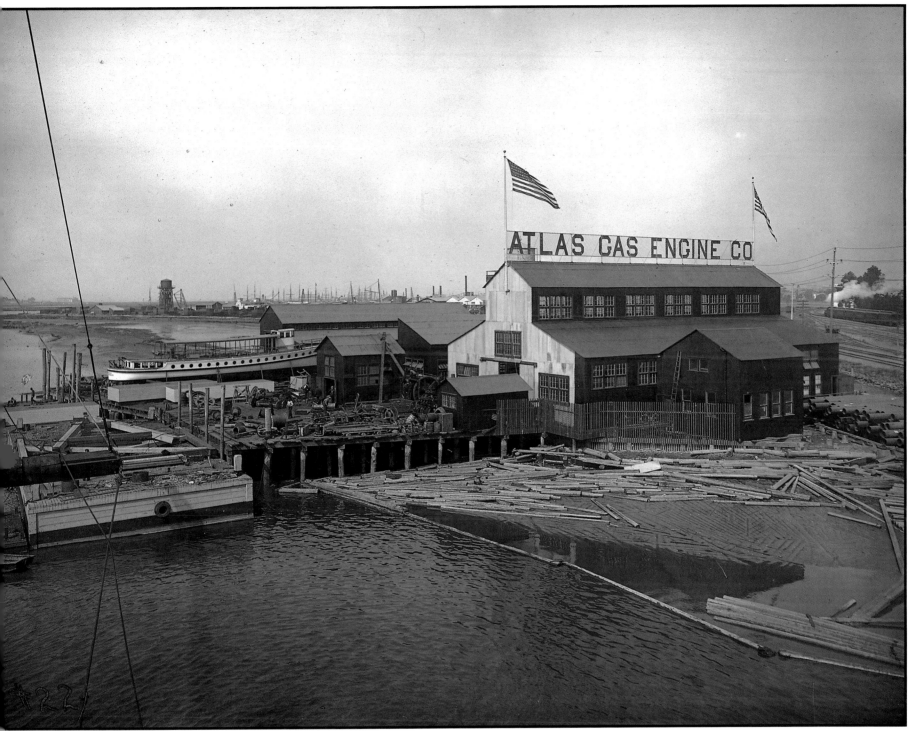

11. 24,924 psl

A photographer climbed atop a nearby floating crane to get this "aerial" shot of the Atlas Gas Engine Company on the Oakland Estuary in 1912. Atlas was one of many suppliers and outfitters to the shipbuilding trade in Pacific Coast seaports and one of the two dozen manufacturers in the Bay Area that pioneered marine gasoline engines. The launch Empress rests on the ways.

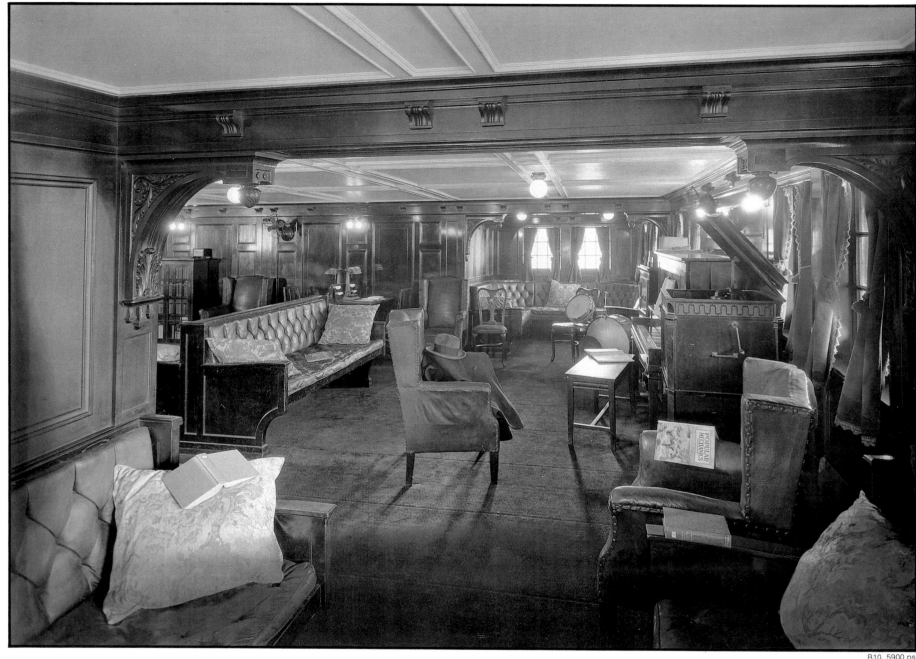

Photographer Walter Scott carefully composed this shot of one of the lounges on the Matson liner SS Manoa, probably in 1913 when she was delivered from her builders at Newport News, Virginia. The craftsmanship evident in steamship interiors ranged from the purely nautical to the flamboyant and was often a mixture of the two. But until the advent of steel, aluminum, and plastic, the principal building material for interiors was wood. Manoa served Matson until 1942 when she was sold to the U.S. Maritime Commission. After World War II she became the Russian ship Balkash and was still afloat in 1969.

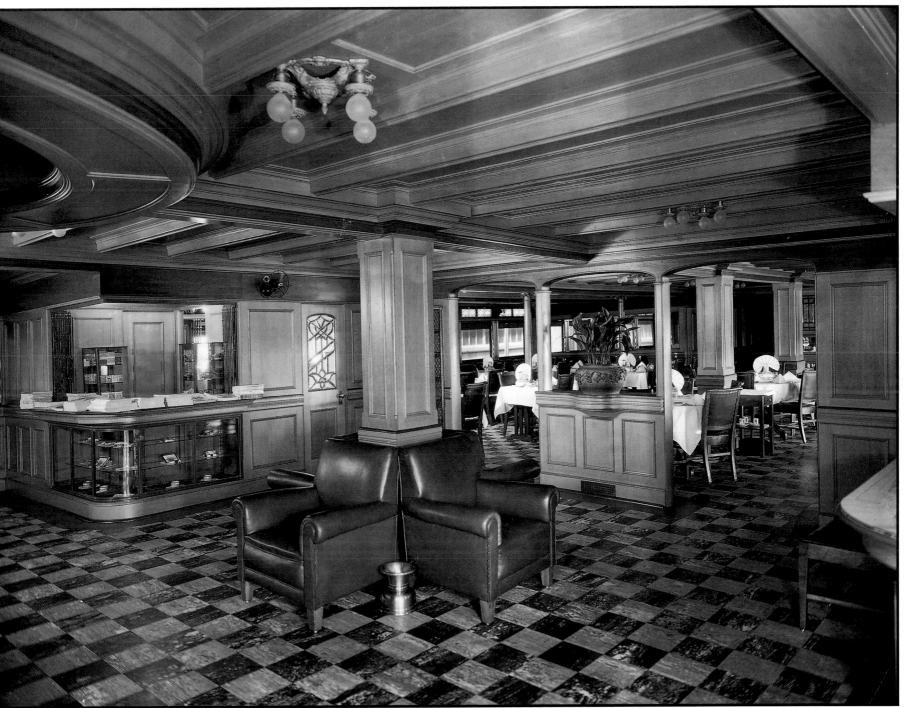

The saloon deck lobby of the Delta Queen. When the proud riverboats Delta Queen and Delta King were launched in 1926, the heyday of Sacramento riverboats had passed. They were, however, splendid boats, each capable of carrying 200 overnight passengers in comparative luxury between Sacramento and San Francisco. Their steel hulls were built on the River Clyde in Scotland, then dismantled and shipped to San Francisco where they were reassembled and the vessels completed. Crankshafts were forged in the giant Krupp mills in Germany, the engines built in San Francisco. The decks were of ironbark, the woodwork of Oregon cedar, teak, and oak, and the magnificent interior paneling of finely polished mahogany, oak, and walnut trim. Both vessels survive today although the Delta Queen has been on the Mississippi since 1947.

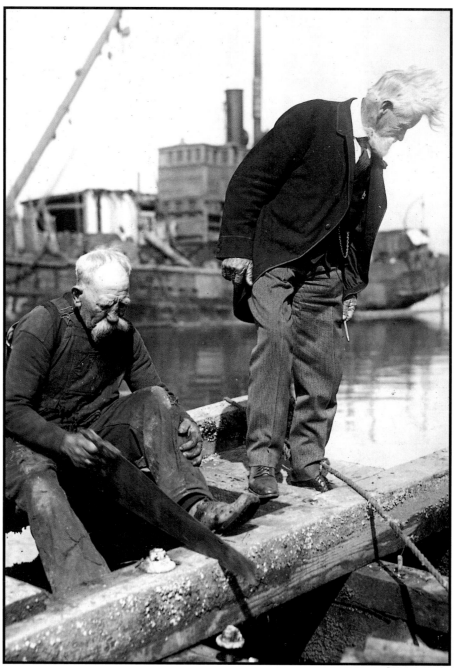

P82. 019a-4102 p

Above: Captain Thomas Whitelaw, on the right, examines part of his domain, the profitable business of ship salvage in this 1930 photo. His wrecking ship, the former steam lumber schooner Greenwood, is in the background. A Scotsman who arrived in San Francisco in 1866, Whitelaw built his salvage business from scratch and became a legendary character on the San Francisco waterfront. Salvage has always been an important part of the cycle of shipbuilding and shipbreaking. Men like Whitelaw recovered thousands of dollars' worth of cargo, metal fittings, rigging, and useful equipment.

Facing page: The French ship Alice was wrecked January 15, 1909, on North Beach Peninsula at the mouth of the Columbia River. She was caught in a gale and driven ashore while awaiting a pilot after a long passage from London via Australia. The weight of her cement cargo, once it became waterlogged, drove her steel hull deeper and deeper into the sand until only her masts protruded from the beach. As the photographer made this shot, his companions explored the wreck for salvage. One can be seen atop the foremast, another astride the foretopsail yard.

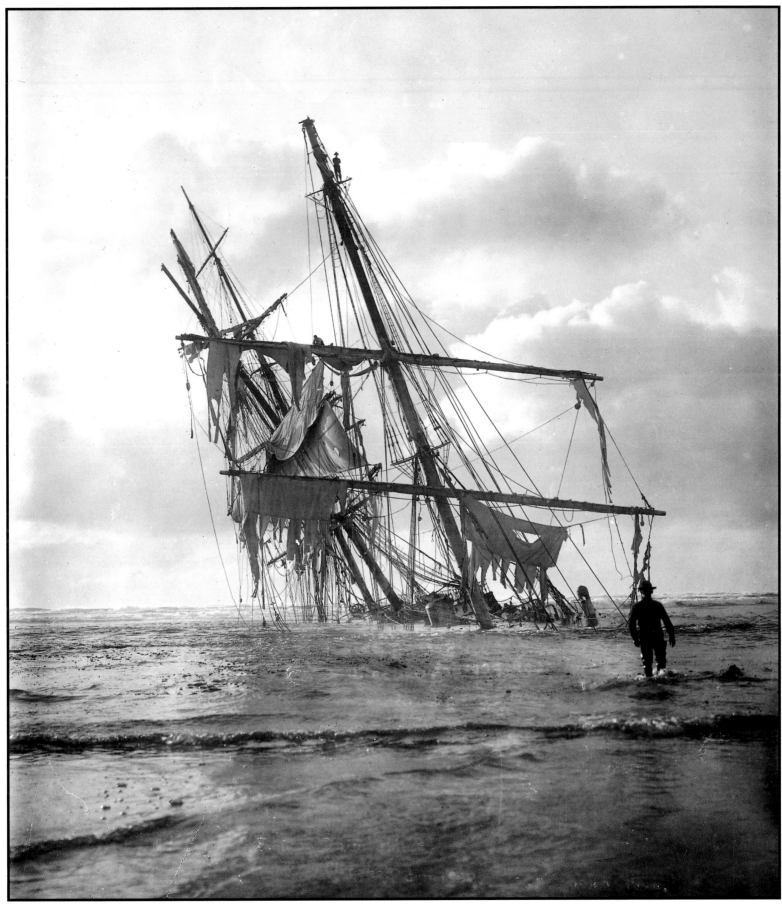

Steel Ships

oundries and machine shops on the Pacific Coast, occupied primarily with manufacturing mining machinery, made a few marine steam engines for use in small craft as early as the 1850s and supplied many of the iron and brass fittings used in shipbuilding, but it wasn't until 1885 that the first steel steamship was launched on the Pacific Coast. Iron-hulled steam vessels built in the east either arrived on the Pacific Coast via Cape Horn or were shipped disassembled via rail across the continent. Local iron works, however, turned out a variety of steam launches, small freighters, and tow boats in San Francisco Bay and Puget Sound. At Mare Island Navy Yard several tugs and small iron utility craft were launched. Union Iron Works in San Francisco, which built the first steel ship, relied mainly on foreign and Navy contracts for its production of steel vessels.

Steel shipbuilding on the Pacific Coast was never a major industry until World War I. Then, the national Emergency Fleet program called for every shipyard, east and west, to produce merchant tonnage in unprecedented amounts. By 1918, over 1,400 steel ships were under contract. Pacific Coast yards on San Francisco Bay and Puget Sound contributed to that effort.

In the two decades between World War I and II, American steel shipbuilding declined almost to non-existence. The American merchant marine consisted mainly of Emergency Fleet vessels built in 1917–1920. Much of the shipyard activity in the few remaining yards was repair and maintenance of existing ships. Then came the second wartime emergency.

American shipbuilding on a scale never imagined by nineteenth-century builders occurred between 1942 and 1945, during World War II. On both coasts, shipyards were kept busy turning out warships, freighters, tankers, and a huge array of smaller support craft in record numbers. The most remarkable part of wartime shipbuilding was the rapid design and construction of new shipyards. Although existing yards were rehabilitated and expanded, the U. S. Maritime Commission recognized the need for greater shipbuilding capacity to meet anticipated expansion of the American maritime fleet.

In the late 1930s there were only ten American shipyards capable of producing ocean-going ships. At the peak of wartime production, 81 American yards on both coasts and the Gulf of Mexico capable of turning out ships 400 feet or longer were in around-the-clock operation.

Throughout the 1920s and 1930s, ship construction, what little there was, was slow, usually taking a full year from keel-laying to launch. Even during the World War I emergency building program, construction averaged ten months. By 1941, the average delivery time for a Liberty Ship was eight months. One year later the construction time had been cut to 55 days, from keel-laying to delivery. Prefabrication, superb management skills, and high motivation paid off. America's wartime shipyards accomplished an unprecedented and unequaled feat of maritime production.

Following World War II, most Pacific Coast shipyards were closed, and steel shipbuilding began a long decline. Fortunately, photographers had recorded the yards, the ships, and the people from the 1850s onward and have left a remarkable document of maritime and industrial history.

Spectators stand in awe as the massive form of the armored cruiser USS Milwaukee looms above them ready to challenge the sea, September 10, 1904. Actually this sturdy product of San Francisco's Union Iron Works was obsolete when she slid down the ways, but that fact didn't diminish the festivities at her launch. The Milwaukee was launched during a time of worldwide naval expansion and modernization, thus, after a brief career patrolling off Central America, she was laid up in reserve at Bremerton, Washington. In 1913, she was reactivated and assigned to duty as a destroyer and submarine tender. It was in this capacity that she met her fate early in 1917, when she attempted to pull the stranded submarine H-3 off the beach near Humboldt Bay. The cruiser became stranded in the attempt and remained there for two years, despite efforts to refloat her. Late in 1918, her back was broken by wave action and she was sold for salvage the following year.

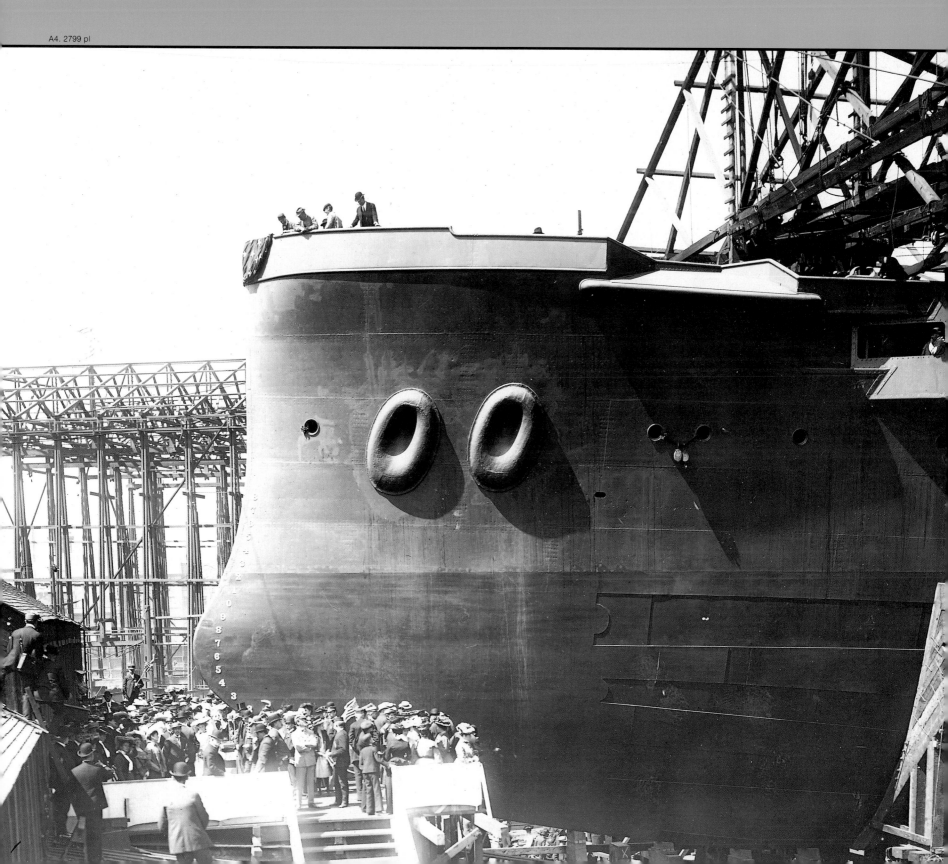

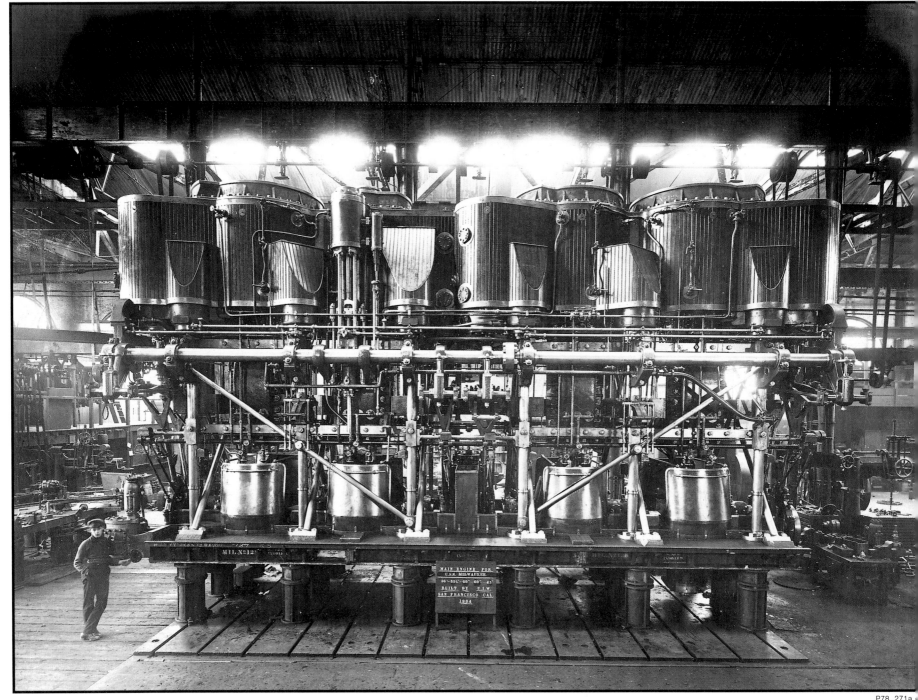

The small boy in the lower left of this shot of the cruiser USS Milwaukee's main engines dramatizes the scale of marine steam engines at the turn of the century. This was one of a series of photographs made at Union Iron Works (later Bethlehem Shipbuilding Corporation) in 1904 during construction under Navy contract. Shipyards routinely made a photographic record of all major repair and construction, and these photos today represent a valuable documentation of one facet of maritime history.

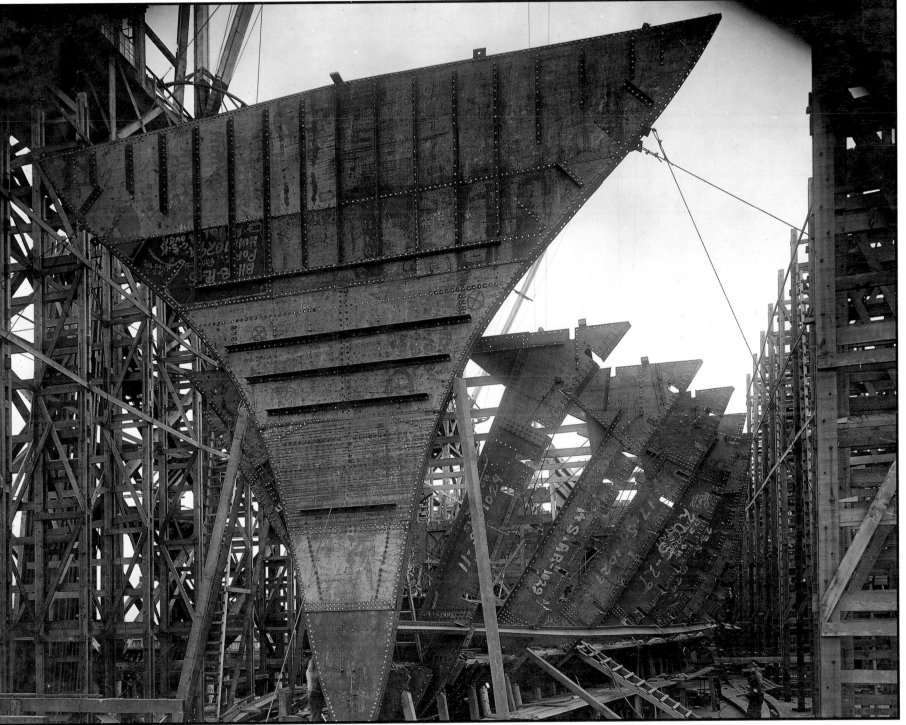

Tanker hull No. 1029, SS Begwaduce, under construction, 1919, Moore Shipbuilding Company, Oakland, California. Gabriel Moulin was one of many local photographers hired to make sequential photos of ships under construction. Moulin applied his skill and artistic talents to an otherwise routine job to create dramatic, well-composed shots of unusual graphic clarity. Here, the oil tanker Begwaduce is seen from the stern bulkhead frames looking forward. The 10,000 ton-capacity tanker was built for the Emergency Fleet Corporation of the U.S. Shipping Board during World War I. Like many emergency vessels, Begwaduce was not completed until after the war had ended, and she immediately went into civilian service.

SS City of Reno, *ready for launching at Moore Shipbuilding, Oakland California, December, 1919. Miss Nathalie Byington,* sponsor of the new vessel, anticipates the big moment.

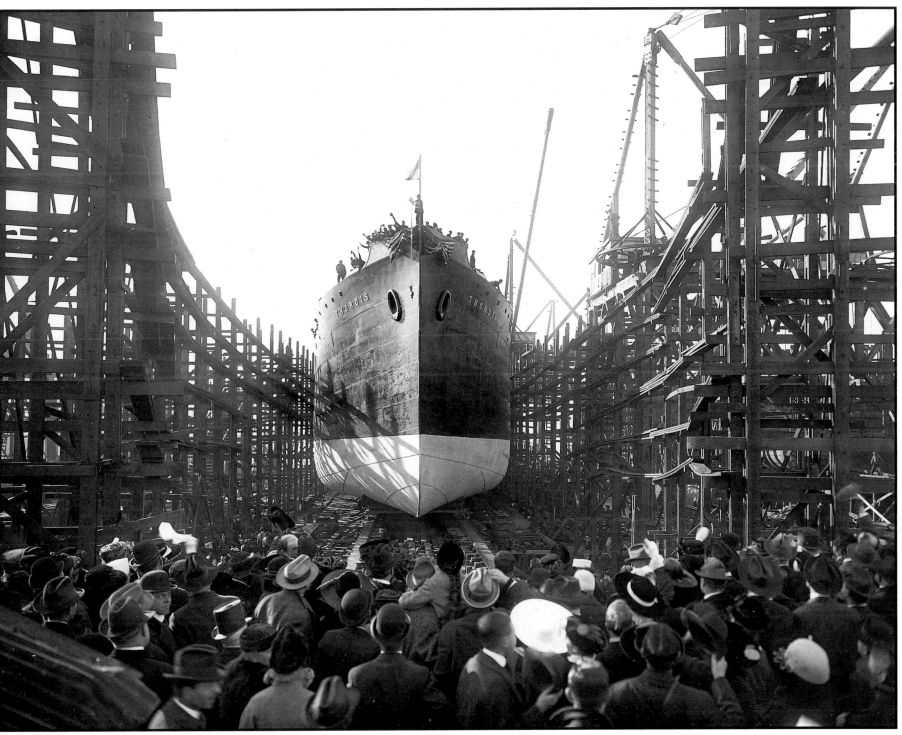

4. 2767 pl

The 7,100-ton turbine steamer Thordis *slides down the launching ways on January 6, 1917, at Moore's shipyard in Oakland, creating a bold and dramatic composition for the photographer, probably Gabriel Moulin. One of the chores of a shipyard photographer was to record launch ceremonies. Unlike the usual static shipyard documentary photos, the shot of the actual launch had to be right the first time.*

During World War I (and later World War II) ship launchings were patriotic affairs attended by local and visiting dignitaries. Each ship had a "sponsor," usually the wife or daughter of a shipyard official or local businessman, who had the honor of smashing the champagne bottle against the bows and sending the new vessel down the ways.

Below: The SS Aniwa is made ready for her first trial run after launch from Moore Shipbuilding in Oakland, July 3, 1918. Ships built for the Emergency Fleet Corporation were painted in camouflage for immediate service in the German submarine-infested waters of the North Atlantic. Even those intended for the Pacific were painted in dazzling patterns according to strict guidelines provided by the Camouflage Section of the Maintenance Division, Bureau of Construction and Repair, Department of the Navy. After much experimentation, six paint schemes with two different purposes were designed for U.S. shipping. Some attempted to make the ships less visible through use of soft, diffused colors. Other designs, like the "Warner" system shown here on the Aniwa, were intended to confuse and dazzle rather than to obscure. The bold patterns were red, blue, green and white, or contrasting grays. Seen from a distance across sunlit seas, the profile of the ship was confusing and misleading.

Facing page: Not all steel ships were steamships. The French four-masted steel bark Champigny lies in drydock at Moore's shipyard in 1918. French sailing ships operated under a system different from that of other maritime nations. Construction and operations were subsidized by the French government to make the vessels competitive. Sailing subsidies, paid at so much per thousand miles, were known as bounties, thus the vessels became known as "bounty" ships. Champigny was one of the most beautiful of the bounty fleet and she had a long history. Launched in 1902 at Le Havre, she made voyages to the Pacific, including San Francisco, until 1927, when, as the Fennia under the Finnish flag, she was dismasted off Cape Horn and put into the Falkland Islands. She remained at Port Stanley for the next forty years until an effort was made to preserve her as a museum ship. The attempt to save her was unsuccessful, and in 1977 she was scrapped.

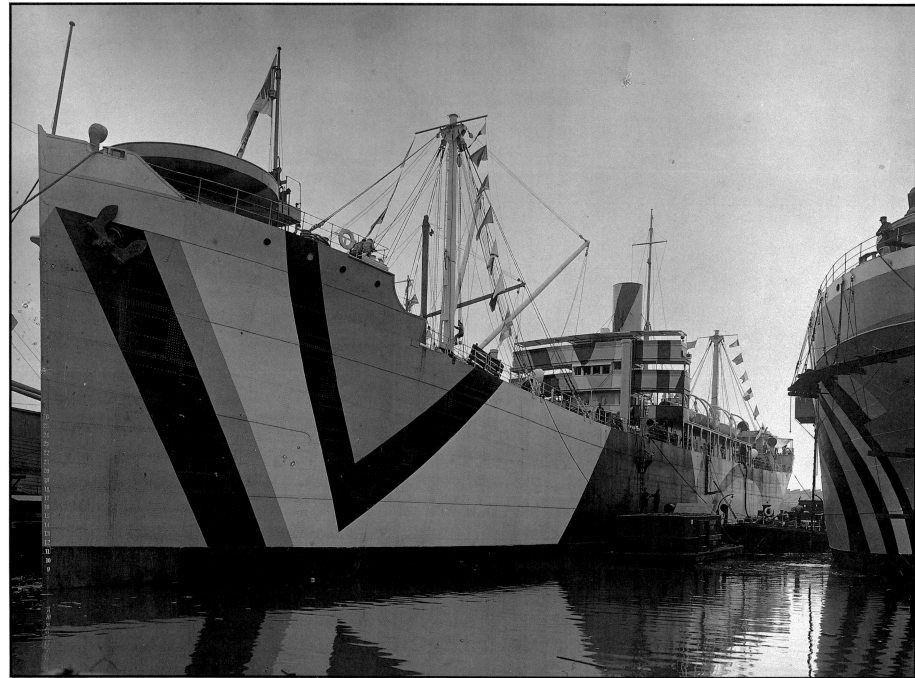

P81-005. 41a psf

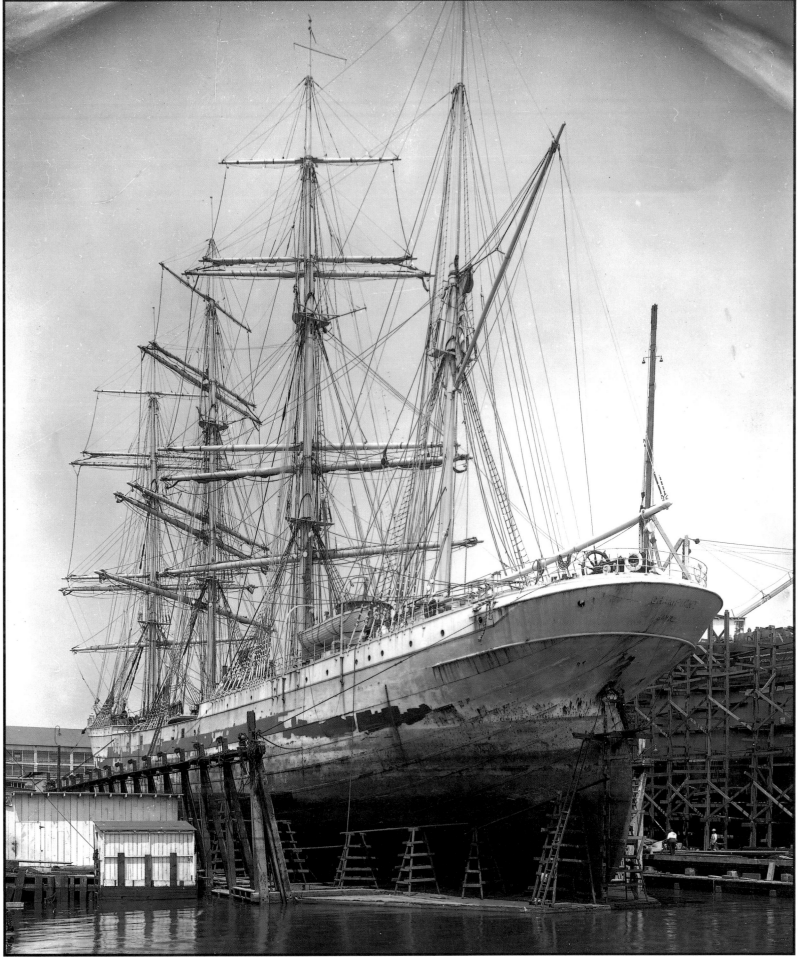

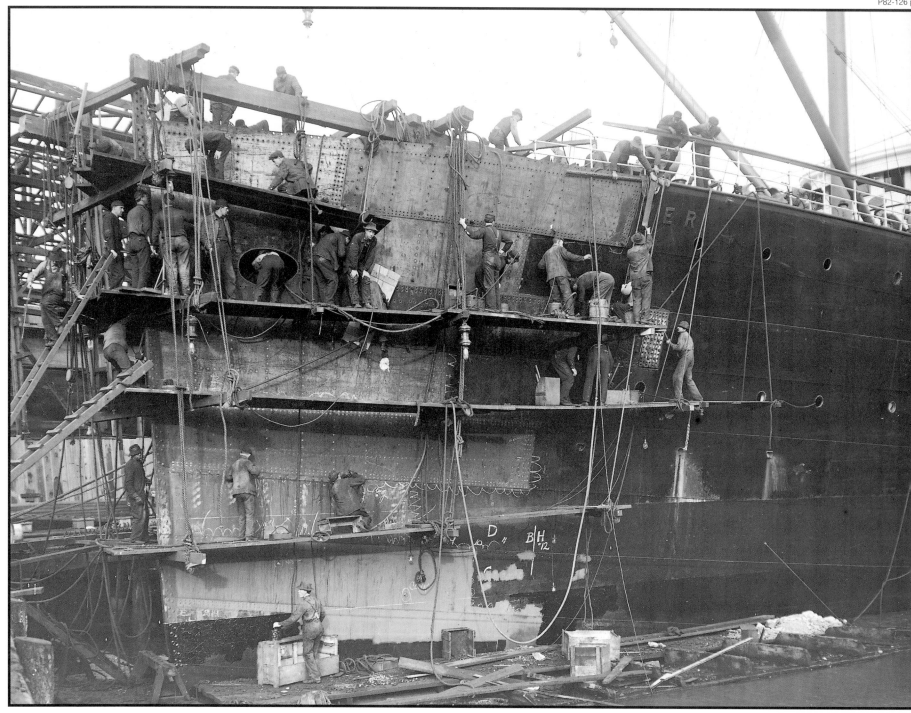

Above: The SS Beaver receives a new bow in 1913 after a collision at sea with another vessel. During World War II, merchant ships were built in welded prefabricated sections so it was relatively simple to cut off damaged parts and install new ones. In the World War I emergency, prefabrication was in its infancy. Hulls of steel ships were still riveted plate-on-frame, essentially hand-made on the spot. Repairs, as evidenced by this photo, required hard work by many skilled men.

Facing page: Repair of SS Apus, Moore Dry-dock Company, Oakland, 1923. A common job at shipyards involved fouled screws. In this photo, the three-year-old SS Apus is in drydock to have a cable untangled from her screw. While it might have been possible to cut the cable free while the ship was afloat, the rudder, shaft and stern plates had to be inspected for damage. Emergency Fleet vessels, mostly under 10,000 tons, were small by today's standards, but out of the water appear massive.

30
79
28
27
26
25
74

6

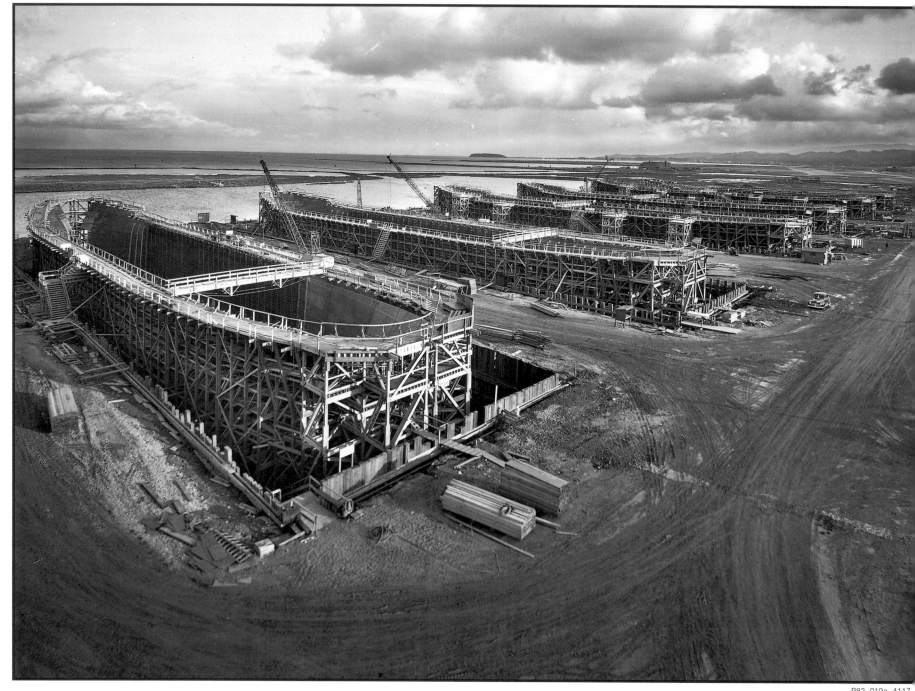

View of Belair Island Shipyard, San Francisco Bay, February, 1943. In a unique exercise in emergency shipbuilding during World War II, contractors Barrett & Hilp excavated a small island off South San Francisco to create these basins. A 400-foot steel-reinforced concrete barge was built in each graving dock and "launched" by flooding the basin. The lightweight walls were six inches thick and poured in plywood forms that were reused for the next vessel. The barges, shaped like ship hulls, were used as floating warehouses and tankers and towed to the South Pacific war zone. World War II emergency shipbuilding on the Pacific Coast, as well as on the Atlantic Coast, was characterized by rapidly built shipyards and rapidly built prefabricated steel vessels. Parts and sub-assemblies for the thousands of ships turned out between 1942 and 1945 were made in all parts of the country and shipped by rail to shipyard assembly lines.

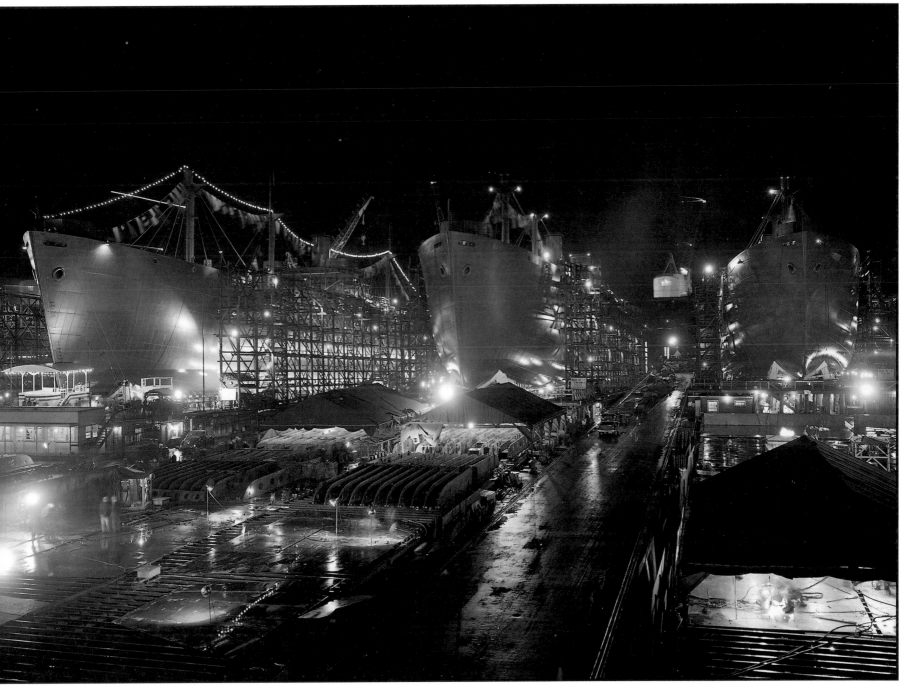

Liberty ships, left to right, Robert B. Harper, Samuel Moody, John Sevier, *April 1942, Oregon Shipbuilding Corporation, Portland. In the fall of 1939, when the European war began, America's merchant fleet consisted of 1,150 vessels and only 28 new ships were added that year. In 1943, the peak year of shipbuilding, American yards launched 1,896 ships. A year later the American merchant fleet had 3,800 vessels in spite of wartime losses. By 1945 the American fleet had grown to a size estimated to be two-thirds of the entire dead-weight tonnage afloat in the world in 1939. Nearly half of that wartime tonnage was launched from Pacific Coast shipyards, many of which did not exist prior to 1941.*

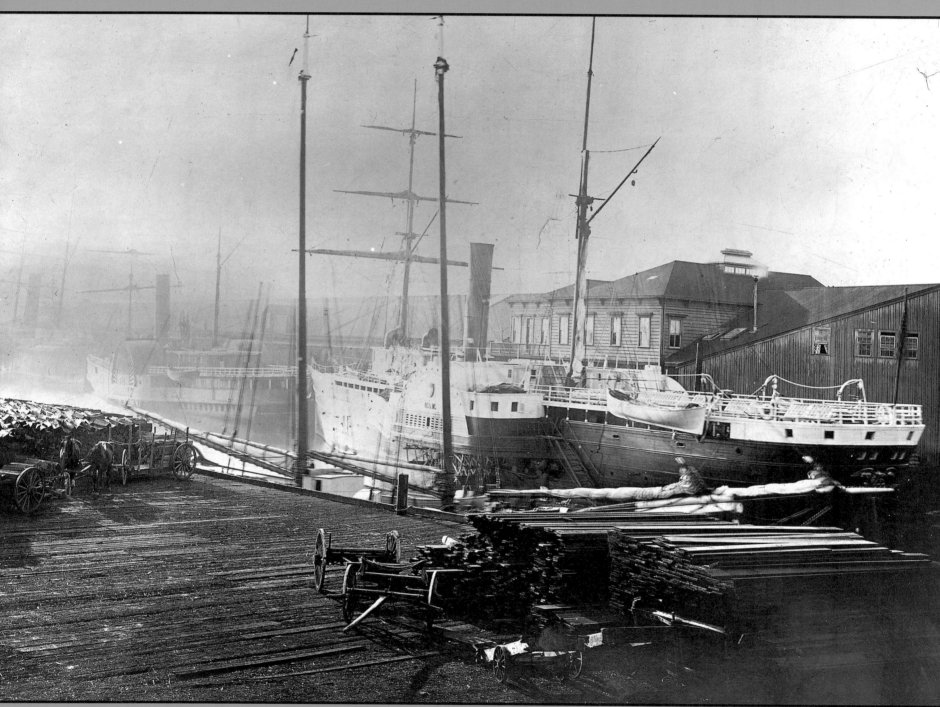

Pacific Mail Steamship Company's Panama docks, San Francisco, 1873. The SS California, right, was the first Pacific Mail steamship to enter San Francisco Bay. The paddle-wheel steamer Senator, left, was an early coastwise vessel operated out of San Francisco. She was built in 1846 for the run between Boston and Bangor, Maine, but came west during the gold rush. For several years she operated profitably between San Francisco and Sacramento as a river steamer then served under various steamship companies for decades more. She retired after thirty-two years service.

Pacific Voyagers

rior to the California gold rush there were several attempts to establish regular passenger and freight routes along the Pacific Coast. The great distances between settlements and the widely scattered, sparse population made regular service impractical, but that didn't deter ambitious traders. Coastal schooners carried local freight, lumber, furs, household goods and supplies, and occasional passengers. The Hudson's Bay Company steamer *Beaver* arrived on the Pacific Coast from England in 1836 and began service for the company on the Columbia River, and a few other small steamers were in operation a few years later.

The first passenger vessels appeared on the Pacific Coast at the time of the California gold rush. The Pacific Mail Steamship Company was founded in 1848 to carry mail and passengers between Panama and Astoria at the mouth of the Columbia River. The plan called for steamers to pick up mail and passengers transported across the isthmus from steamers on the New York to Panama run. After gold was discovered in California, the Pacific Mail steamers and anything that could float carried hordes of gold seekers from Panama City to San Francisco on a 3,245 mile "coastwise" run that was as arduous as any trans-oceanic voyage.

In the mad rush, coastwise passenger service between other ports was neglected. Starting in the early 1850s, the side-wheeler *Columbia* ran between San Francisco and Portland and the former steam tug *Goliah* established a regular run between San Francisco and San Diego, but other than that, the person anxious to travel along the Pacific Coast had few options.

Within three years of the discovery of gold, the Pacific Coast changed more than it had in the previous three centuries. Steamship companies were formed to fill the needs of a growing population. Their vessels were often well past their prime or ill-suited to Pacific conditions, and as a consequence there were an inordinate number of maritime sinkings and boiler explosions with a shocking loss of life.

By the 1860s Pacific Coast shipping was controlled by a handful of men who engaged in rate wars and cut-throat competition. Coastwise travel became affordable to many who would otherwise never make a sea voyage. As business expanded, new larger steamships were introduced and coastwise service became faster and relatively safer. Eventually, the railroads got into the steamship business to fill gaps in their rail systems, and coastwise maritime travel reached a peak of efficiency. In the twentieth century, railway express trains cut heavily into the steamship lines' bread-and-butter runs between San Francisco and Portland and Los Angeles, and the number of vessels in the coastwise trade grew smaller. Finally, private cars and trucks brought an end to the coastwise steamers.

When the Pacific Mail Steamship Company began operations in the late 1840s, there was no regular steamship service from the Pacific Coast to the Far East. There was little trans-Pacific commerce, and the idea of trans-Pacific travel for pleasure was non-existent. There was, however, impetus to extend American mail service to China. In 1865, with a trans-Pacific mail contract, the Pacific Mail Steamship Company began a decade of expansion. The company built four new wooden paddle-wheel steamers, the largest ever built, and began regular monthly runs between San Francisco and Hawaii, Yokohama, and Hong Kong.

In the 1870s, other steamships gave Pacific Mail competition, including Japanese-flagged vessels of the Toyo Kisen Kaisha and Nippon Yusen Kaisha. The Spreckels sugar interests founded the Oceanic Steamship Company to provide regular service to Hawaii in 1882, and by 1900 there was regular freight and passenger steamship service to the Atlantic Coast via the Strait of Magellan. In the early twentieth century other American steamship lines entered the freight and passenger competition to the Orient, Australia, and New Zealand. The 1920s and 1930s, before the advent of air travel across the Pacific, proved to be the high-water mark of trans-Pacific steamship travel.

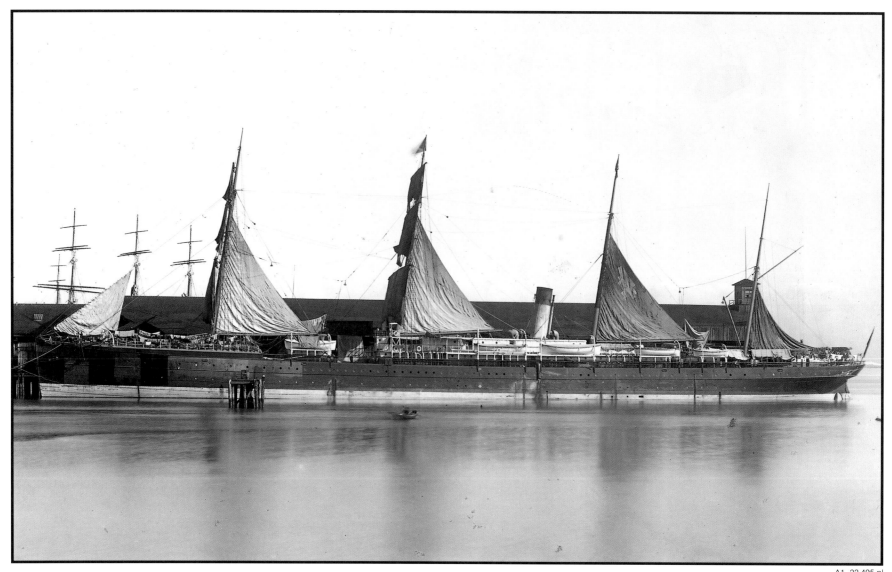

Few photographs show ships in the transition period between sail and steam with a full suit of sails on display. In this rare shot, the White Star liner SS Oceanic, under charter to the Occidental and Oriental Steamship Company, dries her sails in San Francisco around 1875. Built in 1870 in Liverpool, Oceanic was intended for the Atlantic run of the Oceanic Steam Navigation Company, better known as the White Star Line. In 1875 she went to the Pacific via Suez and served on the Hong Kong, Yokohama, San Francisco run.

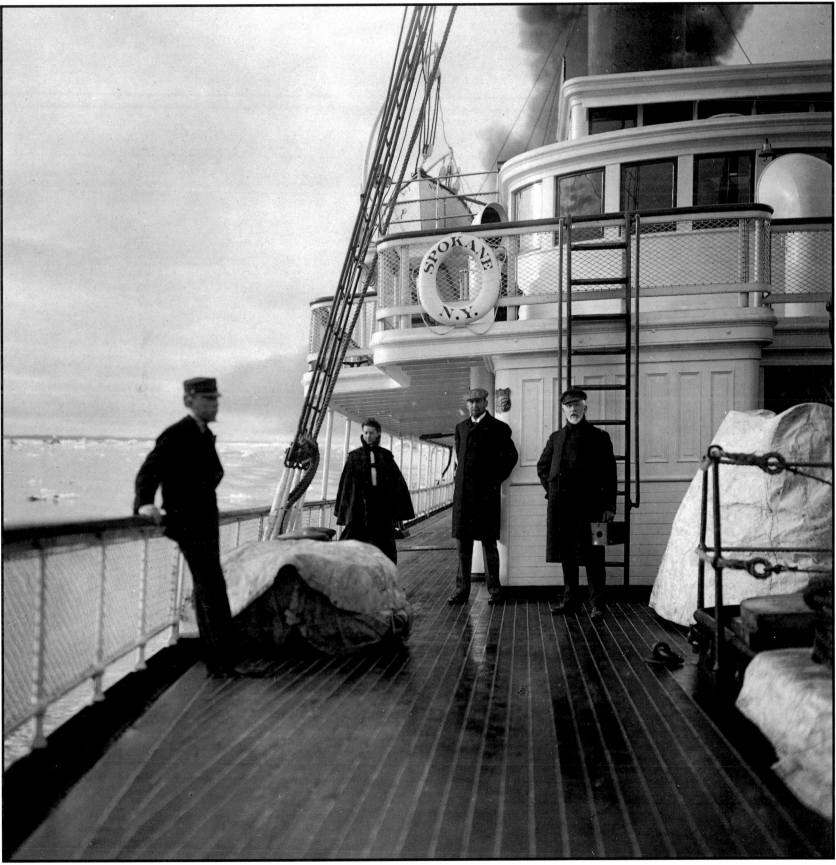

F9. 2908 pl

*Passengers and crewman aboard the Pacific Coast Steamship
Company's steamship Spokane at Funter Bay, Alaska, in June 1905.
Summer excursions on the "inside" passage to the wild Alaska shores after
the Yukon gold rush were the beginnings of the cruise ship business on the
Pacific Coast. Courtesy Society of California Pioneers.*

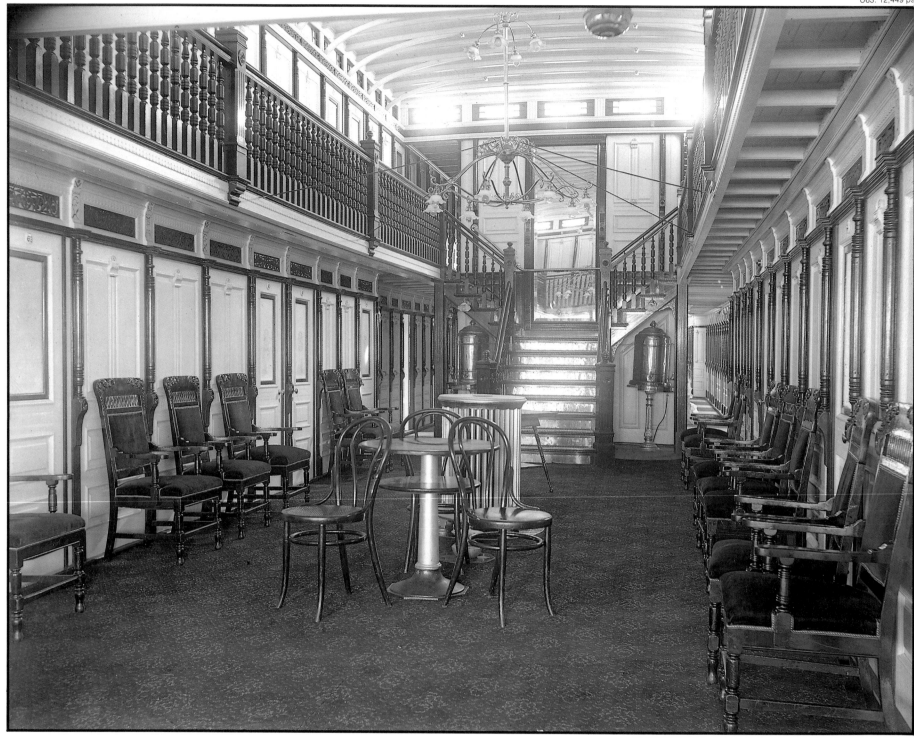

Above: SS City of Seattle, forward social hall, by Wilhelm Hester. This photo, and the one opposite, may have been taken in 1905 when the City of Seattle lost her propeller and was docked for repairs. The graceful steamer was typical of coastal liners at the turn of the century, with passenger accommodations that provided comfort if not luxury. Many of the Puget Sound and Alaska steamers were pressed into service during the Alaska gold rush from 1898 to 1900, when thousands of gold-seekers were desperate for transportation.

Facing page: Passenger cabin aboard City of Seattle, by Hester. Built for the Puget Sound & Alaska Steamship Company at Philadelphia in 1890, the City of Seattle had a long career in the Southeast Alaska trade for Dodwell & Company and the Pacific Steamship Company. She returned east in 1921 and steamed out of Miami until the late 1930s.

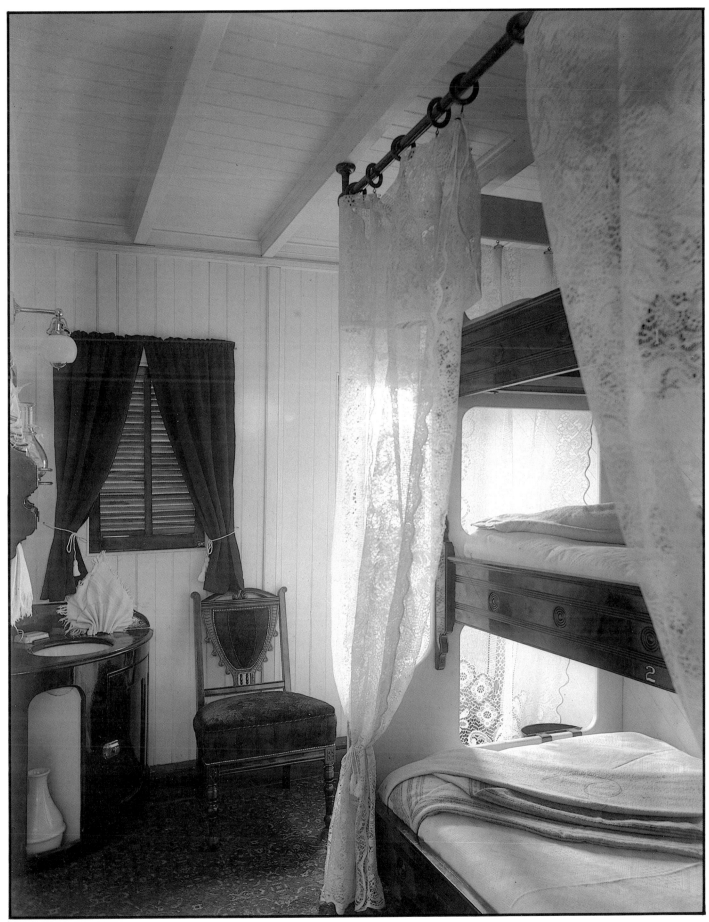

U63. 12,487 psl

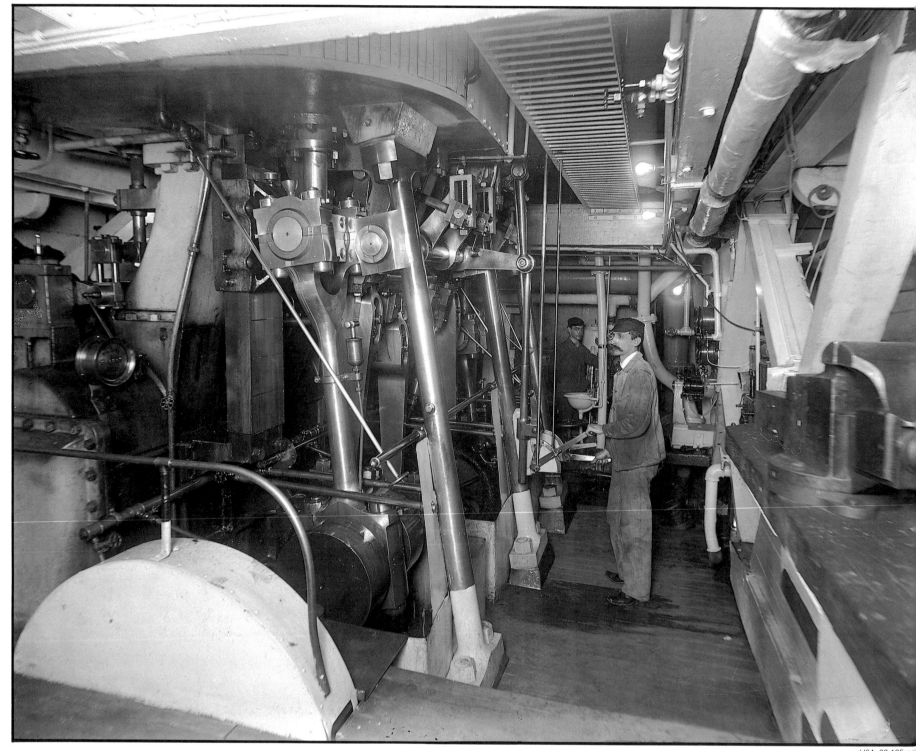

SS Flyer engine room, c. 1900. *The engine rooms of coastal steamers were as meticulously maintained as the dining saloons. The fast little steamer Flyer was built at Portland, Oregon, in 1891 and made four daily round-trips between Seattle and Tacoma for the Columbia River and Puget Sound Navigation Company. She became known throughout Puget Sound for her reliability and punctuality until her retirement from the run in 1911. Renamed the* Washington *by her new owners, the Black Ball Line, she served for another decade and was scrapped in 1929.*

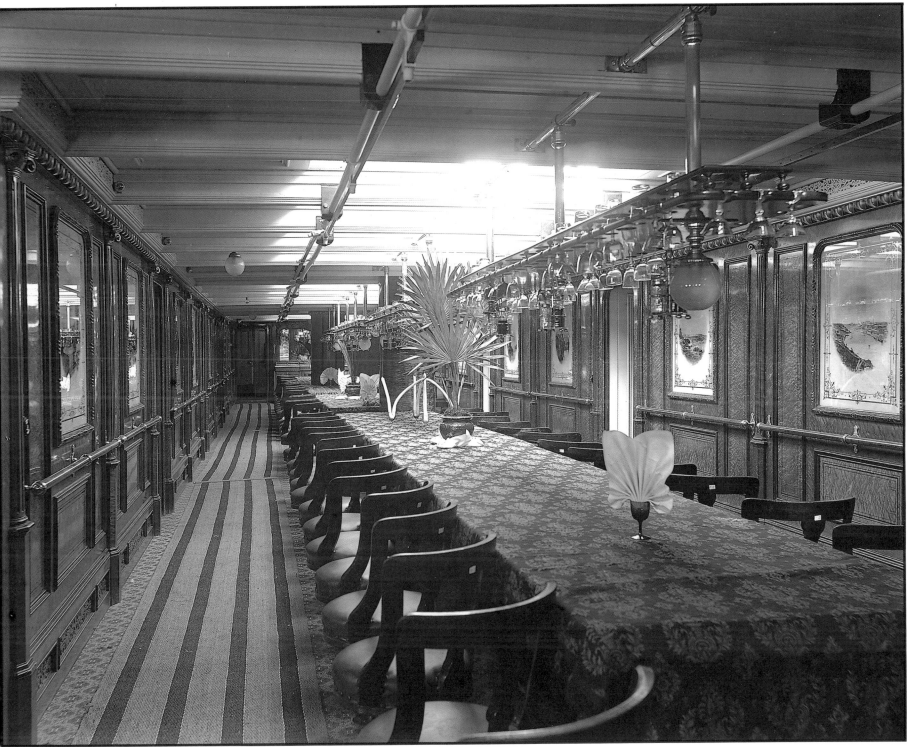

The dining saloon of the British steamer Garonne, resplendent with polished wood paneling and etched glass. Hester made this photograph when the visiting steamer participated in the gold rush out of Puget Sound. She was built in 1871 and was one of the first refrigerated vessels in the British merchant marine. Like several other steamers after the Alaska gold rush, Garonne went to Manchuria in 1905 to run the Japanese blockade of Port Arthur during the Russo-Japanese War.

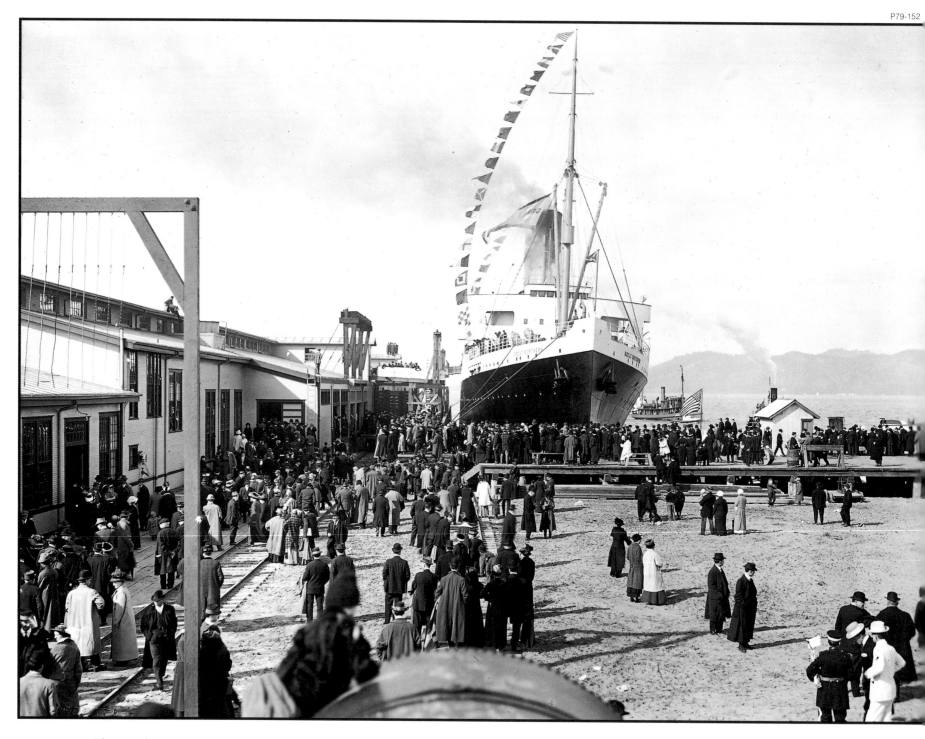

Photographers were on hand when the SS Great Northern arrived at Flavel, Oregon at the mouth of the Columbia on April 21, 1915. The Great Northern Railroad steamer had just completed her inaugural run from San Francisco. When rail tycoon James Hill ran into difficulty trying to extend his transcontinental tracks south from Portland to San Francisco, he ordered two ships, the Great Northern and the Northern Pacific, for his Great Northern Pacific Steamship Company to compete with express trains on the route. The Great Northern made the trip in twenty-four hours, four hours faster than the express train. She soon became a Pacific Coast favorite.

During World War I she saw service on the Atlantic as the troopship Columbia, and in 1922 she returned to the Pacific Coast as the H.F. Alexander of the Pacific Steamship Company and made speedy runs between San Francisco and Seattle. To make ends meet during the depression, the company ran the H.F. Alexander in winters between New York and Florida. The ship was retired in 1936, but she had one more job to perform as the troopship General George S. Simonds during World War II.

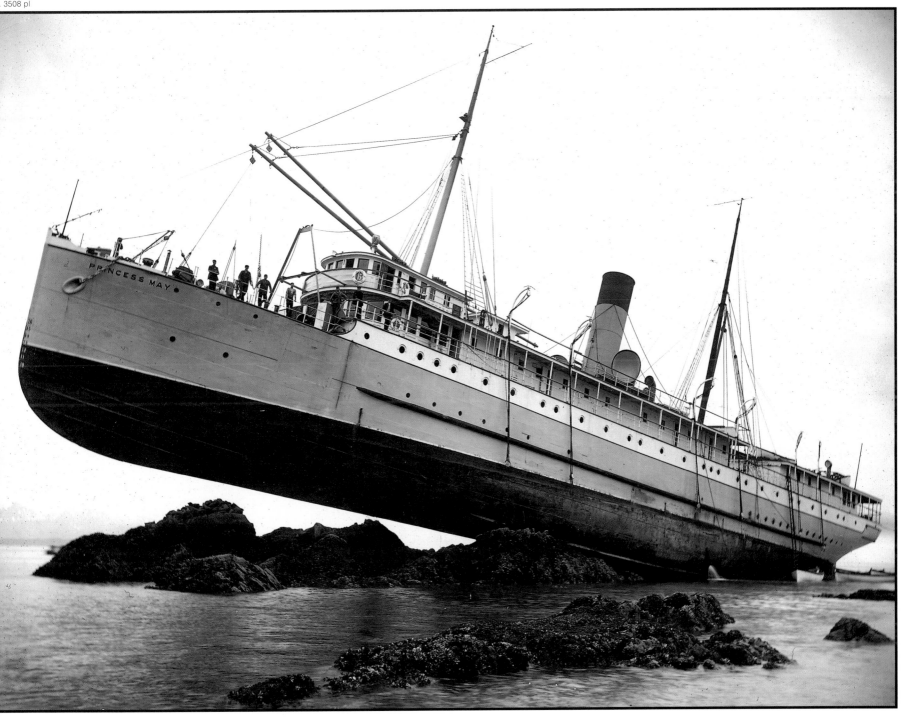

Princess May *aground on Sentinel Island, Alaska. After 1900, Pacific Coast shipwrecks became less common as navigational aids improved. Still, there were dramatic and terrifying collisions, fires, groundings, and sinkings. Photographer W. H. Case was one of several photographers who recorded this spectacular grounding of the Princess May of the Canadian Pacific fleet on August 5, 1910. She ran aground at high tide and settled in this precarious position as the tide ebbed. Her passengers were safely evacuated and the ship successfully refloated. This photo appeared on postcards and in magazines and newspapers and is one of the most widely reproduced maritime photographs.*

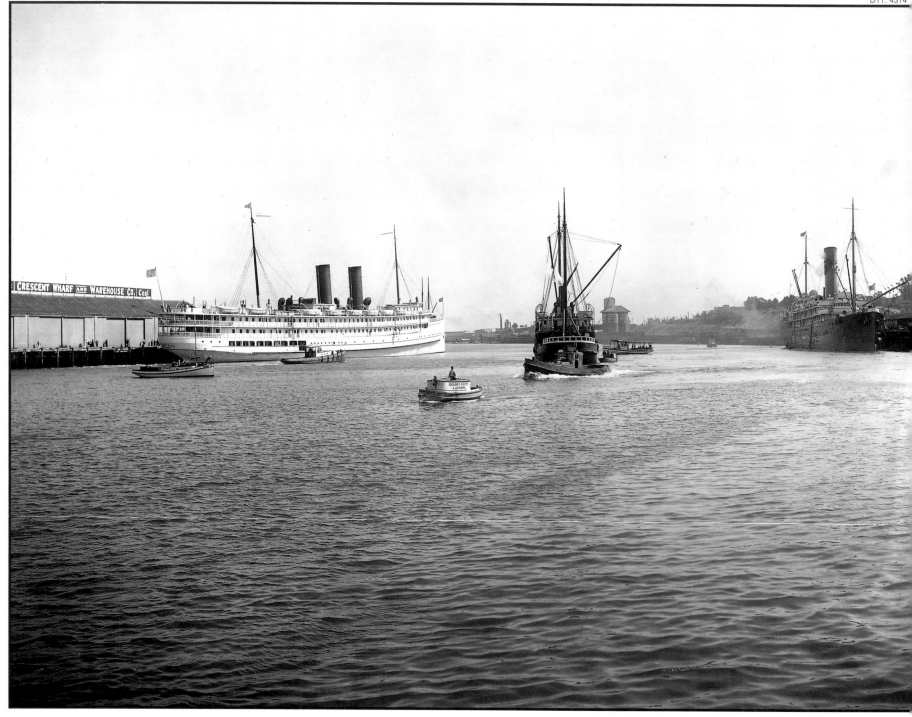

The Los Angeles Steamship Company's Harvard, on the left, rests at her Terminal Island wharf in the Port of Los Angeles in the late 1920s. The Golden State Laundry launch Golden State is at center and the steamer Acme is in the channel with an unidentified tug crossing her stern. The ferry launch Real heads across channel to Terminal Island and on the right is the steamer Roanoke. With her sister ship Yale, the sleek steam turbine Harvard made regular bi-weekly round trips from San Francisco's Pacific Street wharf. They were launched in 1907 in Philadelphia for the express run between Cape Cod and New York and came west in 1910 after the New Haven Railroad gave them competition.

During World War I the two ships ferried troops between England and France before returning to their regular Los Angeles-San Francisco run. The ships were fast and reliable, but they were also notorious for pitching and twisting their way through the Pacific swells and creating widespread mal de mer among the passengers. The Harvard was wrecked in 1931 and the Yale retired in 1936, but they left behind vivid memories for many travelers.

Pacific Mail Line steamer Korea, San Francisco. By 1900 trans-Pacific passenger service had come of age. The couple in the foreground had a choice of ships on which to cross the Pacific and a choice of destinations. They could have boarded the SS Korea or one of six other Pacific Mail ships. They might have chosen one of the Canadian Pacific Railway Empress liners out of Vancouver or one of the Occidental & Oriental Steamship Company's chartered White Star liners from England. After 1903 they could have sailed on the Great Northern Railway's new SS Minnesota or SS Dakota, the largest American built ships at that time. If they had waited until 1908, they might have chosen to sail with Captain Matson's new passenger service to Hawaii or on one of the new Japanese passenger vessels.

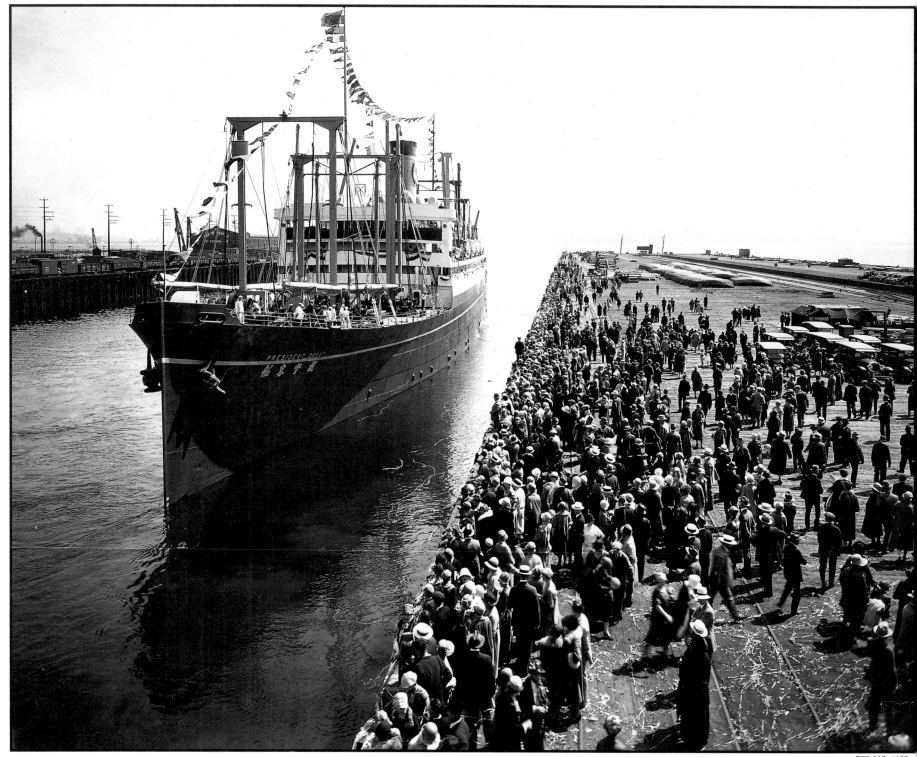

SS President Grant, *one of ten World War I Emergency Fleet vessels operated by Robert Dollar, departing on her maiden voyage to Asia for Dollar's Admiral Oriental Line from Seattle, 1921. In 1923, Dollar purchased the ships, which were named for U.S. presidents, and the Dollar Steamship Line began round-the-world passenger service the following year. The Dollar Line was superceded by American President Lines in 1939, which continued the practice of naming ships for American presidents.*

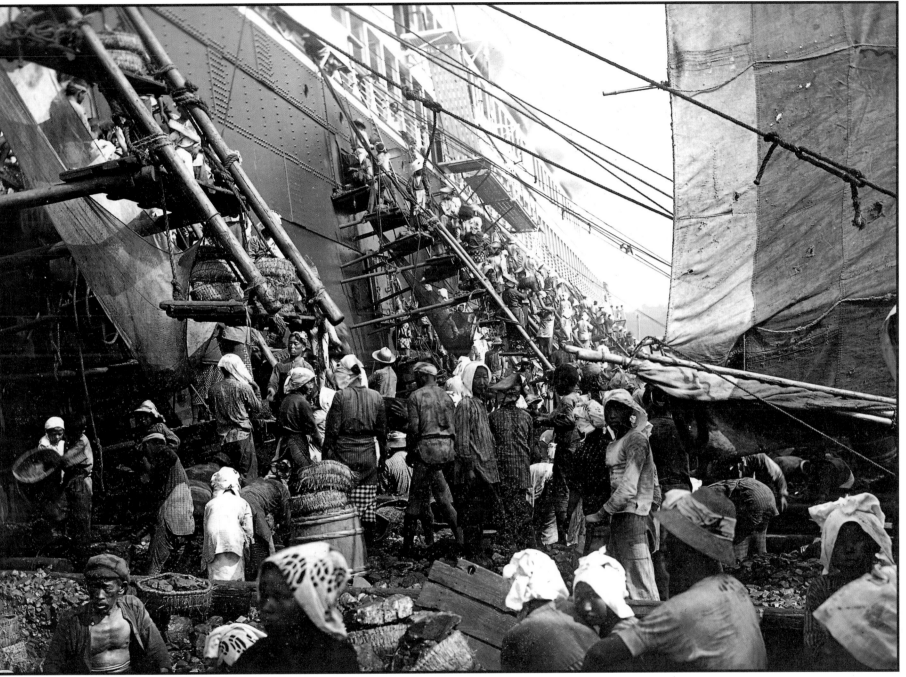

Coaling ship, SS Shinyo Maru, Toyo Kisen Kaishi lines, c.1915. This photo by S.S. Marshall in Nagasaki, Japan, of men and women coaling a ship by human elevator from a lighter alongside illustrates a scene repeated in many world ports in the nineteenth century and well into the twentieth century. Very few seaports outside Europe and America had mechanized coaling facilities. Nagasaki was a major Asian coaling port, yet not only was coal bunkered by hand, cargo was unloaded the same way.

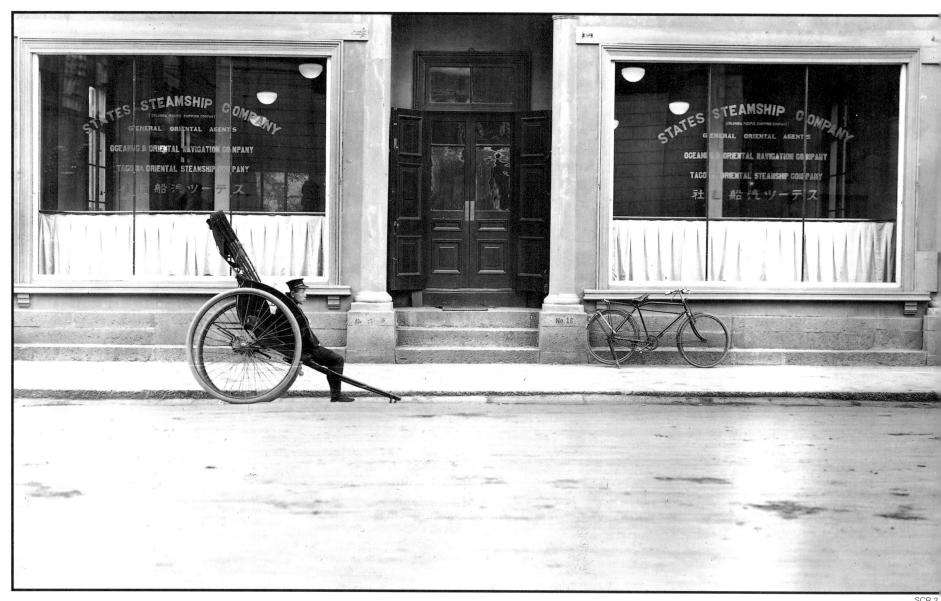

The States Steamship Company office in Kobe, Japan, served as
general agents for the Oceanic & Oriental Steamship Company, a joint
venture between Matson Navigation Company and American-Hawaiian
Steamship Company to operate twenty-one freighters from the Shipping
Board. American steamship company offices in foreign ports provided mail
and banking services for visiting Americans throughout the 1920s and 1930s.

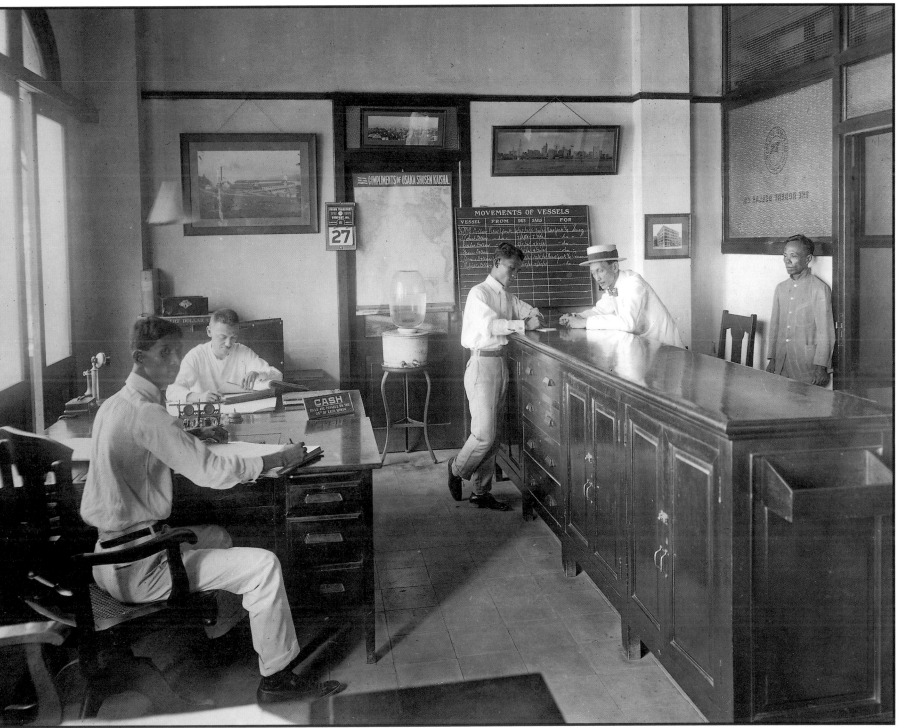

Photographer Gerald Thompson took this publicity photo of the Manila office of the Dollar Steamship Line in 1921. It was part of a series on the company's far-flung operations. The history of Pacific Coast steamship companies is convoluted with mergers, acquisitions, and name changes. Vessels were sold and acquired and renamed so that the sea-going public often had difficulty keeping track of their favorite ships.

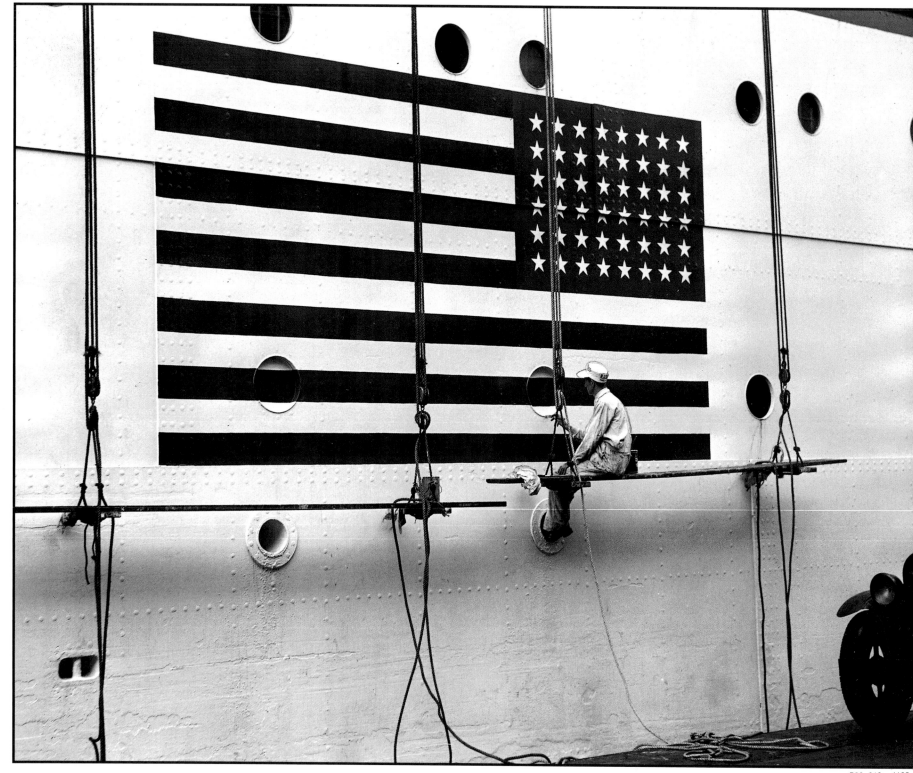

The Matson liner SS Monterey receives her neutrality flags in September 1939. Huge American flags were painted fore and aft on each side and on the deck on U.S. merchant vessels after World War II broke out as protection against German submarines. America was officially neutral in the "European" war until 1941, and the idea was that a German submarine would be kind enough to identify a ship before firing its torpedoes.

Matson liners, Bethlehem Shipbuilding Corporation, San Francisco, 1947. After America's entry into World War II following the Japanese attack on Pearl Harbor, most serviceable passenger vessels became troop transports. The neutrality flags were obliterated, while the gleaming white paint, varnish, and polished brass received a uniform coat of gray paint. Here, the Matson liners SS Mariposa, left, and SS Monterey await restoration of their pre-war livery.

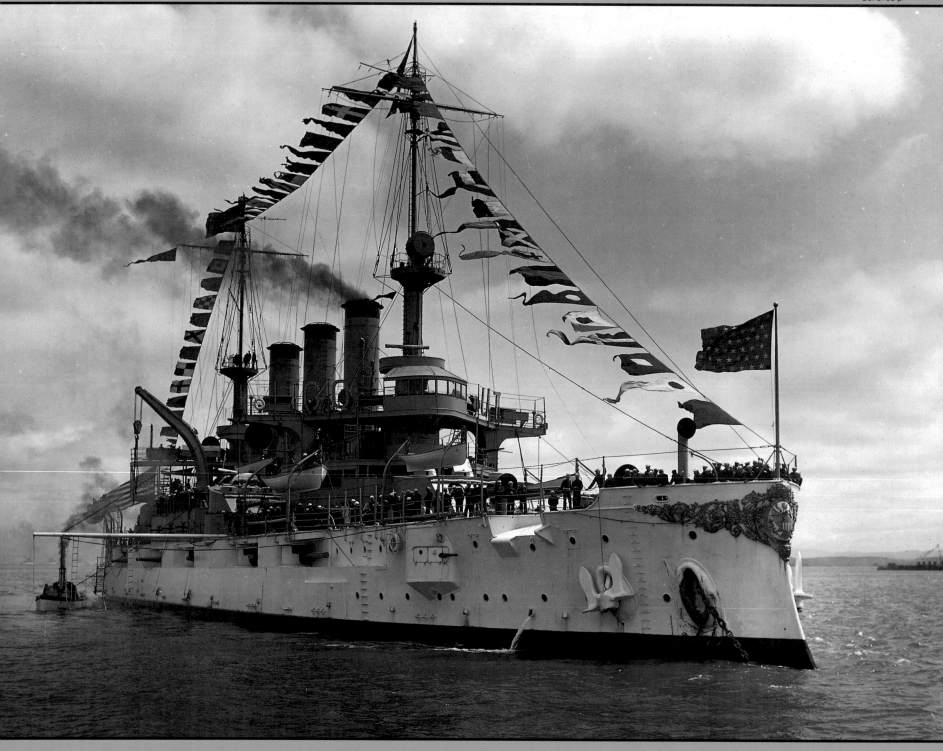

Battleship USS Connecticut, San Francisco Bay, flagship of the American fleet that anchored in San Francisco Bay, May 6, 1908. The unknown photographer carefully noted that this picture was taken at 1:45 P.M., less than two hours after the Connecticut had led a procession of fifteen battleships and dozens of other Navy vessels through the Golden Gate. The ships stopped at San Francisco on their 14,000 mile journey around the globe five months after departing Hampton Roads, Virginia, and after successfully negotiating Cape Horn. Pacific Coast seaports eagerly awaited the fleet and competed with one another in bestowing honors and throwing parties.

The Grand Fleet, as it was called by the press, was the largest armada ever seen on the Pacific Coast until then, and the last to wear the traditional color scheme of brilliant white hulls and buff upper works with gilt bow decorations. Even on this diplomatic voyage, the battleships' paint lockers were filled with grey paint in the event of an outbreak of war somewhere along the way.

Uncle Sam's Navy

The United States Navy's presence on the Pacific Coast dates from 1813, when the 32-gun frigate *Essex* rounded Cape Horn and sailed north to protect American whalers and attempt to destroy the British whaling fleet off the Galapagos Islands. Five years later, the second American naval vessel to visit the Pacific, the sloop of war *Ontario*, rounded Cape Horn. Her mission was to establish American sovereignty in the Columbia River region, which had been claimed also by Great Britain. Her commander, Captain James Biddle, spent most of his cruise showing the flag for American interests in South America. His experiences and the clear need for protection of American vessels on the high seas resulted in the creation of the Pacific Squadron in 1821. Within a few years American trade in Asian waters required additional naval support, and in 1832 the East India Squadron was formed.

As imposing as those names sound, the squadrons actually consisted of a handful of ships, some relics from the War of 1812. Their presence did more to establish and reinforce American claims in Oregon and the Sandwich Islands than to protect individual merchantmen from pirates or thieves ashore. By 1845 Commodore Lawrence Kearny of the East India Squadron had gained trade concessions from the Chinese, and a treaty between the United States and China followed that lasted until the rise of Mao Tse-Tung. The U.S. Navy maintained ships on "China Station" during that span of time.

The Pacific Squadron under the command of Commodore John D. Sloat, with fewer than a dozen ships, succeeded in taking and holding the California coast during the war with Mexico in 1846. Fortunately for Sloat, there was no Mexican navy with which to do battle. The most difficult task for the Pacific Squadron was assisting Colonel Richard Barnes Mason, the senior American army officer on the Pacific Coast, in maintaining a semblance of order in the new possession. Small garrisons at Monterey and San Francisco and, at one point, just four ships were all that protected the American Pacific Coast from any nation that had designs on it. The California gold rush put a particular strain on commanders of the Pacific Squadron, whose crews tended to desert and head for the goldfields.

In the years before the Civil War, Pacific ports were still remote outposts for the U.S. Navy. Fort Point was built near the old presidio in San Francisco, and Alcatraz Island was heavily fortified, but other than the potential danger of Confederate raiding vessels, the war between North and South was a world away. It was not until the outbreak of the Spanish-American War in 1898 that Pacific ports played a strategic role beyond that of refueling and supply stops. Naval expansion continued after the war for the next twenty years, and in 1919 a reorganized Pacific Fleet was established on the Pacific Coast. San Diego, Alameda, San Pedro, San Francisco Bay, and Puget Sound became home ports to ships of the fleet.

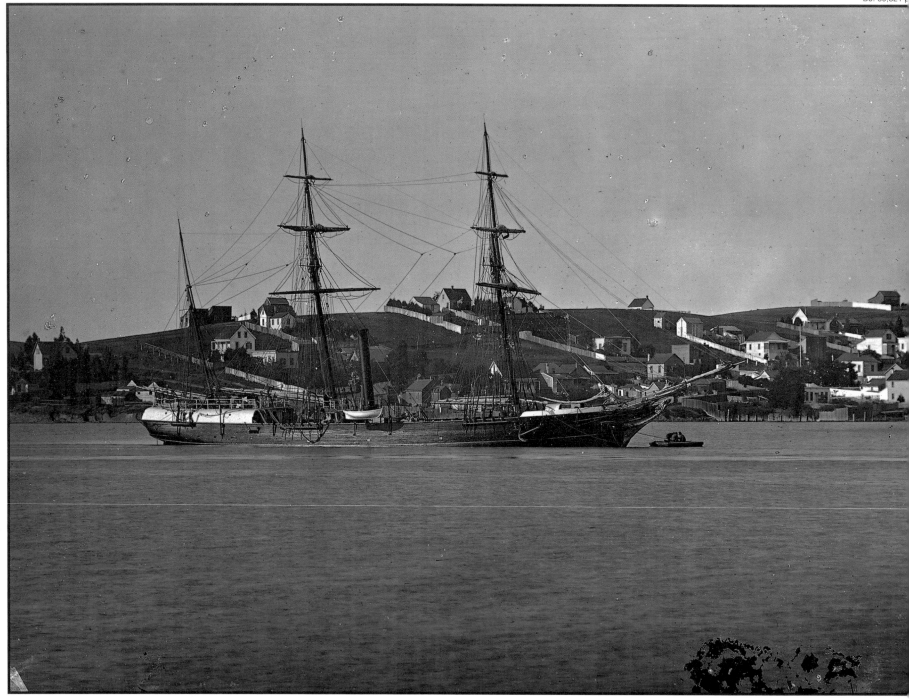

Above: A rare wet-plate photograph shows the steam bark Jeanette *anchored off Mare Island Navy Yard in the fall of 1876. Although privately owned, the Jeanette was commissioned by the U.S. Navy to carry a team, led by Lt. George Washington DeLong, to the North Pole via the Bering Strait. The vessel, which had been used for polar exploration previously, was strengthened and fitted out with the latest equipment for the expedition.*

Jeanette *departed San Francisco on July 8, 1879, and eight weeks later she became trapped in pack ice and drifted northward for twenty-one months. Pressure from the ice finally crushed her hull and she was abandoned by Lt. DeLong and his crew. Dragging Jeanette's boats over the ice, the men attempted to reach open water. One boat, commanded by Chief Engineer George*

Melville, did finally reach safety in Siberia; another was lost at sea; and DeLong's boat met disaster on the frozen tundra. One by one his men died of starvation and cold, and ultimately Lt. DeLong perished as well. In 1881, his body and the log book of the Jeanette *were found.*

Facing page: The US Revenue Cutter Bear *with her officers and men, Oakland, 1917. The* Bear, *a sturdy little steam bark built in 1873, served the United States faithfully for over sixty years and was one of the best known vessels to three generations of seafaring men. Built in Scotland as a sealer for private owners, she had a reinforced prow, massive oak beams, and was*

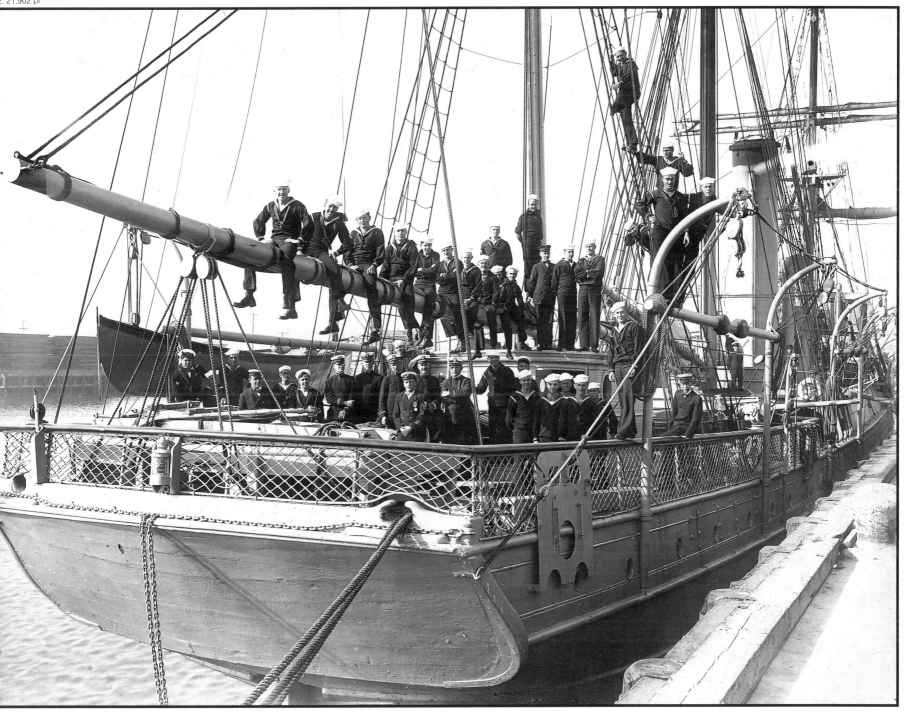

sheathed with Australian ironbark. After ten years as a seal hunter off New-foundland, she was purchased by the U.S. Navy for Arctic service. In 1884, the Bear located survivors of the ill-fated Greely expedition, which had been stranded in the Arctic wilderness. She was then declared unfit for further service by the Navy and transferred to the Revenue-Cutter Service.

For the next forty years her home port was San Francisco Bay, while she continued her Arctic voyages. She carried mail to remote regions, provided medical service to Alaska natives and served as both courtroom and jail in the Revenue Marine's efforts to maintain law and order in the Arctic.

She was commissioned again by the U.S. Navy for service in World War I, twenty years after she had been declared unfit. After more years of service with

the Coast Guard, she was turned over to the city of Oakland as a floating museum. But her active service was far from over. She accompanied Admiral Richard E. Byrd on his Antarctic expedition in the early 1930s and again in 1939. This time she was refitted with modern diesel equipment to replace her ancient steam engine and boiler.

The Bear again joined the Coast Guard for active duty in World War II. On Greenland Patrol she participated in the capture of a Norwegian vessel used by the Germans as a spy ship. After the war she was sold and laid up in Nova Scotia until 1963. Then she was sold again and was to become a museum ship once more—and a floating restaurant. Apparently the indignity was too much for the old adventurer: she capsized while under tow and sank.

123

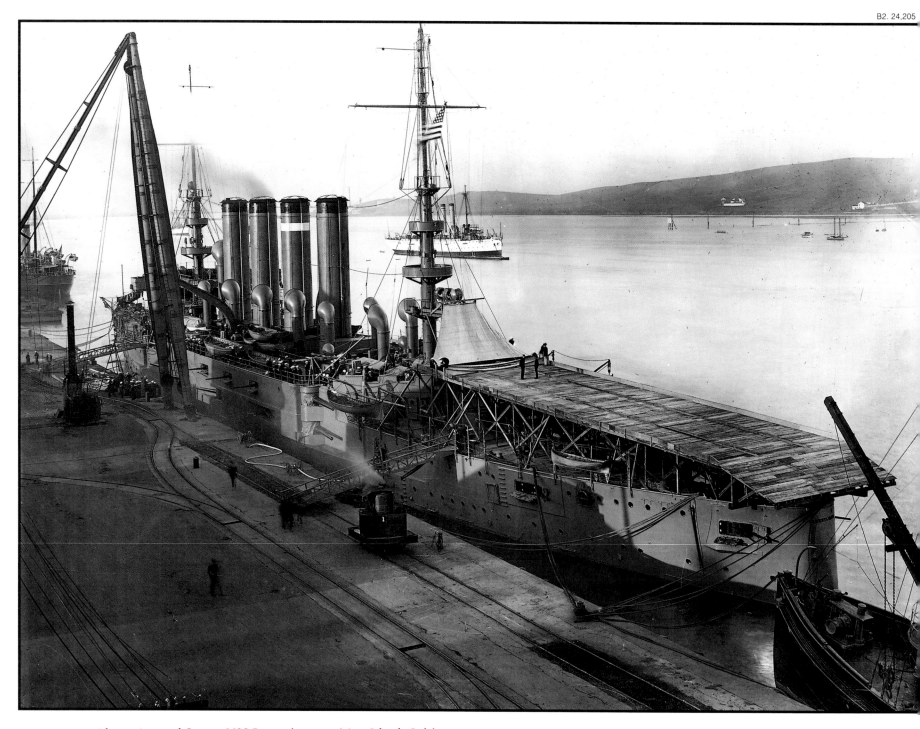

Above: Armored Cruiser USS Pennsylvania at Mare Island, California, 1911. The slanting flight deck atop the after 8-inch gun turrets was built for a daring aviation experiment. Despite obvious hazards and the shortcoming of flimsy aircraft of the day, a Curtiss "pusher" airplane was successfully launched in 1910 from the decked-over bow of the cruiser Birmingham anchored in Hampton Roads, Virginia. Two months later, in January 1911, the same aircraft and the same pilot, Eugene B. Ely, took off from San Francisco and landed safely on the deck built on the Pennsylvania as the cruiser lay anchored in San Francisco Bay. Ely's airplane was then turned around, and using the down slope of the flight deck to his advantage, Ely made a successful take off from the cruiser.

Facing page: Mexican gunboat Zaragoza, right, in dry dock, Union Iron Works, San Francisco, c.1900. It is difficult to believe that only twelve years separate the launch of Zaragoza and that of the armored cruiser USS Pennsylvania, shown above. Obvious differences between the two vessels indicate the rapid evolution of naval strategy and tactics in the two decades preceding World War I. When Zaragoza was built in England in 1891 she represented the latest thinking in fleet support. Within a few years her two 4 inch guns and her full suit of sails and fifteen knot speed left her hopelessly obsolete. By 1911, the surviving older types looked like harmless relics from a Gilbert and Sullivan opera.

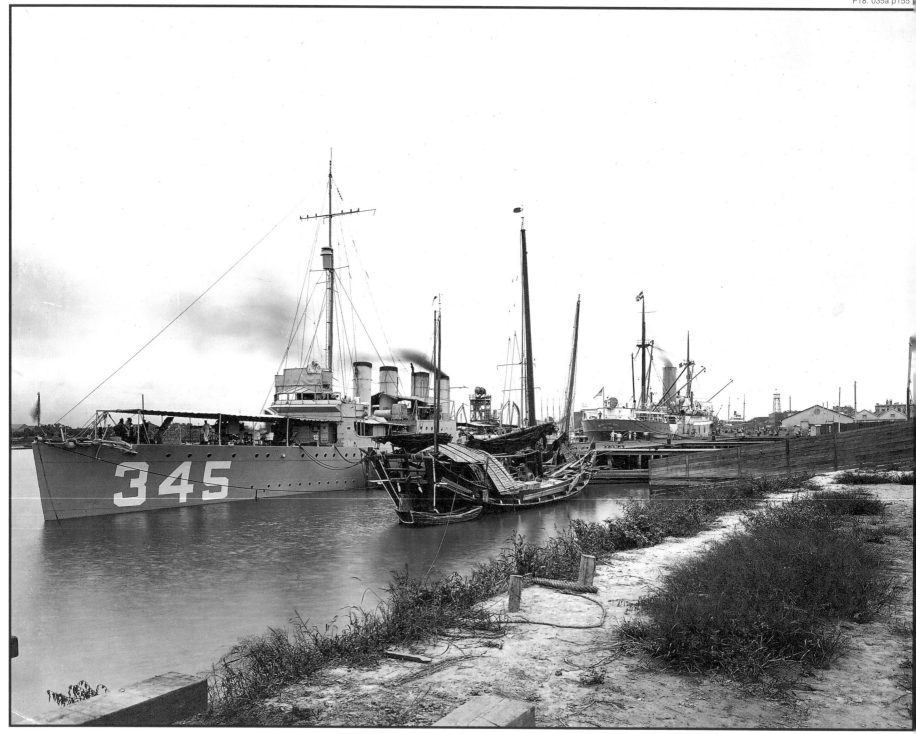

Destroyer USS Preble *alongside the Dollar Pai Lien Chien Wharf, Shanghai, 1924, to protect American property. Abaft of the* Preble *lies the steamer Bessemer City out of New York. Throughout the 1920s and early 1930s the ubiquitous "four piper" destroyers were symbols of American naval presence in Asian waters, the Caribbean, Mediterranean and along the Atlantic Coast. They provided practical sea experience for an entire generation of fledgling naval officers, many of whom became flag officers during World War II. On the eve of that war, many of the old destroyers had been decommissioned and some had been converted to mine layers. Forty of them were sent to Great Britain as part of the Lend-Lease Program, where they were refurbished and served the Royal Navy during the critical early years of the war in the Atlantic.*

126

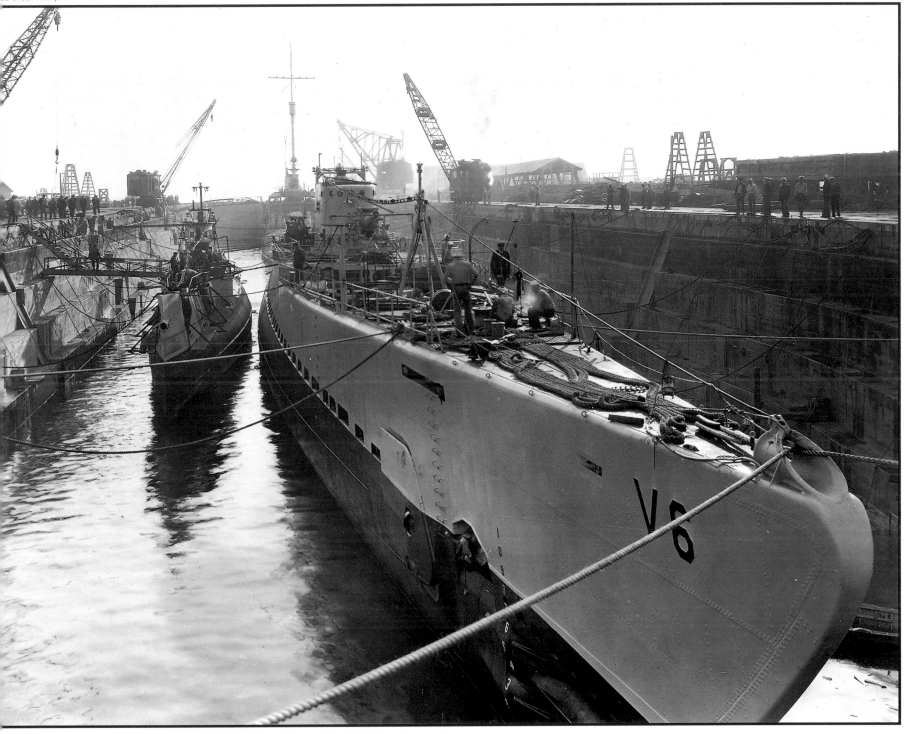

The submarine USS Nautilus in the graving dock, Mare Island Navy Yard, San Francisco Bay, 1930. Photo taken shortly after launch, when she was still carrying her original name, V-6. Comparison between the 371 foot long Nautilus and the small R-Class sub of 1918 at her side illustrates the growing importance of the submarine during the 1920s. German U-boats in World War I clearly demonstrated to the world the destructive potential of submarine warfare. Their development changed strategic thinking in every modern navy. Nautilus operated out of New London until she was reassigned to San Diego in 1931. In 1938 she joined the fleet at Pearl Harbor. During World War II she sank six ships and completed fourteen patrols in the Pacific war zone. She was decommissioned and scrapped in 1945.

Although there are other Pacific Coast navy bases and drydock facilities at Hawaii, San Diego, on San Francisco Bay, and on Puget Sound, the Mare Island Navy Yard has the longest and most colorful history. It began when the United States Government purchased Mare Island upon the recommendation of Commodore John Sloat, who had raised the American flag at Monterey in 1848. In 1853 a floating dry dock was shipped disassembled around Cape Horn and reassembled at Mare Island under the supervision of Commander David Farragut. By 1854 the navy yard with its dry dock was in operation, serving the Navy's needs for the entire Pacific Coast.

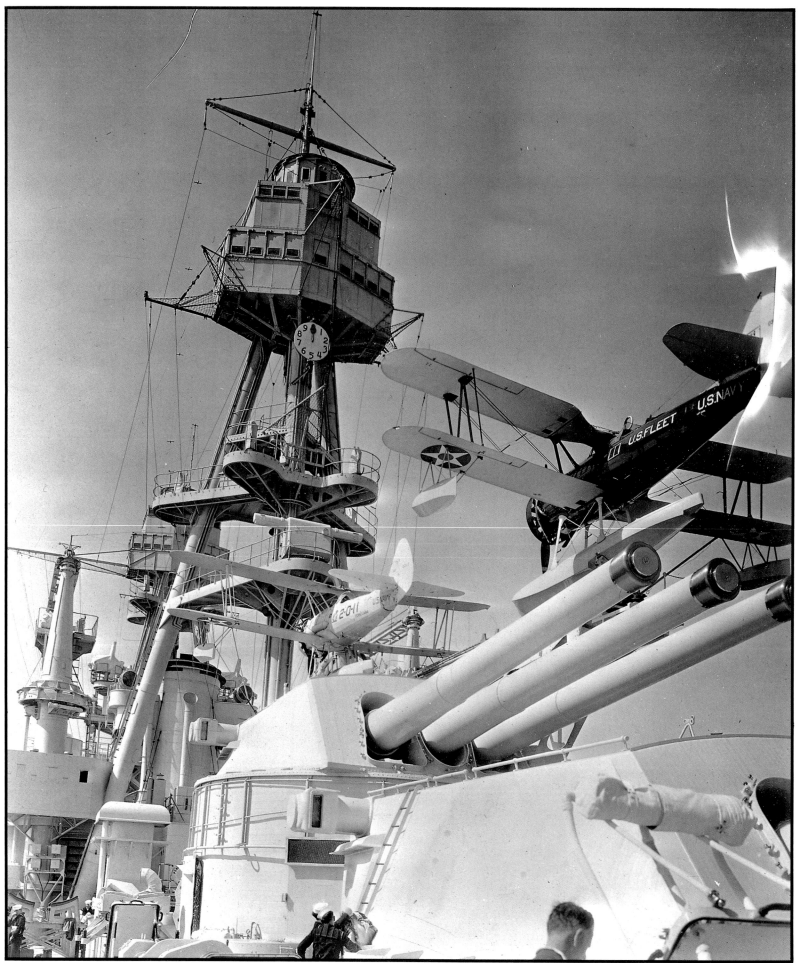

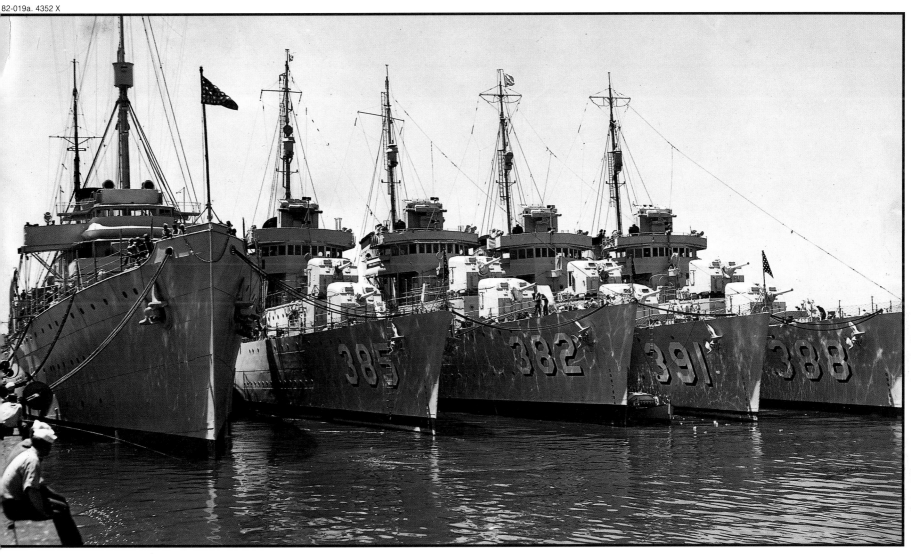

Facing page: View from the quarterdeck, flagship USS Pennsylvania at San Pedro, 1937. Launched in 1915, the big battleship represented the big-gun naval strategy of the period and was considered quite formidable. By the mid-1930s the battleships' vulnerability to air attack resulted in major modifications to capital ships of her type. Among other changes, Pennsylvania received scout aircraft mounted on catapults on the quarterdeck and atop one of the after gun turrets.

Pennsylvania served during World War II and took part in the A-bomb tests off Bikini Atoll in 1946 as a stationary un-manned target. Her contaminated hulk was scuttled in 1948.

Above: Destroyer tender USS Melville, on the left, with her brood of destroyers at San Diego, 1939. Melville was named in honor of Chief Engineer George Melville, hero of the Jeanette Arctic disaster (Page 122). The destroyers are USS Fanning (DD 385), USS Craven (DD 382) of Destroyer Squadron Six, and USS Henley (DD 391), and USS Helm (DD 388) of Destroyer Squadron Four. All were part of the Battle Force, U.S. Fleet and are shown assembled at San Diego in preparation for assignment at Pearl Harbor. All four served with distinction during World War II.

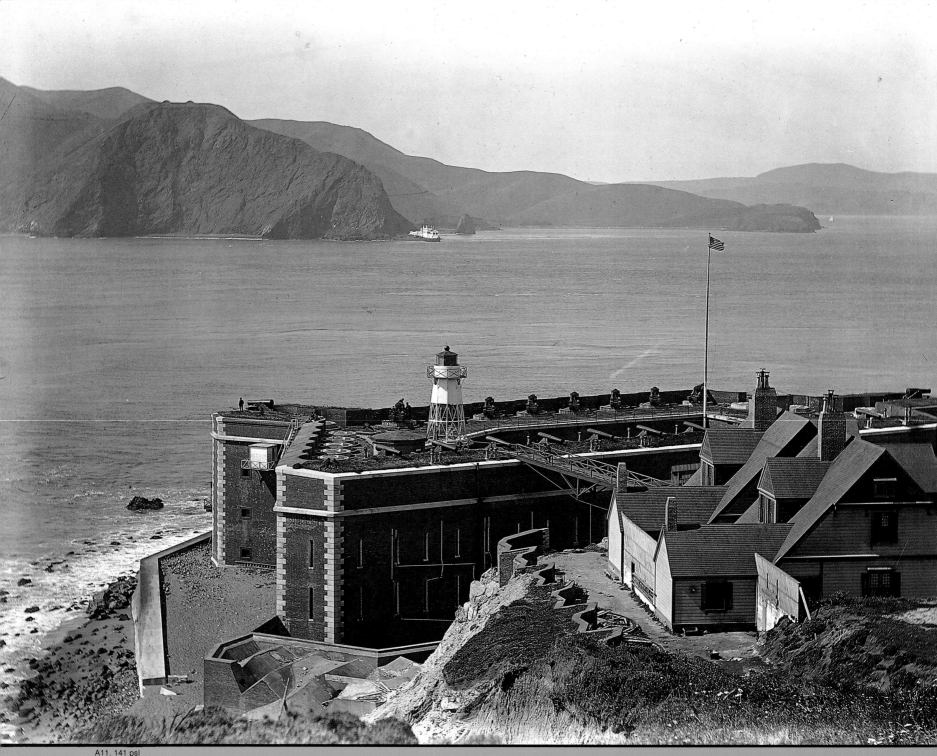

The Golden Gate from Fort Point, c. 1896.

Inside the Golden Gate

For almost a century San Francisco Bay was the vortex of the Pacific Coast and is the setting for a large part of historic Pacific Coast maritime photography. The Bay was a well-spring of maritime activity, and photographers were drawn to it like moths to a flame. As a result, the photo-documentation of San Francisco Bay Area is extensive. Among the photographs are many that are mundane and simply documentary. But a surprising number are timeless and exquisite. Perhaps that is understandable, given the natural beauty of the Bay itself.

Anyone who has stood on the headlands overlooking the Golden Gate and San Francisco Bay has seen one of the truly inspirational sights of the hemisphere. Irresistible to poets, painters and photographers, the Golden Gate, before and after construction of the bridge spanning it, has generated more words and pictures than almost any union of land and sea in the world. For seafarers, the Golden Gate has been both beginning and ending for long careers at sea. For generations of sailors it has been a symbol, the first or last glimpse of home.

The city by the Gate, San Francisco, has lived up to its early expectations. It has seen a century of superlatives. As other metropolitan areas on the Pacific Coast—Los Angeles, Seattle, San Diego—have matched and even surpassed San Francisco in size or commercial volume, San Francisco today seems sedate compared to the days of its rambunctious adolescence. But its spirit, undaunted by fire and earthquake, is intact. There is

something irresistible about The City and the broad expanse of bay inside the Gate when seen from the Marin Headlands. Maybe it's just the scale of the place, or the constantly changing, spectacular lighting, that makes it special. But from that vantage point overlooking the Bay, the sense of adventure and challenge that the first seafarers experienced on entering the Golden Gate for the first time is still palpable.

For commercial maritime photographers, San Francisco Bay has been a source of income as well as of inspiration. Ships from every maritime center of the world gathered there and ships of almost every type were built there. Opportunities abounded for good commercial documentation, from ships' launchings and publicity shots to repairs and maintenance.

It was a rare photographer, professional or amateur, who could resist exposing a few plates on San Francisco Bay. The world's largest fleet of ferryboats traversed Bay waters. River-boats as proud as any on the Mississippi plied the Sacramento River and churned across the Bay to San Francisco. Dredges, tugs, fishing craft, and work boats of every description criss-crossed the Bay. Great ocean liners, freighters, tankers, and warships of every type and size from every navy and steamship company have passed through the Golden Gate. Fabled clipper ships, down-easters, notorious hell-ships, and hard-working schooners have called at the port of San Francisco, and, for the most part, photographers have been there to record them.

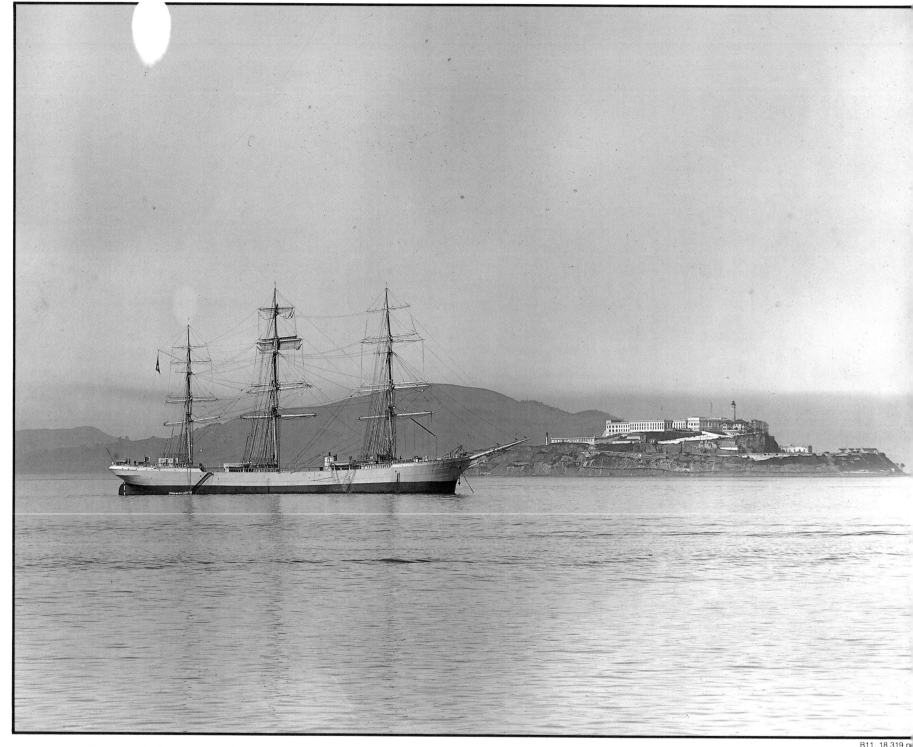

The French "bounty" ship General Faidherbe *lies in ballast off Alcatraz Island in San Francisco Bay, 1911. Photo by E.B. Swadley. The huge bay inside the protective headlands provided dozens of ports and anchorages for vessels of any size and type. It is said that every sailing ship worthy of the name passed through the Golden Gate at least once. In addition to being the primary inbound destination on the Pacific Coast for ships of many nations, San Francisco was home port for most of the lumber and general cargo carriers owned on the Pacific Coast. In 1870, San Francisco had ten times the combined population of Los Angeles, Seattle, and Portland. By 1890, the other seaport cities had expanded rapidly, but San Francisco was still twice as large as the three combined.*

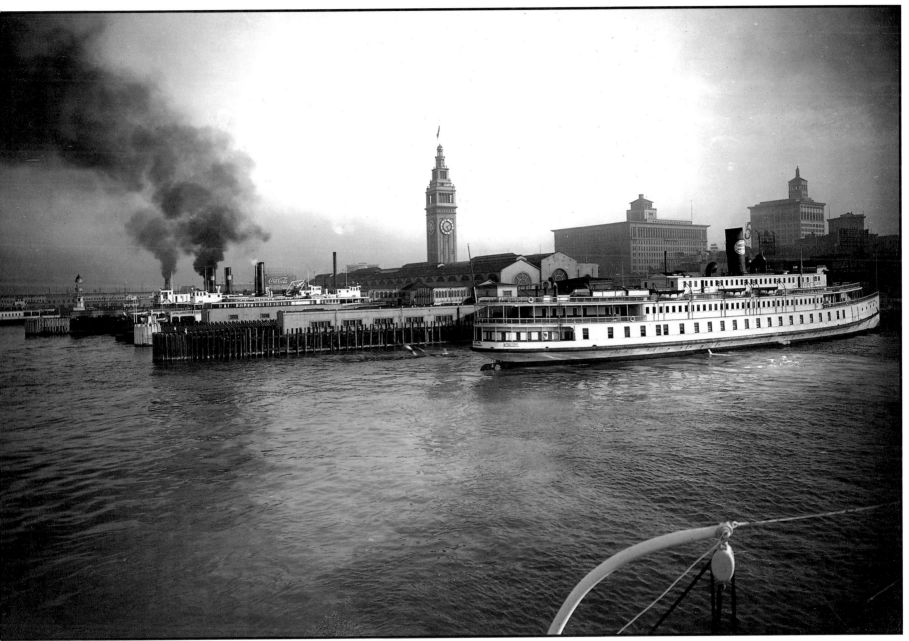

From the deck of a passing ferryboat, Gabriel Moulin shot this scene around 1920. The ferryboat Asbury Park is in the foreground. Built by William Cramp and Sons, Philadelphia, in 1903 for the Central Railroad of New Jersey, the Asbury Park became the "Pride of the Sandy Hook Fleet." The Montecello Steamship Company of Vallejo purchased her in 1918 for the San Francisco-Vallejo run, and she was refitted in San Francisco. In 1922 she was converted to an auto carrier.

Renamed the City of Sacramento in 1925, she continued the Vallejo run for Golden Gate Ferries and Southern Pacific until 1936. After a tour of duty during World War II as a ferry for the War Shipping Administration, the old veteran headed north to Puget Sound and became the Black Ball ferry Kahloke. In 1961, she was renamed Langdale Queen and ran from Horseshoe Bay to Port Langdale in British Columbia. She was still afloat in 1988.

133

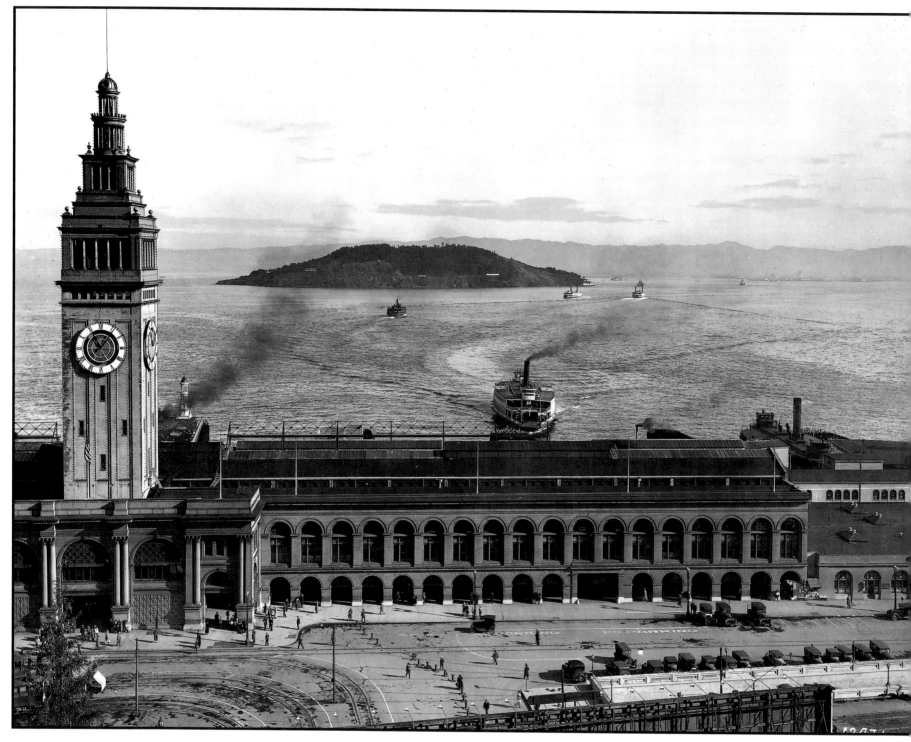

*San Francisco Ferry building, 1928. The two biggest ferry terminals in
San Francisco Bay were the foot of Market Street in San Francisco and
Oakland's Key Route Pier. San Franciscans claimed their terminal was the
busiest in America. The tower, built to resemble the bell tower adjoining
the Cathedral of Seville, was completed in 1898 and stands on the site of
an earlier riverboat and ferry terminal constructed in 1877. The numerous
boats rounding Yerba Buena Island and traversing the Bay in both
directions testify to the level of ferry service before construction of the
Oakland–San Francisco Bay Bridge in the 1930s.*

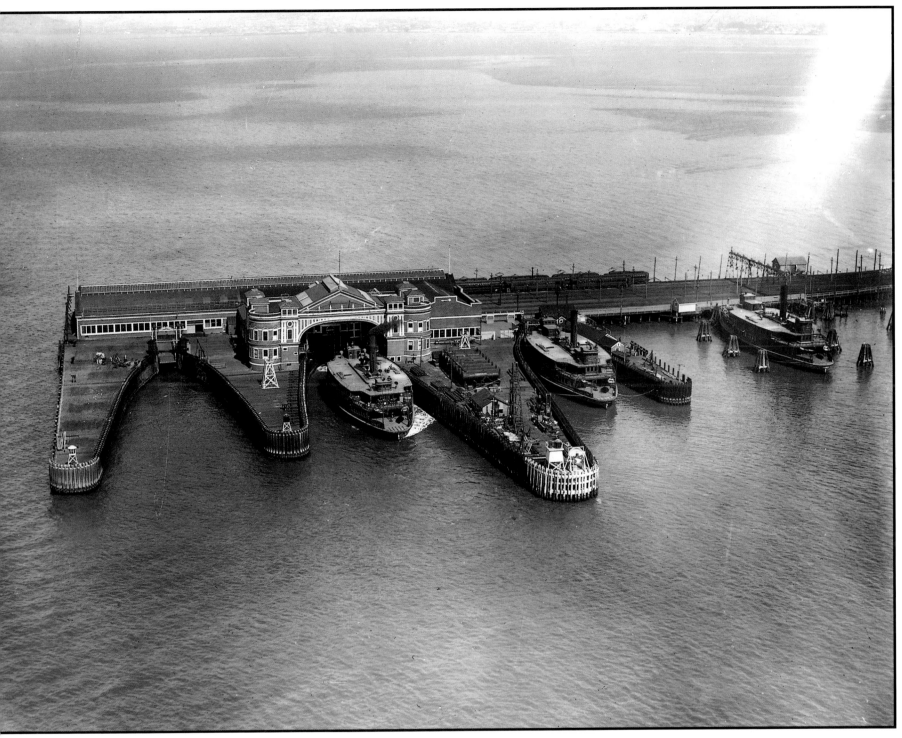

The ferryboat Yerba Buena, *left, at the Key Route Pier, Oakland, California, c. 1930. The big orange Key System boats were met by trains from Oakland, Berkeley and other commuter points in the Eastbay. Shallow bay water required long moles or piers on the east shore. The terminal buildings burned in 1933, and the ferry system was discontinued a few years later when the bridge across the Bay was completed.*

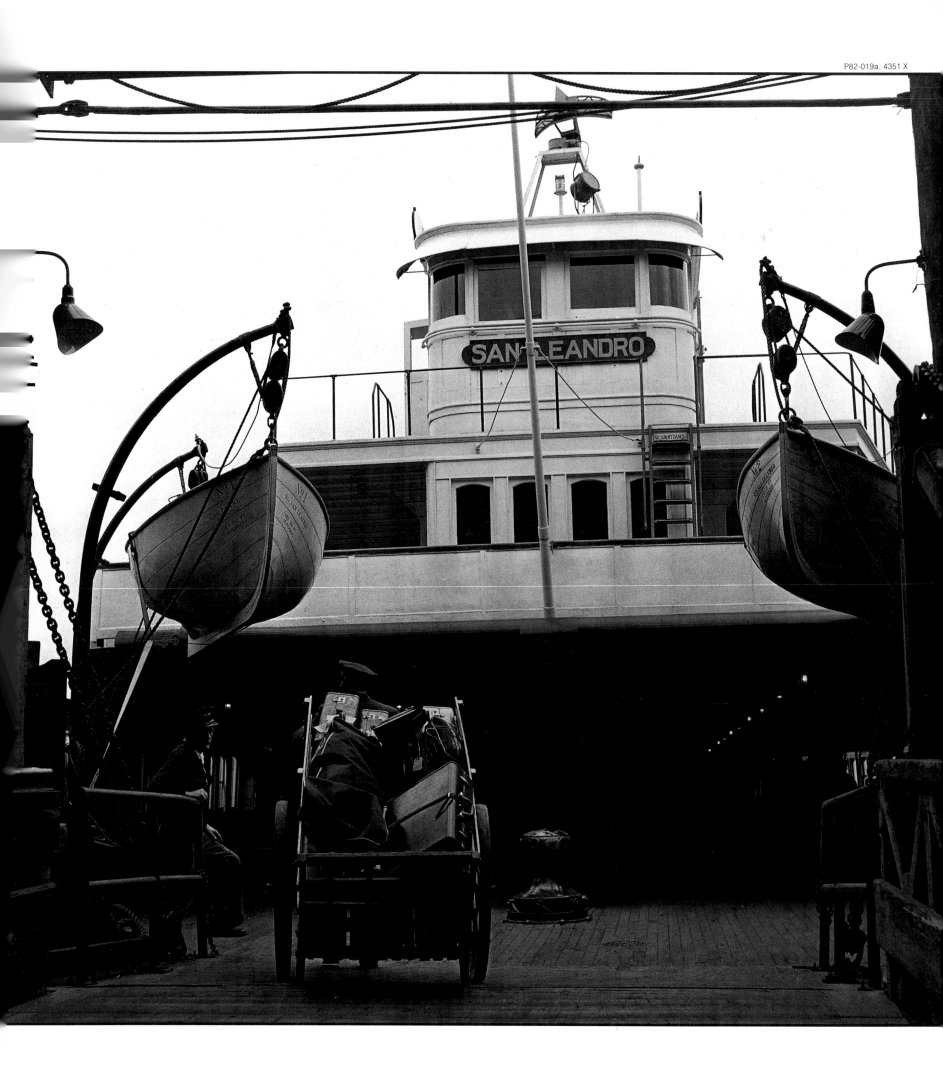

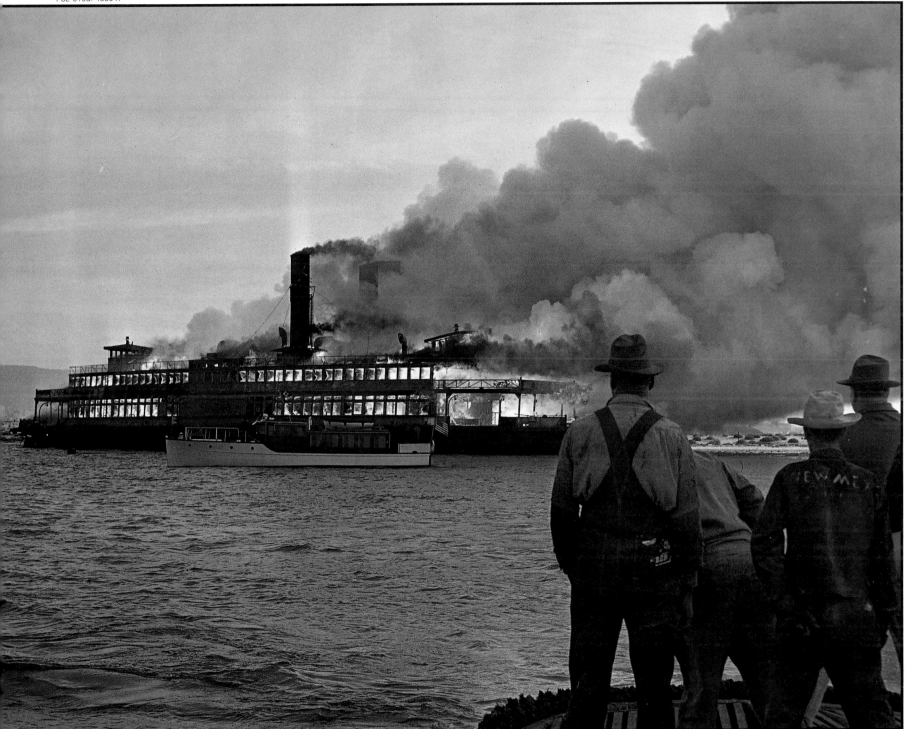

Facing page: End of the line. A San Francisco Call-Bulletin photographer captured the foreboding mood aboard the ferryboat San Leandro as she pulled into San Francisco on her last day in service in 1958. Highway bridges strung across the Bay in the 1930s supplanted the need for ferryboats (or so people thought at the time) and the veteran boats were laid up or scrapped. Some went to Puget Sound to begin new careers, a few others survived ultimately to serve other masters or become museum pieces.

Above: Ferryboat Santa Clara, San Francisco Bay. The ignominious fate of some boats was to be burned for scrap metal. Here the twin-stacked Santa Clara goes up in smoke on December 10, 1947, as fascinated spectators, perhaps those who set her ablaze and who will pick her bones, watch the end of an era.

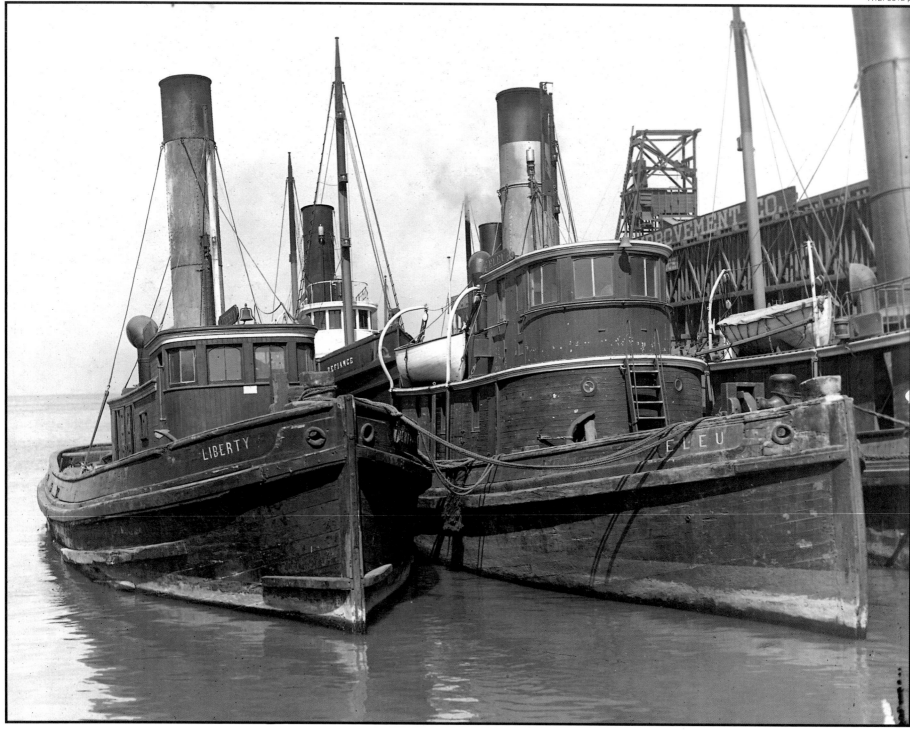

Above: *Tugboats Liberty, Eleu, and Defiance, 1909. This excellent camera study of steam harbor tugs exemplifies traditional bay work boats. The scene could be New York Harbor, Boston, Puget Sound, or any busy American harbor. In this case it is the Red Stack pier, San Francisco.*

Facing page: *Walter Scott made a series of artistic shots of scow schooners on the Bay around 1910. Here, the heavy loaded Annie Maria ghosts away from San Francisco's hay wharf. She is typical of the scow schooners that emerged on San Francisco Bay as early as the 1850s. Descended from the sailing scows of colonial New England, the scow schooners evolved on the Bay as rugged freight carriers, handy sailers, and profitable enterprises. The typical* scow schooner was owned by its skipper and carried a mate and perhaps a third crewman, most likely a cook. They were the independent truckers of their day. Most scows were constructed with fore-and-aft planking over frames and others were cross-planked without frames, with stout sides and heavy chines. Their schooner rig made them capable of handling almost any condition likely to be met in San Francisco Bay or its estuaries and rivers. Throughout the later half of the nineteenth century they carried hay and grain to San Francisco, bricks and building materials, local produce, and almost any general cargo.

Even though some scow schooners were fitted with engines after 1900, improved highways in the Bay Area and motor trucks numbered their days as profitable carriers. By the late 1930s, the scow schooner had faded away as a Bay Area water craft.

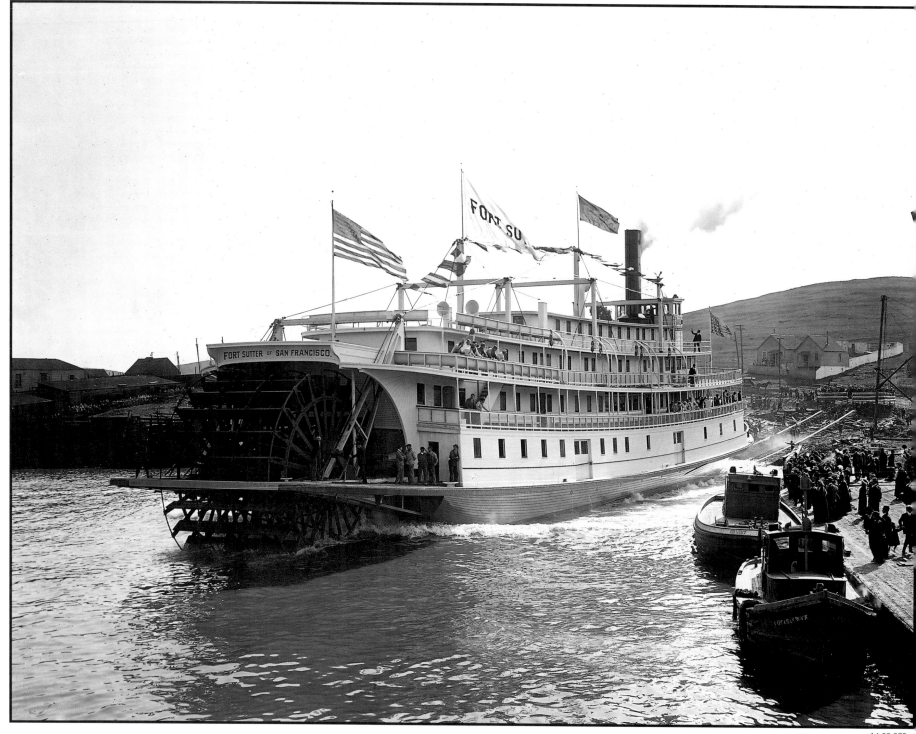

The riverboat Fort Sutter slides down the ways at Hunters Point in San Francisco, 1912, photo by Sacramento photographer Harold McCurry. Shallow-draft water craft navigated the rivers that fed into San Francisco Bay for almost a century following the gold rush. The earliest riverboats on the Sacramento River were shipped from the east disassembled or made their way around Cape Horn to California. In time, new boats were constructed on the Pacific Coast similar to their eastern counterparts but with several subtle differences in deck and house configuration. After the gold rush, riverboats contributed to the development of California's agricultural heartland. It was possible at high water for steamboats to navigate six hundred freshwater miles on the Sacramento and its tributaries from the foothills through the central valley.

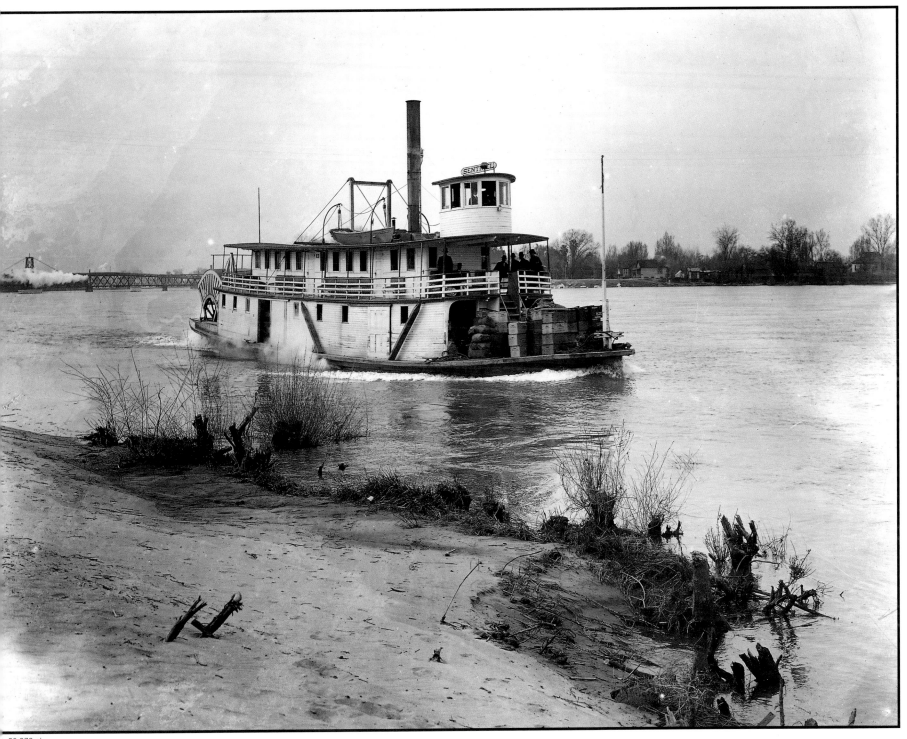

Harold McCurry captured the essence of Sacramento river freighters in this shot of the Sentinel, *c. 1910. While the grand passenger boats like the* Fort Sutter *catered to the commuters between San Francisco and Sacramento, "trading boats" like the* Sentinel *served the needs of local farms and small communities along the river. They were floating general stores, stocked with household goods, farm implements, tools, and clothing. In addition, they carried consignments of livestock and produce.*

141

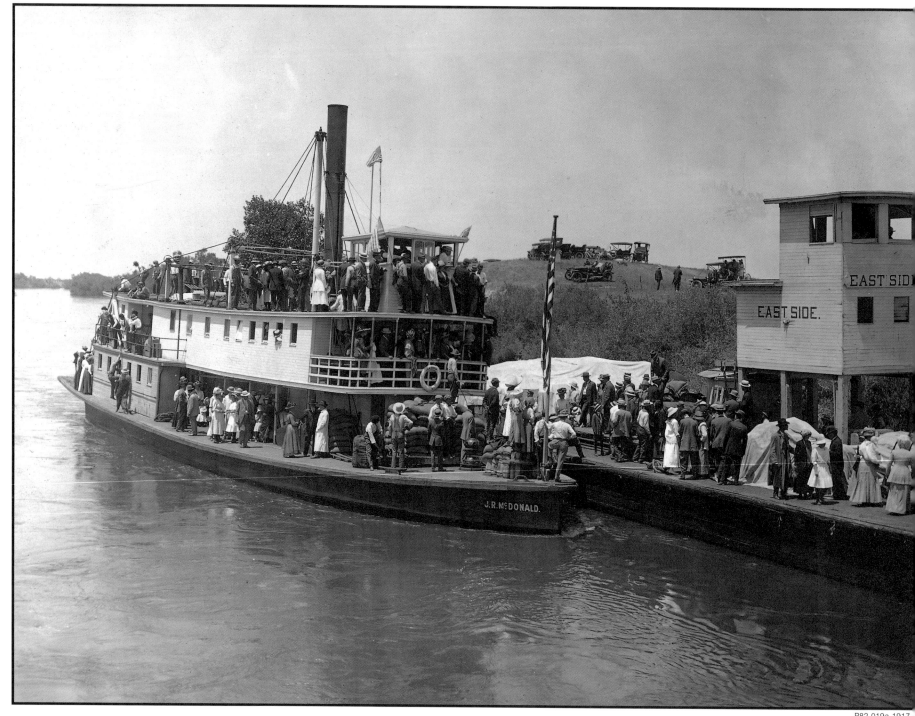

Riverboat J.R. McDonald *on San Joaquin River near Fresno, California, March 1913. The "up-river" boats of the California Navigation and Improvement Company, like the* J.R. McDonald, *were tow boats. Barges of fresh produce were strung along a steel cable attached to the single tall tow-post behind the stack and transported down-river to market. On holidays, workboats were often used for excursions and picnics, as demonstrated by the activity in the photo.*

142

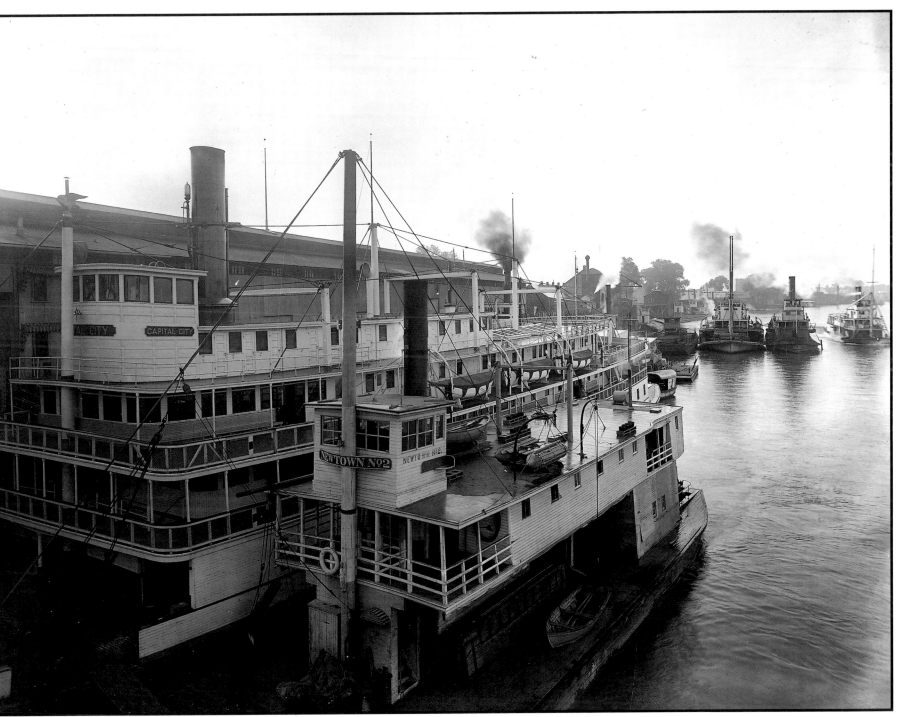

1. 20,374 pl

The big river packet Capital City *and the freighter* Newtown No.2 *at Sacramento.
Behind them in this McCurry photo are the barge* Rio Vista, *the riverboats* Colusa *and*
San Joaquin, *and an unidentified boat under way. The* Capital City *and her sister* Fort
Sutter *were the last Sacramento River packets built at San Francisco. In 1915, the big
boats departed San Francisco's Jackson Street Wharf at 6:00 P.M. and arrived in
Sacramento at 6:00 A.M. The fare was $1.50, a berth and meals one dollar additional.
In the 1930s, many riverboats were laid up or abandoned, and improved highways
brought an end to the riverboat era on California's rivers.*

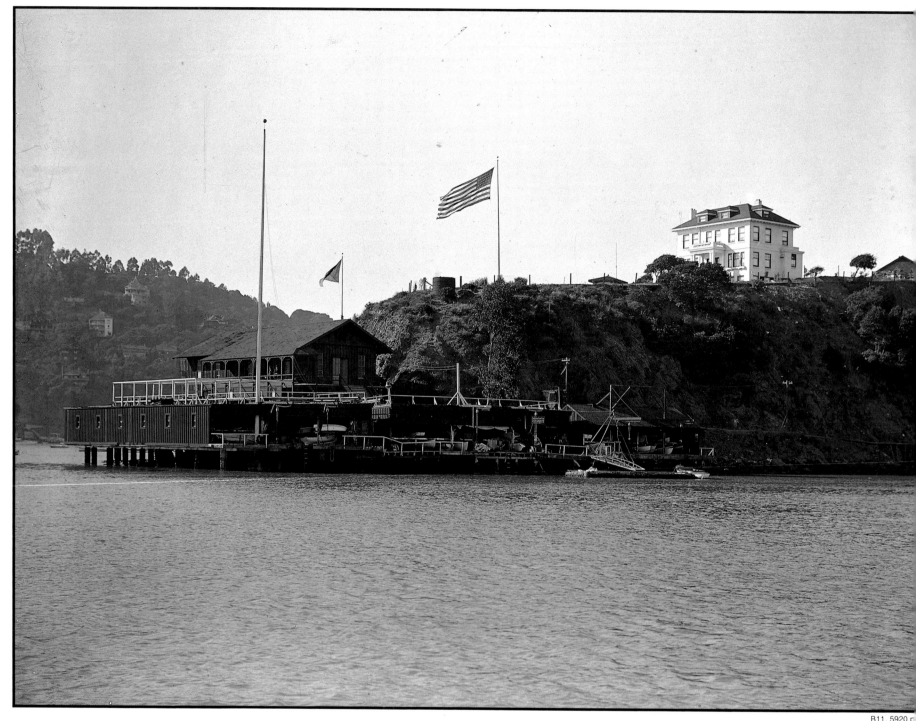

The Corinthian Yacht Club Building, Tiburon, California, by Walter Scott, 1911.
San Francisco Bay has been used for sport and pleasure boating since the first settle-
ments on its shores. Yachting enthusiasts formed the San Francisco Yacht Club, the first
on the Pacific Coast, in 1869 and held their first regatta on July fourth of that year. By
1886, when the Corinthian Yacht Club was formed, yachting had spread to Puget Sound
and southern California. Ocean races between big schooners from San Francisco to Santa
Barbara and other coastal locations were popular with the "big boat" set, while regattas
and informal weekend sailing on the Bay became popular with owners of smaller boats.

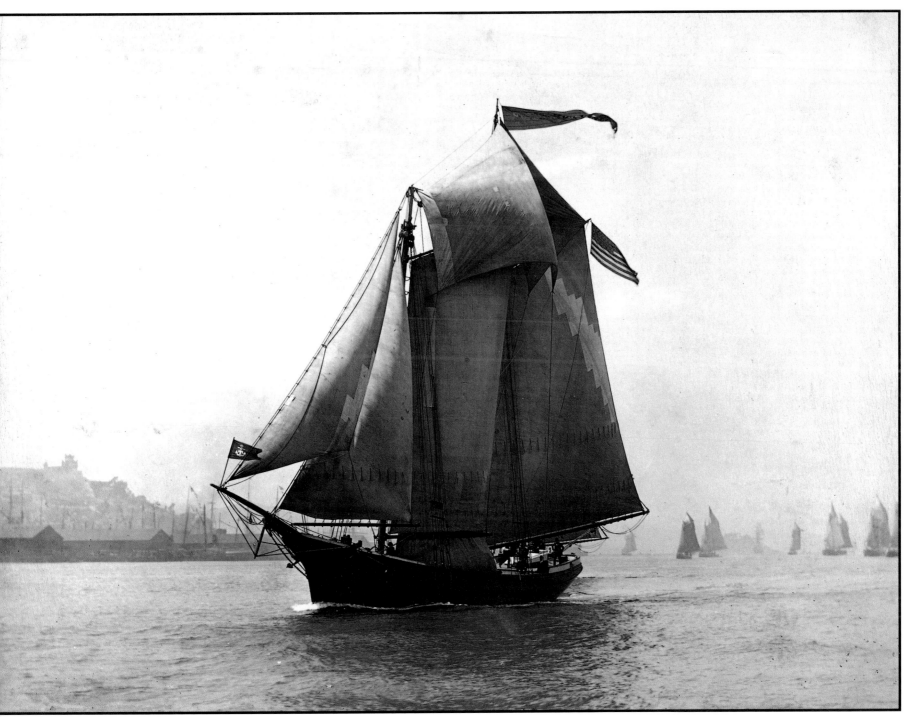

7. 9133 pl

Schooner Lizzie Merrill, Master Mariners' Race, c. 1885. San Francisco Bay has always provided some of the roughest and most dramatic sailing conditions anywhere. Men who earned their living on the Bay were proud of their boat handling abilities and were always eager for a good race. They organized the Master Mariners' Regatta in 1867, two years before the first yacht club was formed, to give workboat skippers an opportunity to demonstrate their skill. It became a popular annual event until 1891 when steamboats had replaced much of the working sail fleet on the Bay. (The event was revived in 1965 and continues today.) William Letts Oliver took this shot probably from his yawl Emerald. Oliver was an avid sailor who made many fine yachting photographs on San Francisco Bay.

145

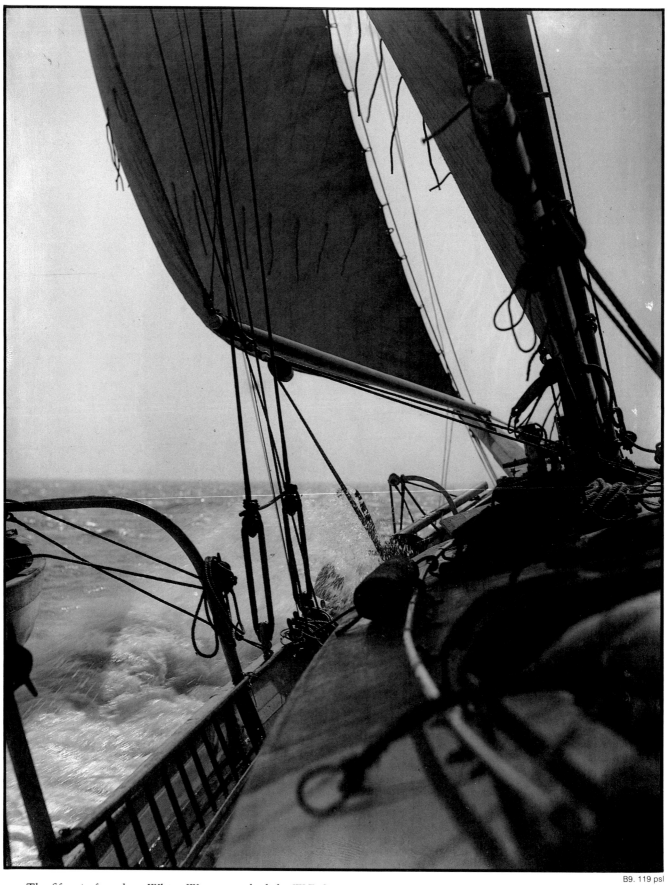

The fifty-six-foot sloop White Wings *was built by W.F. Stone in 1881 and was owned over the years by a number of prominent yachtsmen. While photographers were drawn to the beauty of sailboats on the Bay, they had difficulty making action shots because of their bulky equipment.*

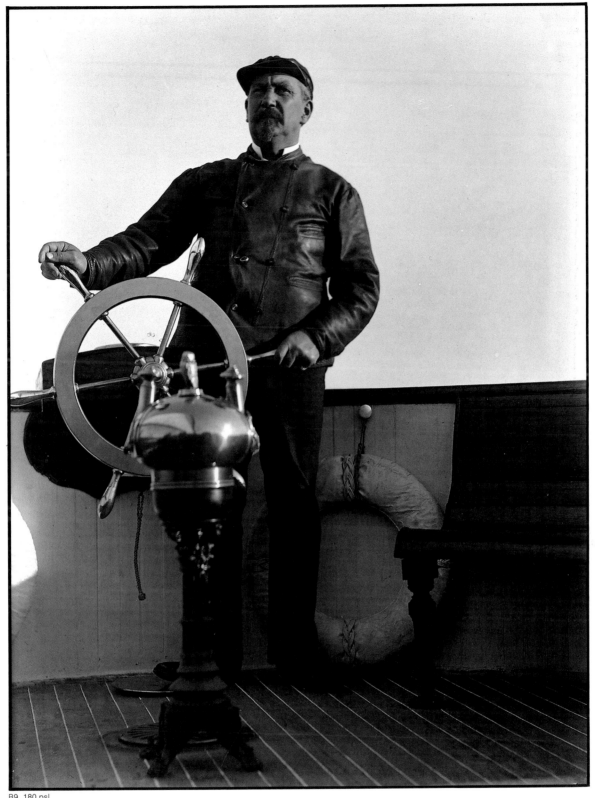

B9. 180 psl

Isidor Gutte, Commodore of the San Francisco Yacht Club, at the helm of his schooner Chispa. Gutte, Commodore of the San Francisco Yacht Club eleven times between 1883 and 1896, was a skilled and devoted sailor who helped popularize yachting on the Bay.

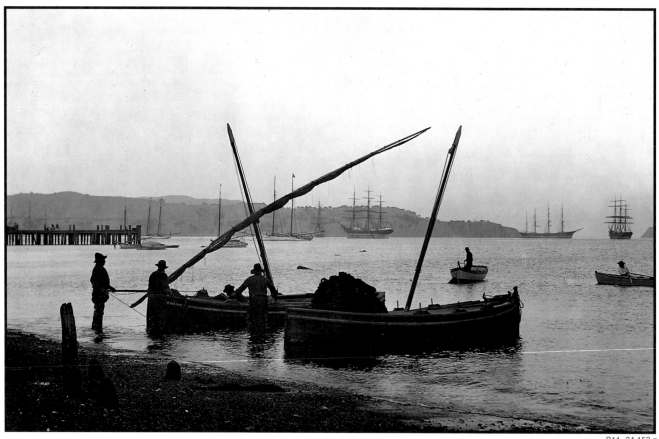

Feluccas off Sausalito, c. 1900, with grain ships lying in Richardson's Bay. Sicilian and Italian immigrant fishermen dominated commercial fishing inside the Golden Gate, although the Chinese and Portuguese were also active. Italian boatbuilders made hundreds of similar craft, straight-bowed double enders with lateen rigs identical to those on the Mediterranean. They fished mainly in the Bay for salmon, herring, shrimp, and crab. Sometime around 1900, fishermen experimented with simple one-cylinder gasoline engines that allowed them to venture more safely outside the Golden Gate after deep-water fish as commercial fishing in the Bay declined. Over the next twenty years, sails were abandoned and the boat's lines modified to accommodate the engine. A high-rising "clipper" bow was added to keep the boat drier in rough water outside the gate. By the 1920s the Monterey boat was the dominant type operating out of San Francisco.

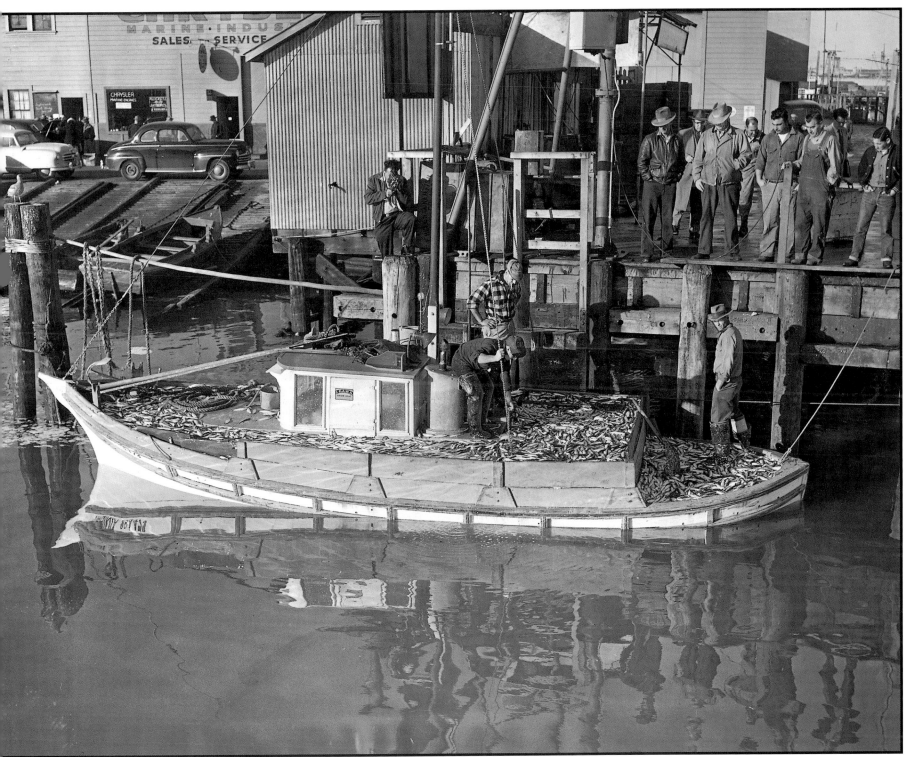

Monterey fishing boat, San Francisco, 1953. A San Francisco Call-Bulletin photographer made this dramatic shot of the Virginia *with ten tons of herring caught off Lime Point at the Golden Gate. It was the biggest single catch since 1944. The little boat is testimony to the endurance and versatility of the type. The Monterey fish boat, often called "Monterey Clipper," was born and bred on San Francisco Bay and endured through the 1960s. By then it was much less practical for a single fisherman in a small boat to make day-trips outside the Gate. The fisheries became more distant, and boats became more sophisticated and expensive. A few examples of the Monterey boat are still working and the type has become a symbol associated with San Francisco Bay.*

A San Francisco Call-Bulletin *photographer shot this montage of human emotions at San Francisco's Fort Mason, May 26, 1952, during the Korean War. Family and friends anxiously await returning soldiers aboard the troopship* General A.W. Brewster. *On board, soldiers of the 40th Infantry Division, California National Guard, line the rail. Fort Mason was the principal port of embarkation for the Pacific Coast through the Spanish-American War, World Wars I and II, and the Korean War.*

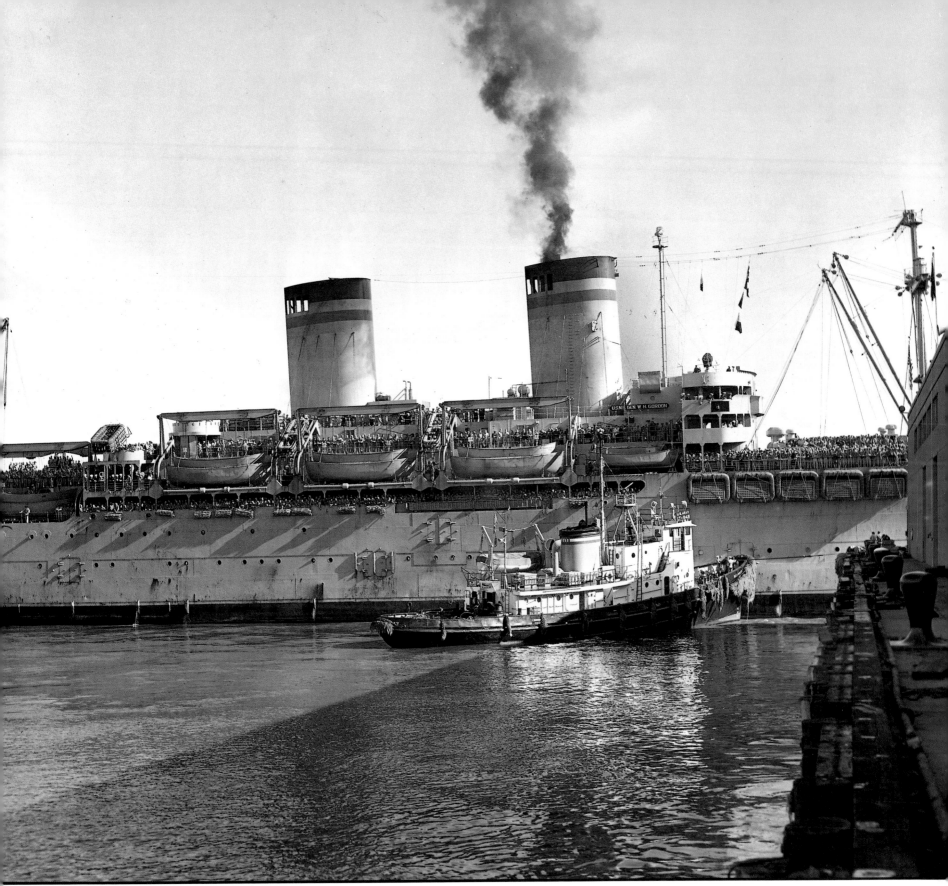

A Call-Bulletin *photographer was also on hand June 12, 1952, as the troopship General Walter H. Gordon was nudged to its moorings at Fort Mason. Of the 3,524 passengers, over two thousand were returning soldiers, including five hundred men of the 40th Division. These were scenes that had been repeated many times during World War II, but due to restrictions on photography during that period, few arrivals and departures were recorded so dramatically as these.*

151

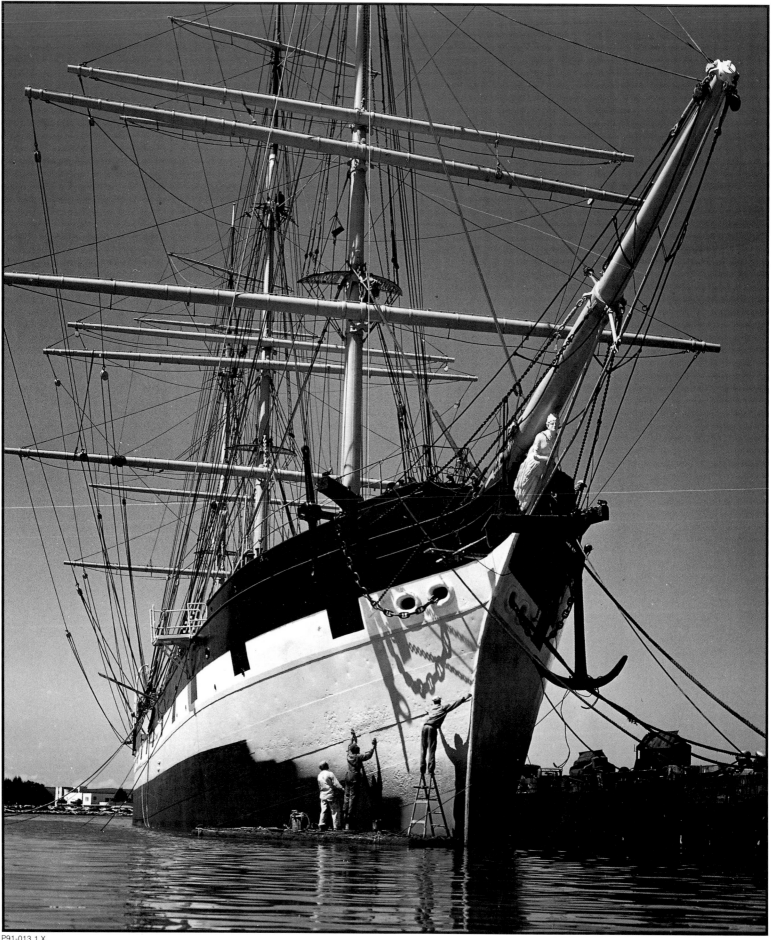

The museum ship Balclutha, San Francisco, 1955. Karl Kortum photo.

SAN FRANCISCO MARITIME
NATIONAL HISTORICAL PARK

by Stephen A. Haller,
Curator of Historic Documents

The San Francisco Maritime National Historical Park is the pre-eminent museum of maritime history in the western United States. Its purpose is the collection, preservation, and interpretation of the maritime heritage of the Pacific Basin—the history of the trades, technologies and traditions of those who lived on and by the water. There is considerable emphasis on the San Francisco Bay region and its riverine tributaries, but the nature of maritime commerce brings within our scope the breadth of the Pacific Coast, far-flung ports-of-call, vessels and crews from around the world, and exotic trade routes.

Now a part of the National Park Service, the institution has its roots in the San Francisco Maritime Museum, which opened its doors in 1951, and the collection of historic ships assembled by the state of California at the Hyde Street Pier. With the addition of the full-rigged ship *Balclutha,* the museum manages the largest floating collection by tonnage of turn-of-the-century sail and steam vessels in the world, an exhibits building located in a 1930s-era streamline-moderne bathhouse, an important library, and an extensive collections of artifacts, artworks, manuscripts, and photographs.

The founders of the Maritime Museum, in particular Karl Kortum (himself a talented photographer), were well aware of the application of historic photographs to the goals of preservation and interpretation. They avidly collected such photographs from the very beginning. Over the years the collection has become widely renowned. Recently, great strides have been made both in creating access to the images and to their preservation for future generations. At present, the collection consists of some 200,000 images representing many kinds of media: glass plates, nitrate negatives, and albumen prints as well as modern safety film, silver gelatin prints, and motion picture film.

Some of the major acquisitions that serve to define our collection are well-represented in this book, including the Wilhelm Hester and H.H. Morrison Collections. These, and the photographic scrapbooks of John W. Procter and the large, sharp glass plate negatives of W.A. Scott provide a solid basis for classic views of ships and the waterfront from the 1880s through the 1930s. Shipbuilding activity is well documented in the massive collections of the Bethlehem Shipbuilding Corporation and the marine architectural firm of David W. Dickie. But, as this volume so beautifully demonstrates, much of the strength of the museum's photograph collection comes from the range of collections, large and small, and the many individual images. Taken together, they provide insight and information in many Pacific Coast subject areas, such as vessel portraits, shipbuilding and ship repair, the fishing industry, yachting, bay and river traffic, the great San Francisco earthquake of 1906, waterfront views and cityscapes.

We encourage the use of our photograph collections. Finding aids are available in both traditional card catalogs, and computer-generated book catalogs. In the future, we hope to see computer terminals provide users with instant access to photograph databases. The services of the museum's own photo lab are available to patrons and assistance with reference is provided at the library, Building E, Fort Mason Center, San Francisco.

The San Francisco Maritime National Historical Park welcomes public use and enjoyment of all our facilities. For further information, you may write to the Superintendent, whose address is: Fort Mason, San Francisco, CA 94123.

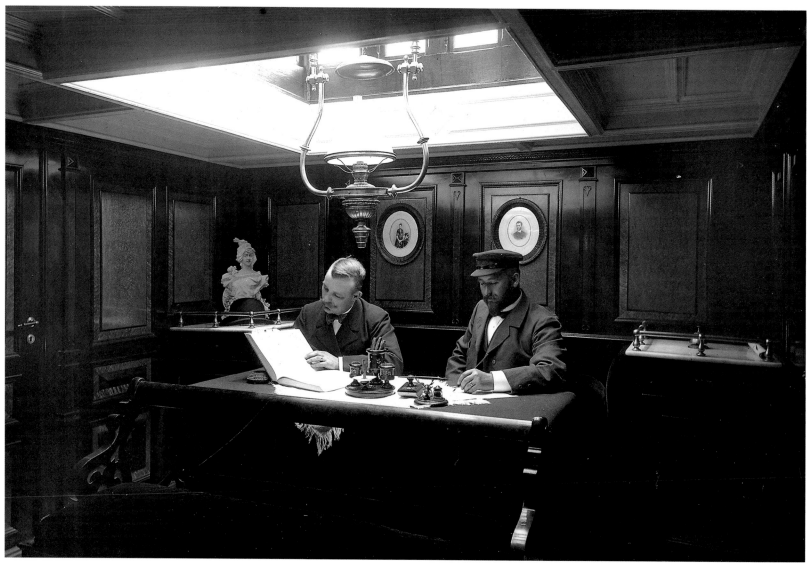

Unidentified officers and vessel, by Wilhelm Hester, c. 1905.

BIBLIOGRAPHY

The maritime history of the Pacific Coast is richly documented with scholarly works, firsthand accounts, oral histories, company records, log books, and, of course, photographs. While I have been guided principally by photographic documentation in the preparation of this book, the invaluable work of others in the history field has made my voyage through the past a pleasant one. In writing the captions and text, I relied mainly on sources within the comprehensive and excellent J. Porter Shaw Library of the San Francisco Maritime National Historical Park. From this collection, and other sources, I found the following to be most helpful.

Albion, Robert Greenhalgh. *New England and the Sea*. Middletown, Conn.: Wesleyan University Press, 1972.

Alden, John D. *American Steel Navy*. Annapolis: Naval Institute Press, 1972.

Arnott, David (ed.). *Design and Construction of Steel Merchant Ships*. New York: The Society of Naval Architects and Marine Engineeers, 1955.

Bancroft, Hubert Howe. *The Works of Hubert Howe Bancroft*, Vol. 23–24, California, Vol. 30 Oregon, 1848–88. New York: McGraw Hill, The History Co., Publishers, 1888.

Benson, Richard M. *Steamships & Motorships of the West Coast*. Seattle: Superior Publishing Co., 1968.

Best, Gerald M. *Ships and Narrow Gauge Rails: The Story of the Pacific Coast Company*. Berkeley: Howell-North, 1964.

Bevis, L.R.W. *Passage: From Sail to Steam*. Bellevue, Wash.: Documentary Book Publishing Corp., 1986.

Brock, P.W. and Greenhill, Basil. *Steam and Sail: In Britain and North America*. Princeton: The Pyne Press, 1973.

Brodie, Bernard. *Sea Power in the Machine Age*. Princeton: Princeton, University Press, 1941.

Brown, Giles T. *Ships That Sail No More: Marine Transportation from San Diego to Puget Sound, 1910–1940*. Lexington, Kentucky: University of Kentucky Press, 1966.

Camp, William Martin. *San Francisco-Port of Gold*. New York: Doubleday & Co., 1947.

Carse, Robert. *The Twilight of Sailing Ships*. New York: Galahad Books, 1965.

Chapelle, Howard I. *The American Sailing Navy*. New York: W.W. Norton Co., 1949.

———. *The History of American Sailing Ships*. New York: W.W. Norton & Company, Inc., 1935.

Clark, Arthur H. *The Clipper Ship Era*. New York: G.P. Putnam's Sons, "The Knickerbocker Press," 1910.

Cutler, Carl C. *Greyhounds of the Sea*. New York: Halcyon House, 1930.

DeNevi, Don and Moulin, Thomas. *Gabriel Moulin's San Francisco Peninsula*. Sausalito, Calif.: Windgate Press, 1986.

Dobie, Charles Caldwell. *San Francisco: A Pageant*. New York: D. Appleton-Century Co., 1933.

Dollar, Robert. *Memoirs of Robert Dollar*, Vol. IV. San Francisco: The Robert Dollar Co., 1925.

Engle, Eloise and Lott, Arnold S. *America's Maritime Heritage*. Annapolis: Naval Institute Press, 1975.

Gates, Charles Marvin (ed.). *Readings in Pacific Northwest History* (Washington State: 1790–1895). Seattle: University Bookstore, 1941.

Gibbs, Jim. *Pacific Square-Riggers*. Seattle: Superior Publishing Co., 1969.

———. *West Coast Windjammers*. Seattle: Superior Publishing Co., 1968.

Gilliam, Harold. *San Francisco Bay*. Garden City, NY: Doubleday & Co., 1957.

Gleason, Duncan. *The Islands and Ports of California*: The Devin-Adair Co., 1958.

Greenhill, Basil. *The Ship: The Life and Death of the Merchant Sailing Ship*. London: National Maritime Museum, 1980.

Greenhill, Basil and Giffard, Ann. *The Merchant Sailing Ship*. New York: Preager Publishing Co., 1970.

Hamilton, James W. and Bolce, William, Jr. *Gateway to Victory*. Stanford: Stanford University Press, 1946.

Hardy, A.C. *The Book of the Ship*. New York: The Macmillan Co., 1949.

Martin, Wallace E. (ed.). *Sail & Steam on the Northern California Coast 1850–1900*. San Francisco: National Maritime Museum Association, 1983.

Marquez, Ernest. *Port Los Angeles-A Phenomenon of the Railroad Era*. San Marino, Calif.: Golden West Books, 1975.

Maslin, Marshall (ed.). *Western Shipbuilders in World War II*. Oakland, Calif.: Shipbuilding Review Publishing Assoc., 1945.

McCullough, David. *The Path Between the Seas*. New York: Simon & Schuster, 1977.

McNairn, Jack and MacMullen, Jerry. *Ships of the Redwood Coast*. Stanford: Stanford University Press, 1945.

Miller, Nathan. *The U.S. Navy, An Illustrated History*. New York: American Heritage Publishing Co., 1977.

Mitchell, Donald W. *History of the Modern American Navy*. New York: Alfred A. Knopf, 1946.

Newell, Gordon and Williamson, Joe. *Pacific Coast Liners*. Seattle: Superior Publishing Co., 1959.

———. *Pacific Lumber Ships*. Seattle: Superior Publishing Co., 1959.

———. *Pacific Steamboats*. Seattle: Superior Publishing Co., 1958.

Palmquist, Peter E. *Lawrence & Houseworth / Thomas Houseworth & Co*. Columbus, Ohio: National Stereoscopic Association, 1980.

Queenan, Charles F. *The Port of Los Angeles From Wilderness to World Port*. Los Angeles: The Los Angeles Harbor Dept., 1983.

Villiers, Alan and Picard, Henri. *The Bounty Ships of France: The Story of the French Cape Horn Sailing Ships*. New York: Charles Scribner's Sons, 1972.

Way, Frederick, Jr. *The Saga of the Delta Queen*. Cincinnati: The Picture Marine Publishing Co., 1951.

Weinstein, Robert A. *Grays Harbor 1885–1913*. New York: The Viking Press, 1978.

Whidden, John D. *Ocean Life in the Old Sailing Ship Days*. Boston: Little Brown & Co., 1914.

Worden, William L. *Cargoes—Matson's First Century in the Pacific*. Honolulu: University of Hawaii Press, 1981.

Workman, Boyle. *The City That Grew*. Los Angeles: Southland Publishing Co., 1935.

Harlan, George H. *San Francisco Bay Ferryboats*. Berkeley: Howell-North Books, 1967.

Hart, Robert A. *The Great White Fleet*. New York: Little, Brown & Co., 1965.

Jupp, Ursala (ed.). *Home Port: Victoria*. Victoria, BC: Ursula Jupp, 1967.

Karmon, Yehuda. *Ports Around the World*. New York: Crown, The Jerusalem Publishing House, Ltd., 1980.

Kemble, John Haskell. *San Francisco Bay, A Pictorial Maritime History*. New York: Cornell Maritime Press, 1957.

Laing, Alexander. *American Sail, A Pictorial History*. New York: E.P. Dutton & Co., 1961.

Lott, Arnold S. *A Long Line of Ships: Mare Island's Century of Naval Activity in California*. Annapolis: United States Naval Institute, 1954.

Lubbock, Basil. *The Down Easters: American Deep-Water Sailing Ships 1869–1929*. Boston: Charles E. Lauriat Co., 1929.

———. *The Last of the Windjammers* (Vol. I and II). Glasgow: Brown, Son & Ferguson, 1927.

MacArthur, Walter. *Last Days of Sail on the West Coast*. San Francisco: The James H. Barry Co., 1929.

MacMullen, Jerry. *Paddle-Wheel Days in California*. Stanford: Stanford University Press, 1944.

———. *They Came By Sea: A Pictorial History of San Diego Bay*. San Diego: The Ward Ritchie Press and the Maritime Museum Association of San Diego, 1969.

Captain Robertson of the Sandhurst, by Wilhelm Hester, c.1900.

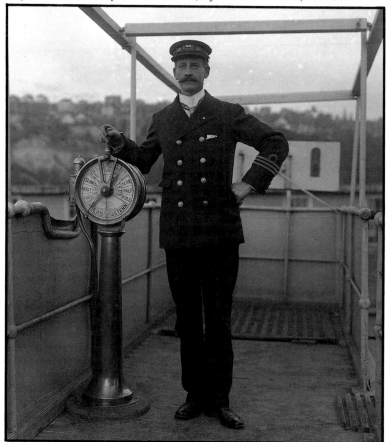

P50. 12,391 psi

INDEX

Aberdeen, 17, 24
Aberdeen (steam schooner), 69
Acme, 112
Admiral Oriental Line, 114
Alameda, 39, 57, 80
Alaska, 22, 24
 gold rush, 76–7, 105–6
 salmon fishery, 39
Alaska Packers' Association, 13, 32, 38–9
Alaska Steamship Company, 54
Albania, 19
Alcatraz Island, 121, 132
Alice, 88–9
Allen, J.E., 1
American Gulf Coast, 23
American-Hawaiian Steamship
 Company, 116
American merchant shipping, 22, 90
American President Lines, 114
Anacortes, 75
Andrew Jackson, 14
Aniwa, 96
Annie Maria, 138–9
Antioch, 84
Apollo, 14
Apus, 98–9
Arcata, 17
Asbury Park, 133
Asia, 26, 47, 103

Astoria, 17, 52, 71
Astral, 32
Atlas Gas Engine Company, 85
Australia, 10, 26, 103
Aven J. Hanford, 80

B
Balclutha, 152–3
Balkash, 86
Bandon, 16–7
Barrett & Hilp, 100
Bear, 122–3
Beaton, Captain Orison, 8, 18
Beaver (paddlewheel steamer), 103
Beaver (steamship), 98
Begwaduce, 93
Belair Island shipyard, 100
Bellingham, 44
Beluga, 36
Benson log rafts, 71
Benson Lumber Company, 71
Bering Strait, 122
Berkeley, 135
Bessemer City, 126
Bethlehem Shipbuilding Corporation, 92,
 119, 153
Biddle, Captain James, 121
Big River, 66
Birmingham, 124

Black Ball Line, 108, 133
Blunts Reef, 68
Bobolink, 65
Boston, 22, 44
Bowhead, 36
Bracadale, 19
Bremerton, 26, 91
British Columbia, 10, 59
Byington, Miss Nathalie, 94
Byrd, Admiral Richard E., 122

C
Caithness-shire, 33
California, 29, 102
California, 23
 gold rush, 10, 12, 21–6, 29, 59, 75
 republic, 23
 wheat exports, 22, 25
California National Guard, 150–1
California Navigation and Improvement
 Company, 142
California Promotion Committee, 56
Camanche, 17
Camouflage, 96
Canadian Pacific fleet, 111
Canadian Pacific Railway, 113
Cape Horn, 22, 25, 90, 121
Cape Mendocino, 68
Capital City, 143

Carpenter, A.O., 17
Cascade Mountains, 23
Case, W.H., 111
Central Railroad of New Jersey, 133
Challenge, 14
Champigny, 96–7
Chignik Bay, 38–9
China, 47, 121
Chispa, 147
Cissie, 32
City of Reno, 94
City of Sacramento, 133
City of Seattle, 106–7
Civil War, 25, 121
Clatskanie, 71
Claudine, 55
Cliff House, 5, 69
Clipper ships, 22, 24–5, 131
Clyde River, 24, 87
Coast Ranges, 23
Coastwise travel, 103
Colonel de Villebois Mareuil, 8
Colorado, 14
Columbia, 103, 110
Columbia River, 8, 10, 24, 52–3, 71, 75, 88, 103, 121
Columbia River and Puget Sound Navigation Company, 108
Colusa, 143
Commencement Bay, 2
Comstock Lode, 24
Connecticut, 25
Connecticut (battleship), 120
Constitution, 44
Coos Bay, 78
Corinthian Yacht Club, 144
Coronado Island, 71
Costa Rica Packet, 37
Cramp, William and Sons, 133
Craven, 129
Crescent, 19
Cressy, Josiah, 14
Cringlin, Georg, 60
Curtis, Asahel, 17
Curtis, Edward S., 17

D
Daguerreotype process, 9–10
Dakota, 113
Dana, Richard Henry, Jr., 22, 45
Davidson, Mr., 17
Defiance, 138
DeLong, Lt. George Washington, 122
Delta King, 87
Delta Queen, 87
Dickie, David, W., 153
Dodwell & Company, 106
Dollar Pai Lien Chien Wharf, 126
Dollar, Robert, 114
Dollar Steamship Line, 114, 117
Dollarton, B.C., 64
Dominion Photo, 64
Doris Crane, 74
Douglas fir, 10, 24, 59
Down-easters, 25, 131

Dumaresq, Philip, 14
Dyea, 54

E
East India Squadron, 121
East Street, 56
Edward Sewall, 13
Eilbek, 58
Eleu, 138
Elliott Bay, 49, 76
Ely, Eugene B., 124
Emanuele Accane, 52
Embarcadero, 56
Emerald, 145
Emergency Fleet Corporation, 90, 93, 98, 114
Empress, launch 84–5
Empress liners, 113
Englehorn, 19
Eppler, Arthur, 57
Ericson, August W., 17
Erskine M. Phelps, 41
Essex, 121
Estrella, 71
Eva Montgomery, 62

F
Fair Oaks, 46
Falkland Islands, 96
Fanning, 129
Farragut, Commander David, 127
Fennia, 96
Fitch, Herbert, 16
Flavel, 110
Flottbek, 60
Flyer, 108
Flying Cloud, 14
Forteviot, 2
Fort Mason, 26, 150–1, 153
Fort Point, 121, 130
Fort Sutter, 140–1, 143
40th Infantry Division, 150–1
Freeman, Emma, 17
French, C.H., 17
Fresno, 142
Funter Bay, 105

G
Galapagos Islands, 121
Garonne, 109
General A.W. Brewster, 150
General Faidherbe, 132
General George S. Simonds, 110
General Harrison, 14
General Walter H. Gordon, 151
George W. Elder, 1
Godfrey, William, 17
Gold rush ships, 11
Golden City, 80
Golden Gate, 5, 73, 130–1, 132, 148
Golden Gate Ferry Company, 80, 133
Golden State, 112
Goliah, 8, 103
Grand Fleet, 17, 120

Grays Harbor, 17, 70
Great Britain, 22–6, 29, 121
Great Britain, 29
Great Northern, 110
Great Northern Pacific Steamship Company, 110
Great Northern Railroad, 110, 113
Great White Fleet, *see* Grand Fleet
Greely Expedition, 122
Green Street Wharf, 6
Greenwood, 88
Guadalupe-Hidalgo, Treaty of, 23
Gulf of Mexico, 23
Gutte, Isidor, 147

H
H.F. Alexander, 110
H.K. Hall, 76
Hall Brothers, 61, 76–7
Hall, Henry Knox, 76
Hampton Roads, Virginia, 120, 124
Hammond Lumber Company, 70
Harrison, Captain and Mrs., 62
Harvard, 112
Haseltine, Martin M., 17
H-3 (submarine), 91
Hawaiian Islands, 10, 55, 59, 103, 113, 121
 whaling in, 22,
 naval base, 26, 127
Helene, 55
Helm, 129
Henley, 129
Hermann, 28
Hermosa, 48
Hester, Wilhelm, 2, 16, 19, 33, 43, 60, 62, 76, 106, 153–4, 156
Hill, James, 110
Hilo, 55
Hollywood, 45
Hong Kong, 103–4
Honolulu, 55
Horseshoe Bay, 133
Houseworth, Thomas, 16
Hudson's Bay Company, 22, 103
Humboldt Bay, 16–7
Hunters Point, 140
Huntington, C.P., 51
Hurst, Alex A., 41
Hyde Street Pier, 153

I
Ione, 53
Ione (riverboat), 53

J
Jackson Street Wharf, 143
James, Captain and Mrs. Edward Gates, 63
Japan, 24, 26
J. Porter Shaw Library, 7
J.R. McDonald, 142
Jeanette, 122, 129
Jenner, W., 17
John Sevier, 101
Judd, M., 17

INDEX

K
Kahloke, 133
Kearney, Commodore Lawrence, 121
Kennydale, 79
Kerwin, Harry, 16
Key Route Pier, 134–5
Kinau, 55
Klondike, 54, 106
Kobe, Japan, 116
Kodakists, 12
Korea, 113
Korean War, 150–1
Kortum, Karl, 153

L
Lahaina, 55
Langdale Queen, 133
Lange, O.V., 6, 17
Lauritzen Transportation Company, 84
Lend-Lease Program, 126
Liberty, 138
Liberty ships, 90, 101
Lime Point, 149
Lincoln, Edward, 17, 61
Lizzie Merrill, 145
Llewelyn J. Morse, 39
Lloyd's of London, 25
Logan, W.I. and Company, 79
Long Beach, 75
Longview, 75
Lord Templetown, 34
Los Angeles, 47–8, 50–1, 131
Los Angeles Steamship Company, 112
Louisiana Purchase, 23
Lumber schooners, 65, 79
Lumber trade, 59–73
Lurline (riverboat), 52
Lurline (steamship), 20
Lyman D. Foster, 19
Lynton, 63

M
Mabel Gale, 61
McCurdy, James, 18
McCurry, Harold, 140–1, 143
MacKenzie, Colin, 17
Madrono, 43
Maine shipyards, 22, 25
Manifest Destiny, 23
Manila, 117
Manila Bay, 26
Manoa, 86
Mare Island Navy Yard, 26, 90, 122, 124, 127
Marin Headlands, 131
Mariposa, 119
Marshall, John, 23
Marshall, S.S., 115
Mascot, 52
Mason, Col. Richard Barnes, 121
Massachusetts, 25
Master Mariners' Race, 145
Matson, Captain William, 113
Matson Navigation Company, 20, 27, 86, 116, 118–9

Melville, 129
Melville, Chief Engineer George, 122, 129
Melville Dollar, 57
Mendocino, 17, 26, 66
Mexican War, 23, 121
Milwaukee, 91–2
Milwaukie, 52
Minnesota, 113
Moebus, F., 17
Monitor, 72
Montecello Steamship Company, 133
Monterey, 121, 127
Monterey fishing boat, 148–9
Monterey (steamship), 118–9
Moore Drydock Company, *same as* Moore and Scott Iron Works, Moore's shipyard, Moore Shipbuilding Company, 82, 93–9
Moran Brothers Company, 76
Morena, 71
Morrison, Hiram Hudson, 18, 31, 153
Mosquito Fleet, 77
Moulin, Gabriel, 13, 82, 93, 95, 133
Muybridge, Eadweard, 16

N
Nagasaki, 115
Nantucket, 22, 24, 37
National Park Service, 153
Nautilus, 127
Nebraska, 76
Nebraskan, 46
New Bedford, 37
New England, 22
New Haven Railroad, 112
Newport, 53
Newtown No.2, 143
New Zealand, 103
Niantic, 14
Nippon Yusen Kaisha, 103
Nokomis, 77
Nome, 54
Norfolk, 26
North Beach Peninsula, 88
Northern Light, 80–1
Northern Pacific, 110
North Point Grain Warehouse, 30
North Pole, 122
North West Company, 22
N.R. Lang, 52

O
Oakland, 57, 65, 69, 74, 80–2, 85, 94, 99, 134–5
Oakland Creek, 36
Oakland Long Wharf, 57
Oakland-San Francisco Bay Bridge, 134
Occidental and Oriental Steamship Company, 104, 113
Ocean Beach, 5
Oceanic, 104
Oceanic & Oriental Steamship Company, 116
Oceanic Steam Navigation Company, 103–4

Oceanic Steamship Company, 103
Oliver, William Letts, 145
Ontario, 121
Oregon City, 52
Oregon Shipbuilding Corporation, 101
Oregon Territory, 22–3, 26, 121

P
Pacific Basin, 21, 26, 153
Pacific Coast ports, 6, 11, 14, 19, 46–57
Pacific Coast Steamship Company, 105
Pacific Fleet, 24, 26, 121
Pacific Mail Line, 113
Pacific Mail Steamship Company, 14, 16, 102–3
Pacific Squadron, 24, 121
Pacific Steamship Company, 106
Pacific Street Wharf, 112
Palmer, Frank, 53
Palmer, Nat, 14
Panama, Isthmus of, 24, 26, 103
Panama Canal, 24, 26, 34–5
Parker Brothers, 17
Passat, 35
Passmore, Lee, 16, 46
Pearl Harbor, 26, 127, 129
Pend d'Orelle, 53
Pennsylvania, 124, 128–9
Pera, 42–3
Phelps, Billy, 16
Philippine Islands, 26
Phoenix, 66
Piening, Captain H., 35
Pilgrim, 45
Plummer, George, 18
Pommern, 40–1
Port Angeles, 10, 75
Port Arthur, 109
Port Blakely, 10, 16, 49, 58, 61
Port Blakely Mill Company, 19
Port Costa, 57
Port Gamble, 10, 49
Port Harford, 50
Port Langdale, 133
Port Los Angeles, 51
Port Ludlow, 10, 49
Port of Los Angeles, 26, 112
Port of Oakland, 26, 57
Port of San Francisco, 26, 56, 131
Port Orford cedar, 59
Port Stanley, 96
Port Townsend, 10, 18
Portland, 17, 26, 47, 52, 103, 108
Pratsch, Charles Robert, 17
Preble, 126
President Coolidge, 160
President Grant, 114
Princess May, 111
Procter, John W., 153
Puget Sound, 9, 23–6, 31, 47, 49, 59, 90, 127, 133
 photographers of, 16–9
 shipbuilding on, 75–7, 79
Puget Sound & Alaska Steamship Company, 106

Q
Queen, 54

R
Real, 112
Red Jacket, 14
Red Stack pier, 138
Redondo Beach, 16, 48, 50
Redondo Railroad Company, 50
Reed, Hans, 78
Revenue Marine, *see U.S. Revenue-Cutter Service*
Richardson, Paul, 17
Richardson's Bay, 148
Rincon Point, 28
Rio Vista, 143
Riverside, 68
Roanoke, 112
Robert B. Harper, 101
Robertson, Captain, 156
Robertson's, James shipyard 80
Rocky Mountains, 23
Rodeo-Vallejo Ferry Company, 80
Russian trappers, 22
Russo-Japanese War, 109

S
Sacramento, 87, 102, 143
Sacramento River, 24, 84, 131, 140, 143
St. Michaels, 54
Samoa, 82–3
Samuel Moody, 101
San Diego, 7, 9, 16–7, 26, 46–7, 70–1, 103, 121, 127, 129, 131
San Francisco, 26, 47, 72–3, 87–8, 102–3, 121, 131–2, 144
San Francisco Bay, 10, 17, 26, 36, 39, 47, 57, 72, 75, 120–1, 124, 131–2, 134, 140, 144–9, 153
 ferryboats, 24, 133–7
 ports, 57
 shipbuilding on, 75, 80–1, 84–5, 88, 90–101
San Francisco Call-Bulletin, 136, 149–51
San Francisco Ferry Building, 134
San Francisco Maritime Museum, 153
San Francisco Maritime National Historical Park, 7, 16, 69, 153
San Francisco Port of Embarkation, 26, 150
San Francisco Yacht Club, 144, 147
Sandhurst, 156
Sandwich Islands, *see Hawaiian Islands.*
Sandy Hook Fleet, 133
San Joaquin, 143
San Joaquin River, 142
San Leandro, 136
San Luis Obispo, 50
San Pedro, 7, 16–7, 48, 51, 75, 121, 129
Santa Ana, 78
Santa Barbara, 50, 144
Santa Clara (ferryboat), 137
Santa Clara (sailing ship), 39
Santa Fe Wharf, 70
Santa Monica, 48

Santa Monica Canyon, 51
Sausalito, 80, 148
Schiller, Rudolph, 17
Scott, Mr., 16
Scott, Walter A., 16, 43, 65, 67, 69, 72, 74, 86, 138, 144, 153
Scow schooners, 10, 138–9
Sea Scout, 71
Seattle, 26, 47, 49, 75–6, 108, 114, 131
Seattle/Tacoma, 26
Senator, 14, 102
Sentinel, 141
Sentinel Island, 111
Shanghai, China, 126
Shenandoah, 17
Sherman, 52
Sherriff, J.A., 17
Shinyo Maru, 115
Shipbuilding, 22–3, 25, 29, 74–101, 127, 140, 148–9
Singapore, 21
Sitka, 17
Skagway, 54
Slattery, Jack, 17
Sloat, Commodore John D., 121, 127
Snow & Burgess, 82
Sonoma, 23
Sonoma (steamship), 27
Southern Pacific Railroad, 10, 48, 50–1, 132–3
Spanish-American War, 26, 121
Spokane, 53
Spokane (steamship), 105
Spreckels, 103
Star of Finland, 39
Star of Shetland, 13
Star of Zealand, 32
States Steamship Company, 116
Steam schooners, 65–70, 78, 82
Steamboat Point, 28
Stearns, Jesse O., 17
Sterns Wharf, 50
Stone, W.F. and Son, 74, 80, 146
Strathnairn, 30
Superior, 64
Swadley, E.B., 16, 132

T
Taber, Isiah W., 16
Tacoma, 16, 47, 108
Tacoma (steamship), 39
Terminal Island, 48, 112
Teschner, Captain Alexander, 42–3
Thompson, Gerald, 117
Thordis, 95
Thrasher, 36
Thwaites, J.F., 17
Tiburon, 144
Timandra, 31
Toyo Kisen Kaishi, 103, 115
Transcontinental railroads, 24–5, 47
Trinidad, 70
Turrill and Miller, 56
Two Brothers, 1
Two Years Before the Mast, 22, 45

U
Union Iron Works, 78, 90–2, 124
U.S. Army, 75
U.S. Maritime Commission, 86, 90
U.S. Navy, 24, 26, 47, 120–9
U.S. Revenue-Cutter Service, Revenue Marine, and U.S. Coast Guard, 123
U.S. Shipping Board, 93

V
Vancouver, 26, 64
Virginia, 149
V-6 (submarine), 127

W
Wanderer, 19
Wapama, 69
War of 1812, 121
War Shipping Administration, 133
Warner system, 96
Washington, 108
Waterman, Bully, 14
Waters, R.J., 16
Watkins, Carleton E., 14, 16
Webster and Stevens, 17
West Santa Fe Wharf, 46
Whitelaw, Captain Thomas, 88
White Star Line, 104, 113
White Wings, 146
Wilder's Steamship Company, 55
Willamette, 67
Willamette River, 52
Willapa Bay, 70
Willie Hume, 48
Wilmington, 50
Wilton, T.H., 16
Witch of the Wave, 14
Wood, Charles, 17
Wood, Mr., 17
Woodfield, Frank, 17
Worden, W.E., 16
World War I, 75, 90, 93, 95–6, 112, 114, 127
World War II, 21, 26, 75, 90, 100–1, 118–9, 126–9, 133
Wrangell, 54

X

Y
Yale, 112
Yerba Buena, 135
Yerba Buena Cove, 11, 22
Yerba Buena Island, 57, 134
Yokohama, 103–4
Young America, 14
Yucatan, 41
Yukon River, 24, 54, 105

Z
Zaragoza, 124–5

SS President Coolidge *departing San Francisco, 1939.*

"Strongly it bears us along in swelling and limitless billows,
Nothing before and nothing behind but the sky and the ocean."

Samuel Taylor Coleridge